The A—Z of Creative Photography
Revised Edition

The A–Z of
Creative
Photography
Revised Edition

LEE FROST

AMPHOTO BOOKS

an imprint of the Crown Publishing Group

New York

Published in the United States by Amphoto Books, an imprint of the
Crown Publishing Group, a division of Random House, Inc., New York.

www.crownpublishing.com

www.amphotobooks.com

Amphoto Books and the Amphoto Books logo are trademarks of
Random House, Inc.

A previous edition of this work was published in hardcover in the
United Kingdom by David & Charles, Brunel House, Newton Abbot,
Devon, in 1996, and was subsequently published in hardcover in the
United States by Amphoto Books, an imprint of the Crown Publishing
Group, a division of Random House Inc, New York, in 1988.

Library of Congress Control Number: 2010924463

ISBN 978-0-8174-0008-8

Printed in China

10 9 8 7 6 5 4 3 2 1

First American Revised Edition

CONTENTS

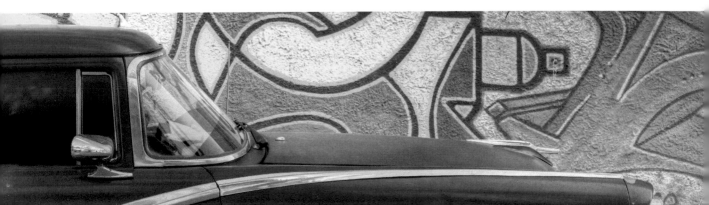

INTRODUCTION

Welcome to *The A–Z of Creative Photography, Revised Edition*!

The "revised" bit is necessary because I wrote the original *A–Z of Creative Photography* more than a decade ago. Since then, quite a lot has changed in the world of photography, so a new version of one of my best-selling books seemed like a sensible idea.

The most significant change of all is the fact that most of us are now shooting with digital cameras. Back in 1998, when I sat down to write the original *A–Z*, if someone had told me that ten years later I would be using a filmless camera to take photographs, and a computer to process them instead of a plastic tank full of smelly chemicals, I would have choked on my coffee. The very idea would have been too preposterous to take seriously.

Fast forward to 2010 and that's exactly what I'm doing. The darkroom door was long ago locked for the last time, I haven't handled a roll of film in almost two years, and I own and use less equipment now than ever.

But do you know what? I'm also more excited and inspired by photography than at any time since I first picked up a camera almost 30 years ago. I resisted making the switch from film to digital for a long time but, looking back, I now wonder why, because since the transition I've discovered a whole new world of creative image-making. Techniques that were once time-consuming and difficult are made quick and easy by digital technology. Effects that would have been impossible to achieve with film are now child's play thanks

to Adobe Photoshop. It's as if I have been creatively reborn. I'm discovering the joys of photography all over again and producing more exciting, new work now than ever.

The A–Z of Creative Photography, Revised Edition is where I have channeled this new-found enthusiasm and knowledge. Between its covers you will find easy-to-understand advice to help you tackle more than 50 subjects, techniques and ideas. From abstracts to architectural details, candids to online calendars, panning to polarizing filters, there's bound to be something to get your creative juices flowing.

To make the information easier to digest, where possible I've presented it in a step-by-step style so you can follow my advice a little at time to help guarantee success. Behind-the-scene images and screengrabs have also been included in many cases to give you an idea of what to expect and, as always, each chapter is illustrated with images that I hope will inspire you to get better and better.

When I was bitten by the photography bug, at age 15, I wished there had been a book like this to help me learn and improve. There wasn't, so I took creative risks, made mistakes and learned from them. It all came out well in the end, but took longer than I'd hoped!

By reading The A–Z of Creative Photography, Revised Edition hopefully you'll make fewer mistakes than I did and become a better photographer sooner rather than later.

Good luck—and keep shooting!

LEE FROST
September 2010, Northumberland, UK

ABSTRACT ART

Most of the photographs we take are of specific objects, recorded in a literal way so the viewer can identify what has been depicted. If we photograph a building, for example, it's usually obvious what our subject is, and whether we capture all or part of it. Similarly, landscape scenes are generally captured with a wide-angle lens to give a broad panoramic view. However, you don't have to work in this way, and often by taking a more abstract view of everyday subjects you will produce far more exciting results.

There are various meanings to the word "abstract," but from a photographic point of view, the most apt is basically "having no reference to material objects or specific examples." In other words, an abstract picture gains its appeal not from the fact that you can identify the object recorded, but from the colors, shapes, patterns and textures that make up that object. This means that literally anything can be used as the basis of an abstract image, big or small, simple or complex, natural or man-made.

WHAT YOU NEED

CAMERA: Abstract photography is more dependent on your eye for a picture than the equipment used, so any type of camera will be suitable. Digital compacts and SLRs are ideal because you can see the results immediately and this can be hugely inspiring.

LENSES: A range of focal lengths from 28mm wide-angle to 200mm telephoto will cover all situations, but you can produce successful images using just one lens.

HOW IT'S DONE

When we stop to take a picture it's because we have seen something that appeals to our visual senses. Unfortunately, those senses tend to work on a limited set of values, so we are selective about what we photograph and what we ignore. You may be naturally drawn to a particular type of building, for example, but pay no attention to another, and what one photographer finds visually appealing you may not even see. As a consequence, every minute of your life, potentially great pictures are being missed simply because you didn't even know they existed in the first place.

The aim of abstract photography is to overcome familiarity so you begin to see things in a completely different way. To do this you need to tune your senses so you're more sensitive and responsive to the world around you. Once you're able to do this, it's amazing how fresh and

exciting even the most familiar things can be. A car parked by the roadside is no longer just a car, but an object full of graceful curves, graphic reflections and contrasting shapes. An old wall covered in peeling posters is suddenly an eye-catching array of patterns, textures and colors.

You can also use different lenses and camera angles to control exactly what appears in the final image and heighten the graphic, abstracted nature of the pictures you take.

Wide-angle lenses allow you to create dynamic compositions, where disparate objects are juxtaposed in such a way that a successful image is created—one that you didn't even see with the naked eye. The distortion wide-angle lenses introduce when used from close range is also ideal for taking your pictures a step further from reality.

Telephoto lenses are equally valuable as they allow you to isolate small parts of a subject or scene, so the part becomes more important than the whole. This, really, is the essence of the technique—"abstracting" a tiny part of reality to limit what the viewer sees.

top tips

- Remember, the less realistic an image looks, the more appealing its abstract quality will be.

- Spend time exploring everyday subjects and scenes—it's surprising how many interesting abstracts will appear.

- Look at familiar things from unfamiliar angles and you'll see them in a completely different light.

- Forget about what something really is and concentrate on shape and color.

Urban locations are the perfect place to take abstract images as there are so many different shapes, colors, textures and patterns all jostling for space in a restricted area. The urban landscape is also ever-changing—no street looks exactly the same for more than a few minutes as people and vehicles come and go, so there is always something different to photograph.

You can also create successful abstract images around your own home if you spend time looking and exploring.

Red brick captured against deep blue sky, a colorful sign against a painted door, the play of shadows on a stone wall—chances are you pass these things everyday without giving them a second glance, but they all make perfect subject matter for appealing abstract images.

Taking abstract pictures can also have a major influence on your photography in general, as it forces you to become more observant and helps to improve your eye for a picture.

These three images were all made in the same place in the space of just a few minutes. I was in the external corridor of a hotel in Cienfuegos, Cuba, supposedly taking a break from the heat of the day, when I noticed the bold color contrast between the red of a wall opposite me and the blue sky. Reaching for a camera and fitting a polarizing filter (see page 116). I started to explore the scene from different angles, taking quite a few shots, reviewing them and deleting any that didn't work. The more I explored, the simpler the images became until it was no longer obvious what I was shooting and the images were just studies in color, shape and tone——the very essence of abstract photography.
Canon EOS 1DS MKIII with 24–70mm f/2.8 zoom and polarizing filter, 1/60–1/125sec at f/11, ISO100

ARCHITECTURAL DETAILS

Walk down any street in any town or city and you'll find buildings in all shapes, sizes and designs, both old and new. Over a period of decades, centuries even, architectural styles and tastes have changed dramatically and this diversity can provide many exciting photo opportunities.

The usual approach to architectural photography is to capture whole buildings on film. However, if you take a closer look at each individual building you'll discover lots of interesting details and aspects of its design that make eye-catching subjects in their own right.

On old buildings, ornate carved stonework details are common, such as figures, faces, columns and cornices, while on newer buildings, eye-catching patterns can be found in the bold, geometric design and repeated features. Think of the hundreds of identical windows on a towering office block, or the dynamic pattern created by external steel frames or concrete panels.

These smaller details tend to be missed as we rush around without paying much attention to our surroundings, but if you take the time to study the buildings in your neighborhood you'll discover a wealth of subjects waiting to be photographed.

WHAT YOU NEED

CAMERA: Any type of camera that accepts interchangeable lenses is ideal for photographing architectural details, though a compact camera with a zoom lens can be used successfully.

LENSES: As most architectural details are either small or some distance away, telephoto lenses are usually required to isolate them and fill the frame. A typical 80–200mm or 75–300mm tele-zoom will cope with most situations.

ACCESSORIES: Often you'll be looking up at buildings, and this is much easier to do for prolonged periods if the camera is mounted on a tripod. As well as reducing the risk of camera shake, it will aid precise composition. A polarizing filter (see page 116) can also be used to deepen blue sky and increase color saturation.

HOW IT'S DONE

The key to success is to eliminate all extraneous information so only the key subject matter is recorded. This means choosing your viewpoint and lens carefully and spending a little time fine-tuning the composition. If any distracting details can be seen creeping into the viewfinder—such as the edge of a street sign, or an annoying blemish on the building, crop it out. Zoom lenses are ideal in this respect because you can make tiny adjustments to focal length to fine-tune the composition.

LOCATION

Spend time exploring buildings and seeking out their best details. Look for patterns emerging, such as the identical windows and columns in old Georgian buildings, or the glass and steel construction of modern office blocks. See what happens when you change your viewpoint. A row of columns or buttresses will look far more interesting when photographed from the side than head-on, for example, because you'll emphasize the pattern aspect more effectively. Telephoto lenses are ideal for emphasizing patterns in a building because the way they compress perspective makes the repeated features seem closer together to produce dramatic results.

Depth of field is limited when using

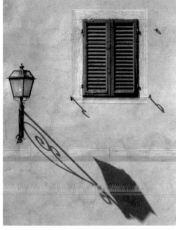

telephoto lenses, especially at wide apertures such as f/4 and f/5.6. To ensure everything in the picture comes out sharply focused you should therefore set your lens to a smallish aperture such as f/11 or f/16, especially if you need to tilt the camera to look up at a building.

The stark contrast between old and new also makes for interesting pictures. You could capture the reflection of an old church in the windows of a modern office block, or photograph an aging building being overshadowed by an enormous skyscraper—again using a telephoto lens to emphasize the effect.

On a smaller scale, architectural features such as windows, doors, mailboxes, door knockers and house numbers also make great subjects.

TIME

The best time of day to photograph architectural details depends on the type of building. Old stone buildings such as cottages, churches, castles and cathedrals tend to look stunning during later afternoon and early evening, when the mellow stonework is bathed in warm sunlight.

Modern buildings suit bright, sunny weather as it emphasizes their bold, angular design, and often allows you to capture reflections of the sky in the windows to produce interesting abstract images. Use a polarizer to deepen the blue sky and reduce glare on the windows. Modern office blocks also look good just after sunset, when the facade reflects the warm colors in the sky.

Architectural details come in all shapes, sizes, colors and designs, and once you start taking a closer look you'll see photo opportunities in the most everyday places. The key is to fill the frame and keep your compositions simple, so either use your feet and move closer or increase the focal length of your zoom to exclude unwanted detail. Canon EOS 1DS MKIII with 24–70mm and 70–200mm zooms, ISO100

top tips

■ Spend time exploring a building, both inside and out, for interesting architectural details—the best ones aren't always the most obvious.

■ You needn't visit exotic or grand buildings to find eye-catching details— the buildings in your own street can be just as rewarding to photograph.

■ The quality of light plays a major role in the success of a picture, so always try to take pictures in the best light.

AT YOUR FEET

When we talk of landscape photography, the images we conjure up are of panoramic vistas and sweeping views; pictures taken on a grand scale that capture the immensity and glory of the countryside. That's generally what we strive to capture because we feel that anything less would fail to do the location justice. So we tramp up hills and through valleys, single-mindedly seeking out viewpoints to capture these vistas, trying to get there before the light fades and hoping the pictures we take will be as good as those taken before us.

But what of the landscape at your feet? What of the many patterns, textures and details in nature; the small scale subjects that make up the very scenes we try so desperately hard to photograph? They, too, can be the source of fascinating pictures and, unlike the grand view, provide much more scope for personal interpretation because no one else is likely to see them in quite the same way.

When you photograph the landscape in miniature, you set out with no preconceptions. Famous vistas around the world have been photographed many times before, so it's hard to photograph them yourself without thinking of the pictures you've already seen, and often what you end up with is no different or better or more creative than anything else.

With details in the landscape, this is never the case because you are unlikely to travel to a location specifically to photograph an arrangement of rocks or a particular tree. You don't know what you'll find until you're there, so the resulting pictures will be unique because they will be unplanned.

WHAT YOU NEED

CAMERA: There are no specific requirements here. I mainly use a full-frame digital SLR but I have also shot many details using film cameras and digital compacts.

LENSES: A standard zoom (24–70mm or 28–85mm) would be ideal, but in some situations wider or longer lenses can be useful and a macro lens will allow you to shoot proper close-ups.

ACCESSORIES: You can shoot details handheld, but I prefer to mount my camera on a tripod for extra stability and control.

HOW IT'S DONE

The first step in focusing your vision on smaller aspects of the landscape is to exclude the horizon from your field of view. Including the horizon in a photograph immediately defines it as a vista because it suggests open space and all sense of intimacy is lost. But once the horizon is gone, so too is that sense of space. Instead you are concentrating on the view—to what extent is up to you.

That's the great thing about photographing the landscape on a smaller scale. One minute you can be capturing an area that covers many square meters; the next down on your hands and knees composing a detail

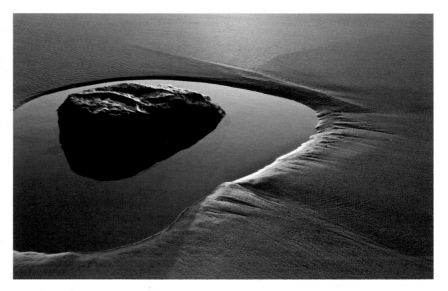

I shot this image soon after sunrise on a beach near my home. The pool and rock were initially used as foreground interest in a wide-angle view across the bay, but once the sun rose I started looking at alternatives and realized this detail made an attractive composition in itself, thanks to the golden sunlight glancing across the smooth sand and the bold shape of the rock and pool.
Canon EOS 1DS MKIII with 24–70mm zoom, 1/8sec at f/16, ISO100

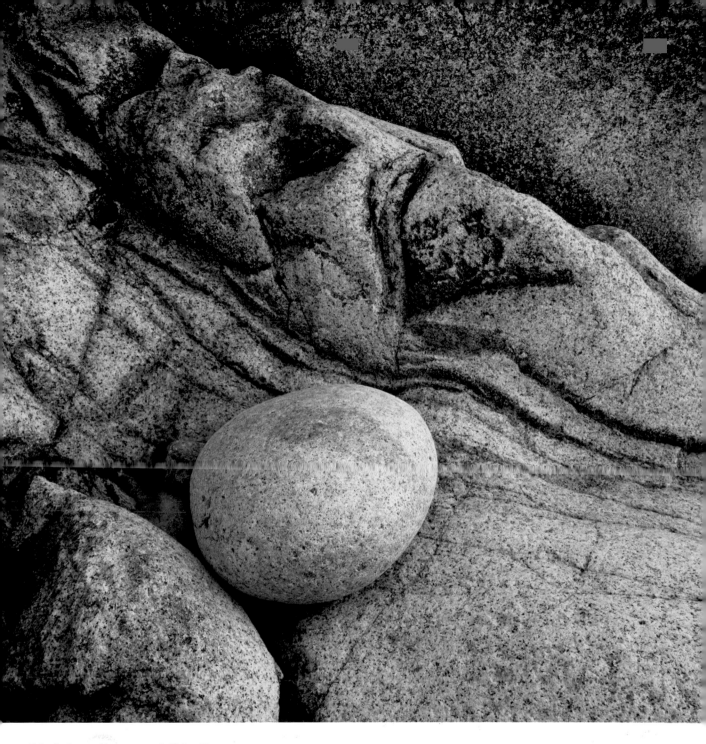

Living by the sea, I have a natural affinity with beaches and can spend hours wandering around in search of details, which are always abundant. Rocks are a particular favorite. I love the way their color, shape, size and texture are so varied, and the contrast between pebbles and boulders worn smooth by the sea, then thrown back up on to the shore where the rocks are still in their raw, natural state.

Bronica SQA with 80mm standard lens, 1/2sec at f/16, ISO100 film

top tips

■ Get into the habit of looking for details when shooting landscapes, instead of always focusing on bigger views.

■ The type of images you see here make great prints for the wall because they're different than the usual "classic" landscapes and more likely to attract attention.

■ Why not set yourself a project to shoot details in the landscape so that you have a reason for doing it?

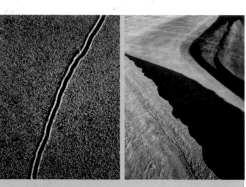

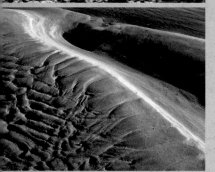

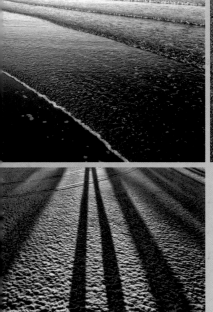

USE THE PHONE

You don't even need a stand-alone camera to take great detail photographs—the digital camera built into your cell phone is capable of surprisingly good results, too, if you work within its limitations and don't expect to be able to produce poster-sized prints from the images.

The series of photographs here were all shot using the 2mp camera in my Apple iPhone. They all started life as color images but were converted to black and white later using Nik Software Silver Efex Pro (see page 86). Not bad—if I say so myself!

The great thing about using a cell phone camera is that you're always going to have it with you, whereas you won't necessarily have a "proper" camera at your disposal all the time.

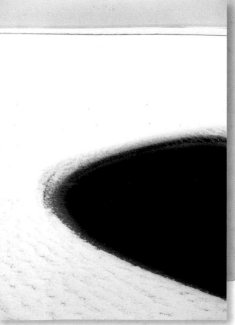

that's just a few centimeters in size.

Scale and size no longer matter—you are entering the realms of the abstract image where color, texture, pattern and form take precedence over subject recognition. In fact, the picture will be more effective if the subject isn't recognizable because this tends to make us focus on what the picture is of rather than the elements contained within its boundaries.

Excluding any sense of scale from your pictures forces the viewer to try to imagine it and this can lead to all sorts of fascinating interpretations. A close-up of the patterns in a rock may appear like an aerial photograph taken from thousands of meters above the earth yet is no bigger than your hand; ripples in a sandy beach look surprisingly like a vast desert; a small trickle in a river could be a towering waterfall cascading over cliffs.

Clearly, your intention isn't to fool anyone, but by removing any sense of scale from your pictures that's exactly what can happen, and it makes those pictures all the more interesting because the viewer has to try to figure out exactly what's going on—they challenge our sense of familiarity.

MAKE USE OF BAD WEATHER

On a more practical level, photographing details in the landscape frees you from many of the limitations imposed by the grand view. For a start, the quality of light becomes less important. Landscape photographers often say that the focal length of their lens, or the scale of their subject, is directly proportional to the weather conditions. In other words, when the weather's good and the light great, they photograph the grand view, but when it's

ABOVE LEFT: This intricate pattern of light and dark tones looks like delicate brush strokes, but in fact was created by particles of sand of different sizes and colors being picked up and deposited again by the water in a beach outflow stream.
Canon EOS 1DS MKIII with 16–35mm zoom, 1/40sec at f/8, ISO50

ABOVE RIGHT: Winter's a great time for shooting natural details because the landscape is transformed by frost, snow and ice and even the most mundane location becomes a photographer's paradise.
Canon EOS 1DS MKIII with 24–70mm zoom, 1/00sec at f/0, ISO000

LEFT: Pssst. I've got a little secret I want to share with you. That small grey pebble wasn't actually there——I picked it up off the beach and placed it in the hole to make the composition more interesting. Cheating? Absolutely not——well, no more than removing a distracting item from a shot, and we do that all the time.
Canon EOS 1DS MKIII with 24–70mm zoom, 1/60sec at f/8, ISO100

not, they concentrate on smaller details.

Obviously, the quality of light is important when you shoot certain details. If you want to record the rough texture of tree bark, or capture the delicate ripples in sand, you need sunlight glancing across it to cast shadows. In some cases it's also the light that creates the picture—as is the case with ripples in sand, which disappear when the sun is overhead, or obscured by clouds.

More often than not, however, you don't need strong, directional light to take successful pictures of details in the landscape, so when the weather takes a turn for the worse and those grand views are out of the question, you can turn to take a more intimate look around you.

MORE THAN ONE

When you do this you will also find that many different pictures can be taken in one small area. Even a single tree can be the source of numerous shots: close-ups of the tree bark, the pattern of fungi growing on its trunk, leaves backlit against the sky, gnarled roots at its base. Take a few steps back and suddenly a pattern emerges in the group of trees before you. Wander along a beach and you could spend all day photographing details like pebbles, driftwood, seashells, the shapes of rocks on the shore worn smooth by the action of the sea and the lines and swirls within those rocks.

Wherever you look, there are intimate details in the landscape that can be the source of pictures just as evocative as those grand views.

BACKLIGHTING

The vast majority of pictures are taken with the main light source—usually the sun—positioned behind the camera so the subject or scene is frontally lit. However, while working in this way is undoubtedly easy, it rarely produces dramatic results. This is because when an object is lit head-on, shadows fall away from the camera so the image tends to look rather flat and lacks any impression of depth.

Shooting with the main light source on one side of the camera will make a big difference, as shadows become an integral part of the composition, revealing texture and form in your subject. But an even better approach is to shoot into the light; in other words, point your camera toward the main light source so your subject is backlit. This technique, usually referred to as *contre-jour* (literally meaning "against the day"), is one of the most exciting photographic techniques available and can be applied to a wide range of subjects, from portraits to landscapes.

WHAT YOU NEED

CAMERA: Any type of camera can be used but it must give you control over the exposure so you can achieve the desired effect.

LENSES: As most subjects suit backlighting, any focal length from extreme wide-angle to long telephoto can be used.

ACCESSORIES: If you want to record foreground detail, an ND grad filter will be required to tone down the sky so it doesn't burn out when you expose for the foreground (see page 92).

HOW IT'S DONE

The first thing you need to remember when shooting into the light is that contrast (the difference in brightness between the highlights and shadows) is going to be much higher than normal.

This does vary enormously—contrast is much lower on a misty morning than it is during mid-afternoon on a bright, sunny day. Nevertheless, in all situations the background or light source is always going to be much brighter than the rest of the scene, so you need to take care when determining the exposure.

If you rely on your camera's integral metering system, more often than not it will set an exposure that's correct for the bright background, while the much darker foreground is recorded as a silhouette. This in itself can produce stunning results (see page 126), but there are other options available when your subject is backlit so you need to make

a conscious decision about the type of effect you wish to record.

You may decide to record some level of detail in the foreground—when capturing a landscape on a stormy day, for instance, with the sun breaking through the dark, cloudy sky, or at dawn on a misty morning with the sun rising above the horizon.

EXPOSURE

To get this type of shot right you should ignore the fact that the background—i.e., the sun and sky—is really bright and concentrate on ensuring that you correctly expose the foreground.

The simplest way to do this with a digital SLR is to compose the scene, take a test shot with your camera set to Aperture Priority Exposure mode, check the image and histogram on the preview screen, then adjust the exposure as required. More often than not you

will need to increase the exposure to reveal more detail in the shadow areas. Do this using the camera's exposure compensation feature. Try +1 stop and see how the image/histogram look. If you need to increase the exposure even more, do so in small increments of +1 1/3, then +1 2/3 then +2 stops. It's unlikely that you will need to go beyond +2 stops.

By exposing for the foreground in this way, you're going to overexpose the much brighter background so it burns out. In some situations this can produce evocative "high-key" images. In woodland, for example, if you expose for the shadows, light will seem to "explode" around the trees like a halo.

Unfortunately, when shooting *contre-jour* landscapes, the dramatic effect will be lost if the sky is overexposed. To prevent this you must use a strong ND grad filter to darken the sky and ensure

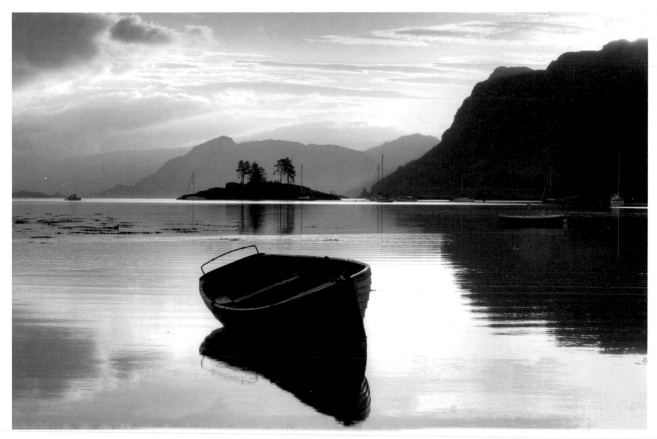

Here's a classic backlit scene, taken soon after sunset on a tranquil summer's morning. The calm water, hazy light and soft colors all combine to create an incredibly atmospheric image. Careful exposure was necessary to record the optimum balance between highlights and shadows, though the great thing about shooting digital images in raw format is that you can adjust that balance during post-processing to achieve exactly the effect you had in mind.
Canon EOS 1DS MKIII with 70–200mm zoom and 0.9ND hard grad, 1/13sec at f/32, ISO100

AVOIDING FLARE

One of the biggest problems encountered when shooting into the sun is flare, which reduces contrast, washes out colors and can produce light patterns across your pictures. Flare is caused by non-image-forming light getting into the lens, and is usually a result of a bright light source, such as the sun, being inside or just outside the camera's viewfinder when a picture is taken.

The easiest way to avoid flare is by fitting a hood to your lens so the front element is protected from stray light glancing across it. Equally important is that you keep your lenses, or any filters on them, spotlessly clean, as dust or greasy finger marks will increase the risk of flare considerably—especially when shooting directly into the sun.

Although flare is usually an unwanted presence, if you're aware of it and use it to your advantage, it can actually improve an image to no end. In this case, I knew flare would be unavoidable but I decided that it would add a heavenly feel to the subject.
Infrared-modified Canon EOS 20D with 10–20mm zoom, 1/40sec at f/11, ISO100

BACKLIGHTING

The interior of this old fisherman's hut was lit entirely by daylight flooding in through a window. I had to increase metered exposure by +2 stops to record detail inside the building. This caused the window to overexpose, but I feel that the intense patch of brightness in the background actually improves the image, adding an extra, unexpected element.
Sony Cybershot 6mp digital compact with integral 5.2–18.9mm zoom, 1/15sec at f/6.3, ISO8

If you shoot into the sun in bright weather, contrast can be so high that it becomes very difficult to achieve the effect you want in a single image. In this case, I tried using a 0.9ND hard grad on the sky, but it still wasn't enough, so I resorted to an old trick of taking five identical shots of the same scene from 2 stops under the metered exposure to 2 stops over, in full stop increments, then merging them using Photomatix Pro software (see page 80). The resulting image was even better than I expected and really captures the drama of this winter scene.
Canon EOS 1DS MKIII with Zeiss 21mm lens, f/16, ISO100

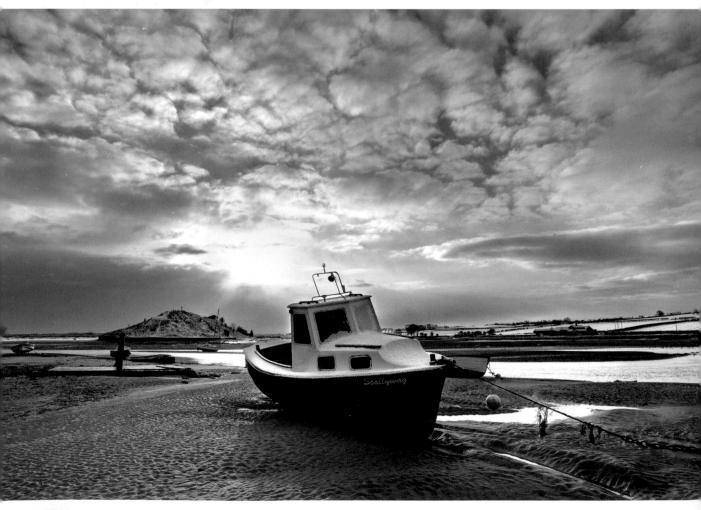

detailed is recorded—usually a 0.9 (3 stop) ND grad will be required. This is particularly important when shooting in stormy weather as it's the dark, dramatic sky that will give the shot its impact. The same applies when shooting a sunrise or sunset. If the sun and sky burn out, the atmosphere of the scene will be destroyed.

Another option is to shoot the same scene at different exposures, from -2 stops to +2 stops in full stop increments, then merge them into a single image so you get detailed shadows without "blowing" the highlights. The effects can look amazing. Turn to page 80 to find out how.

INSIDE JOB

Backlighting can also be used indoors in a more controlled way, to create silhouettes of solid objects or to reveal the colors in translucent objects. If you place a row of bottles on a windowsill at sunset, for example, the warm colors in the sky will pass through the bottles to produce a beautiful effect.

The easiest way to backlight objects like this is by using a studio flash unit fitted with a large "softbox" attachment, which diffuses the light and produces an even, white background. However, a similar effect can also be produced by placing a sheet of white Plexiglass or tracing paper behind your subject then firing a flash through it. Alternatively, if you have a slide-viewing lightbox you can use that. The white viewing panel makes an ideal background for small translucent objects.

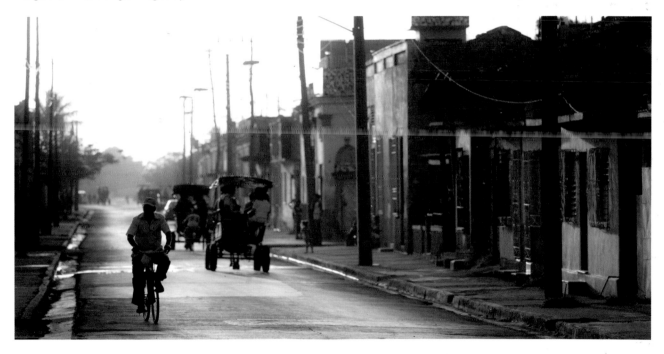

Sunset is a great time to shoot backlit street scenes, especially if you can find a street that runs east to west so the light will be streaming right down it. At this time of day you will also have the opportunity to include people in your pictures for added interest. I stood by the side of this road for half an hour or more, shooting away as people came and went.
Canon EOS 1DS MKIII with 70–200mm zoom, 1/500sec at f/4.5, ISO200

top tips

■ Remember that you can produce completely different effects by varying the exposure when shooting into the light.

■ If you shoot backlit portraits, brighten up your subject's face using a burst of fill-in flash or use a reflector close to the camera to bounce light back on to your subject's face.

■ Early morning and late afternoon are the best times to take *contre-jour* pictures outdoors, as the sun is low in the sky, making it easier to include it in your pictures.

■ See Silhouettes (page 126) for more backlighting ideas, and Enhance Your Image (page 32) for more advice on improving your backlit photographs.

BLURRING

Back in the early days of my photographic life I enjoyed experimenting with soft-focus filters to create delicate, dreamy images. I was also fond of smearing petroleum jelly on pieces of clear plastic, and even experimented with ladies' stockings at one stage. As a diffuser that is, not an item of clothing!

Fast forward two decades and I'm still a soft-focus fan, only my weapon of choice these days is a clever accessory known as the Lensbaby Composer.

WHAT YOU NEED

CAMERA: A digital or film SLR that accepts interchangeable lenses.

ACCESSORIES: A Lensbaby Composer, available from all good photo stores (see www.lensbaby.com).

HOW IT'S DONE

The Composer, like other Lensbabies in the collection (the Muse and the Control Freak), performs two main functions.

First, you can move the lens element out of square with the film/sensor of your camera so that depth of field becomes very shallow and only a small area is recorded in sharp focus. The position of this "sweet spot" can also be controlled, so if your main subject is off-center you simply adjust the Lensbaby until it appears in focus.

Second, you can add lovely soft edges and vignetted corners to your images, similar to the results produced by "toy" cameras like the Holga, but more pronounced.

What makes the Composer more versatile than other Lensbabies is that it uses a ball and socket design so when you tilt the lens to move the sweet spot, it stays in position. All you do then is twist the front ring to bring your subject into focus and fire away.

This is the kind of effect you can expect from a Lensbaby——selective sharpness surrounded by soft blur. I chose to keep the "sweet spot" in the center of the image and used a wide aperture disc (f/5.6) so depth of field was reduced and the rest of the image faded toward the edges.
Canon EOS 1DS MKIII with Lensbaby Composer and f/5.6 disc, 1/60sec at f/5.6, ISO100

As part of the kit you also get a Magnetic Aperture Set with the Composer, which consists of a set of black discs with holes of varying sizes in the center representing different f/numbers (2.8, 4, 5.6, 8, 11, 16 and 22). The discs are held in place on the front of the Lensbaby by magnets and by switching these around you can control depth of field and the level of blurring toward the image edges. Choose a small f/number (wide aperture) if you want lots of blur and a big f/number (small aperture) to reduce blurring. Fitting no disc at all gives you maximum edge blur and minimum depth of field.

Using the Lensbaby Composer is child's play. It bayonets onto your camera instead of a conventional lens, then you simply tilt, focus and fire. It's also perfectly suited to both film and digital cameras, though shooting digitally is definitely a bonus because you get to see the results immediately and have the option to reshoot if they're not quite right. I find the immediacy of digital invaluable when experimenting with creative techniques. Knowing the effect works, I'm spurred on to try it again, whereas with film I was more cautious due to the cost implications and not knowing if I'd gotten any decent shots.

One thing you need to check when using a film camera is if the integral metering is able to give correct exposure readings in stopdown mode. The vast majority of conventional lenses have an automatic aperture, which stops down to the f/number set when you trip the shutter release. But the Lensbaby's aperture size is controlled by whichever magnetic disc you fit, so your camera will

meter through the disc and this may lead to exposure error.

Like all creative gadgets, the Lensbaby Composer should be handled with care, otherwise there's a danger of overkill. Given the right subject and situation, the effects it produces can turn a good photograph into a fine art masterpiece, but too much too often and your work will become predictable and boring.

I find it works best on simple, bold subjects—cars, architecture, people and still lifes. The key is to experiment, and remember that only a small part of the image will record in sharp focus. This doesn't have to be in the center, but it should be where an important part of your subject is, otherwise the final results may look a little odd!

Lens mounts are available for:

- Canon EF (EOS)
- Nikon
- Sony Alpha A / Minolta Dynax
- Pentax K / Samsung GX
- Olympus Four Thirds / Panasonic Lumix

Automatic exposure is possible by shooting in aperture priority mode for the vast majority of digital and film SLR cameras except certain Nikon and Fuji bodies.

The Lensbaby also works well on black-and-white images, adding atmosphere and a timeless feel. The colors in this scene were subdued anyway, so I removed them from the image in Photoshop then added a subtle warm tone (see page 138).
Canon EOS 1DS MKIII with Lensbaby Composer and f/4.0 disc, 1/200sec at f/4.0, ISO100

Subjects and scenes containing bold shapes and strong colors are ideally suited to the Lensbaby. And remember that if the softness of the Lensbaby makes colors appear weaker than they were, you can always give them a boost in Photoshop.
Canon EOS 1DS MKIII with Lensbaby Composer and f/5.6 disc,1/50sec at f/5.6, ISO100

BREAK THE RULES

While the rule of thirds (see page 124) and other compositional aids can be used to help you create interesting images, you don't have to apply them every time you take a picture. In fact, breaking the "rules" can often produce more eye-catching photographs because the resulting images will be less conventional and visually more arresting in many cases, and therefore hold the attention of the viewer for longer.

The key thing to remember about composition is that it should be an intuitive, instinctive process based on your own unique vision and the scene or subject you happen to be shooting, so there is no right or wrong—only an infinite number of possibilities. If you think about what you're doing too much and try to stick to convention, that vision will be impeded and the photographs you take will be no different than anyone else's.

So, once you've learned the "rules" of composition and are able to apply them in your work, be prepared to abandon them from time to time and see what happens. As the late American photographer Edward Weston once said, "To consult the rules of composition before making a picture is a little like consulting the laws of gravitation before going for a walk."

WHAT YOU NEED

CAMERA: Any type of camera can be used to break the rules—it's more about attitude and confidence.

LENSES: Use whatever focal length you'd like, from ultra-wide to super long.

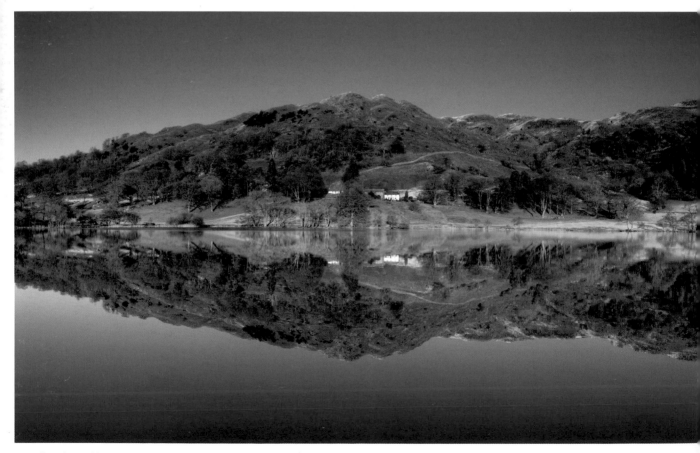

How else could you compose a scene like this? The reflection in the lake creates symmetry and the only way to make the most of symmetry is by placing the horizon at the center of the composition.
Canon EOS 1DS MKIII with 24–70mm zoom and polarizing filter, 1/50sec at f/11, ISO100

HOW IT'S DONE

The classic rule-breaker is placing the horizon across the center of the frame so the image is divided cleanly in two. This goes against all that the rule of thirds stands for and is said to lead to compositions that are "static." But sometimes static can be a good thing because it implies tranquillity and calm, and if you're shooting a scene and its perfect reflection in, say, a glassy lake, then tranquillity and calm are just what you need to capture the true feel of the scene. The symmetry you get by dividing the frame in two also contributes to this and, far from being boring, can lead to stunning results, though only when used intentionally and with the right scene.

Placing your main subject in the center of the frame is another rule-breaker. It's human nature to look straight at the center of anything, so newcomers to photography often make the mistake of composing with this in mind. More often than not it doesn't work because the viewer's eye goes straight to the center of the shot where the main subject is and there's no incentive to search around the composition for anything else worth looking at.

Again, with the right subject this can be just what you want. If you photograph a single tree in the middle of a field, placing that tree in the center of the frame can work well because it forces the eye straight to the focal point—the tree—and there may not be anything else in the frame worth dwelling on anyway.

The small splash of red in this muted seascape stands out boldly against the gray background and screams for attention. So what better place to put it than in the center of the frame where the viewer's eye will be attracted like a magnet?
Canon EOS 1DS MKIII with 24–70mm zoom and 3.0ND filter, 110 secs at f/11, ISO100

Having taken numerous portraits of this Cuban man relaxing on his porch (well, he was until I arrived), I started to experiment with alternative compositions. Spotting the number seven above his head, I decided it would look rather quirky in the composition, so I shot a wider view then cropped the final image to create a vertical panorama with my main subject positioned at the bottom of the frame.
Canon EOS 1DS MKIII with 70–200mm zoom, 1/320sec at f/4, ISO200

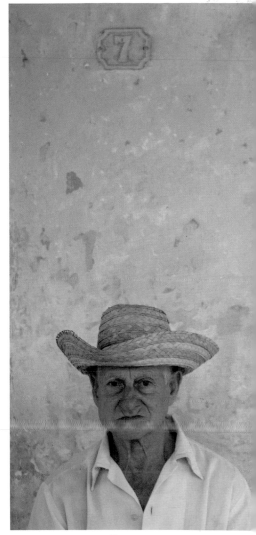

This approach works particularly well when you're shooting with a square-format camera, or you compose a shot with the intention of cropping it to a square, because the center is equidistant from all four sides and the composition is even more static and symmetrical. Try it and find out for yourself.

top tips

- Get into the habit of composing the same scene or subject in different ways. Get the obvious shots out of the way then try something different.

- It's easy to change the angle of an image or crop it during postprocessing, so don't assume that the composition can't be changed later or that you can't make more than one version of a photograph.

- Don't go out of your way to break the rules—only do it when it's going to make a difference. If you try too hard, your work will look forced, and composition should be intuitive.

BREAK THE RULES

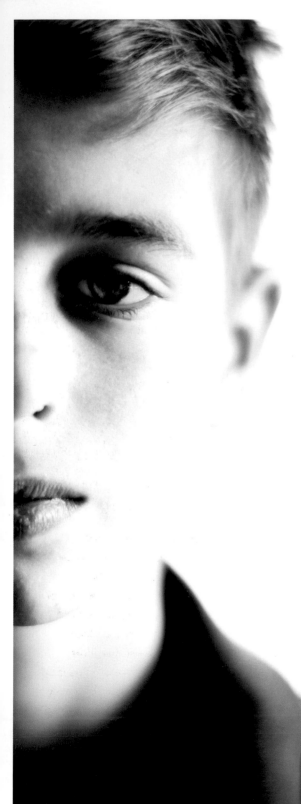

OVER THE EDGE

The other extreme is to intentionally place important subject matter as far away from the center of the composition as it will go. So when the viewers look at the center of an image and sees nothing of interest, they then start searching around the frame until they find something that stimulates their senses. Portraits are a good example of this. We tend to put people in the center of a photograph, but try moving your subject over to the edge of the frame and see how it changes the dynamics of the composition completely.

Taking this idea a step further, excluding important information can add interest and intrigue to a composition because it leaves the viewer wanting. You could crop part of a person's face, for example, or have some of the props in a still life breaking out of the edge of the frame. This tends to hold the viewers' attention for longer than a conventional composition because they have to use their imagination to figure out what the missing bits might look like. If you do this kind of thing by accident it usually looks like a mistake, but when used creatively and intentionally it can work brilliantly, so never be afraid to take the odd risk—it's all part of the fun.

CONFLICT OF INTERESTS

The juxtaposition of elements in a scene can dictate the visual success of a photograph more than the actual subject matter. Once your confidence grows you can use this as a powerful tool—aiming for discord instead of harmony to create images that are interesting and arresting.

Try experimenting with objects or shapes and see how altering their arrangement transforms the look and feel of the composition.

An unusual approach to portraiture, you might be thinking, but composing the shot so that my son's face was half in and half out of the frame has resulted in a striking, contemporary image that he (being 12!) finds far more interesting than the usual mugshot.
Canon EOS 1DS MKIII with Zeiss 85mm lens, 1/320sec at f/1.4, ISO200

This composition is all about shape and space. The curve of the sandbank seems at odds with the wavy black line, while the unusually wide space between them creates visual tension because the main subject matter is supposed to be in the center of the frame, not at the edges. But like pepper and strawberries, for some bizarre reason it works!
Canon EOS 5D MKII with 70–200mm zoom, 1/15sec at f/22, ISO100

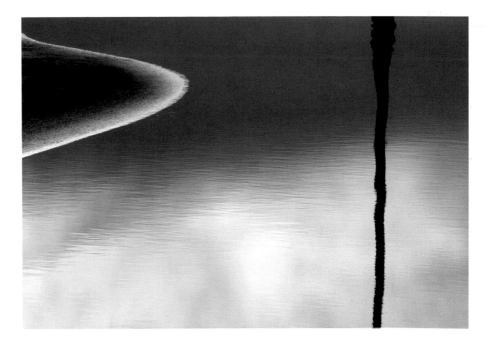

BELOW RIGHT: **Tilt your camera at a jaunty angle and an everyday scene or subject is transformed into a dynamic image that stimulates our senses. In this case, I also set the lens to the minimum aperture and focused on the nearest poppy to the camera, knowing the others would be thrown well out of focus.**
Canon EOS 1DS MKIII with 17–40mm zoom and polarizing filter, 1/400sec at f/4, ISO200

Take a banana and an apple, for example, place them on a simple white background and see how many different compositions you can come up with using those two objects, while avoiding the obvious. For example, an apple sits nicely in the curve of a banana so you can achieve harmony. But if you place the apple against the curve of the banana, you create conflict—our sense of logic and order is challenged.

The same applies if you shoot with your camera at an unusual angle. When we look at photographs we expect the horizon to be horizontal, vertical lines to be vertical, people to be upright and so on. So by intentionally making sure this isn't the case you'll create images that grab the attention. Fashion and portrait photographers often do this, tilting the camera to an angle so their subjects are leaning to one side—it makes the composition far more dynamic.

FOCUS POCUS

Finally, experiment with alternative focusing. Instead of focusing on your main subject, focus on the immediate foreground and shoot at a wide aperture so depth of field is reduced and the part of the composition we expect to be sharp is blurred. Try the same idea but focus on the background, so it comes out sharp and anything in front of it is blurred—a weird twist on convention. Or why not throw caution to the wind and intentionally defocus your lens so everything is thrown totally out of focus, making it impossible to determine what the subject matter was?

There's no end to the number of ways you can break the rules of photography and in so doing create more interesting images than if you'd stuck to them. That said, your actions have to be intentional if the results are to be a success. Happy accidents do happen, but they are few and far between,

so you really need to take control.

Remember, also, that we all have our own way of looking at the world and as your experience grows you'll find that you tend to compose pictures in a particular style because it works for you. Often you won't even be aware that you're doing it. But that's the essence of good composition. Once you know what works and what doesn't it should be committed to your subconscious, so that when you come across a scene you intuitively know how you want to compose it. If you think about it for too long your work will lack individuality and originality.

CALENDARS ONLINE

One of the things I always wanted to do when I became a professional landscape photographer in the early 1990s was to publish my own calendar. I spent hours checking out the calendar displays in local stores, admiring the goods on offer and day-dreaming about my own calendar being among them.

Sadly, it never happened. I designed dummies, obtained quotes and talked to retailers, but back then the only way to make such a project viable was to print thousands of units, which required a bank balance I didn't have and involved a big financial risk—calendars are time sensitive and after a few months become almost worthless.

Thankfully, things have changed in the world of printing and with the aid of digital technology it's now possible to print calendars literally one at a time, which means photographers can do much more with their work than just hang a few framed prints on the wall or fill albums. To find out just how good these services are, I decided to give them a try and finally achieve my dream!

WHAT YOU NEED

ONLINE CALENDAR PUBLISHER: A quick Google search for "Create your own calendar" will reveal a host of online calendar design and printing services. Some are cheap and tacky, others expensive and classy, so log on to a range of websites to see what they have to offer.

HOW IT'S DONE

Having conducted my own search, in the end I finally settled on Bob Books (www.bobbooks.co.uk). This organization is well-known among photographers in the UK for producing high quality photo books, which are very impressive, so I figured the calendars would be decent as well.

Creating a calendar with Bob Books is easy —there are just three stages:

1. Download the software, which is available for Mac OS X 10.5 (Leopard) and 10.6 (Snow Leopard), Windows 2000, XP or Vista and Linux with Kernel 2.6 or newer. This takes a few minutes.

2. After choosing your calendar format from the four available, you can then select a page layout for that format from a range of options and the chosen images (in JPEG format) are dragged and dropped into place. I personally think that having one large image per page looks the best, but if you're using family photographs to illustrate the calendar, for example, then you may decide to choose a page layout where several images per page can be used. That's entirely up to you.

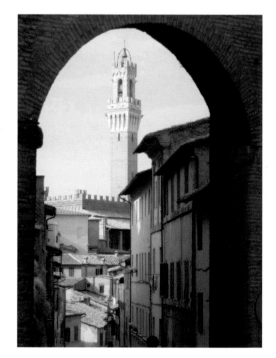

TUSCANY
2010

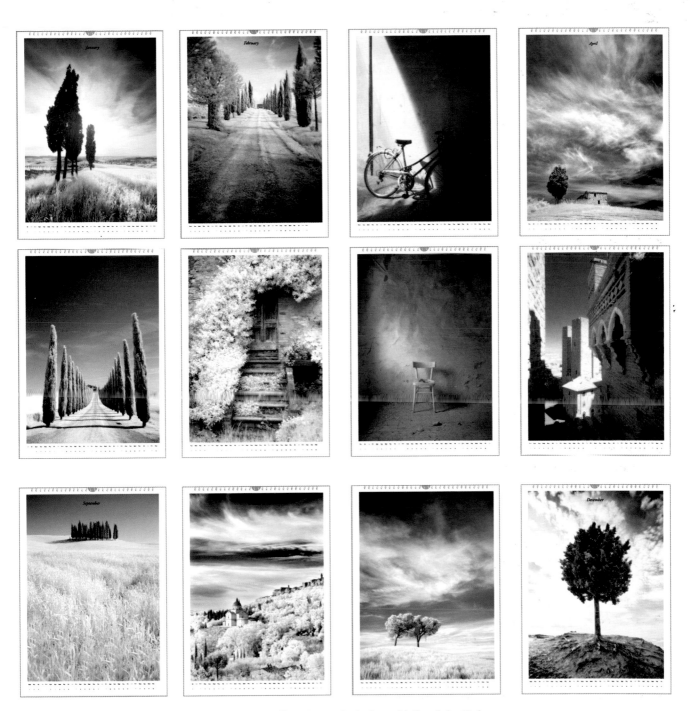

I chose a selection of digital infrared images shot in Tuscany to illustrate my calendar. I wasn't bothered about trying to make it seasonal and instead decided to use images that I would be happy to look at for a month at a time. I also chose a very simple calendar design where the images took center stage and the calendar played a secondary role. Considering this was my first attempt at creating an online calendar, I was very pleased with the finished product.
Infrared-modified Canon 20D with Sigma 10–20mm zoom, ISO200

CALENDARS ONLINE

3. Completed layouts are uploaded to www.bobbooks.co.uk or sent via post and 7–10 working days later the printed calendar arrives.

It took me a little while to get used to the design software and I had to abort the project a couple of times when I did something I couldn't work out how to reverse, but after half an hour or so I'd got the hang of it and then it was easy.

The key is to get yourself organized before starting. Choose the images you want to include, make sure they're saved as JPEGs at 240 or 300 dpi and size them according to the calendar format you intend to use. For the A3 Portrait calendar, I sized the images at 40cm high.

To see how it's done, follow this step-by-step guide.

1. After downloading the free Bob Designer software to your Mac or PC, launch the application and click on the Calendars tab.

2. When the next window opens, click on the calendar format you want to use. I went for the biggest one—A3 Portrait.

3. Click on Title Page at the bottom of the screen then scroll through the layout options on the left and double click the one you want for the calendar cover.

4. Click on January at the bottom of the screen, then scroll through the page layout options. I chose a single image with a border. Repeat for all months.

5. Go back to Title Page and adjust the shape of the image, if you wish, by dragging the red tabs. I changed it from a square to an upright rectangle.

6. Click the Text tab near the top of the screen then add your title. The text box can be dragged into position using the red tabs and the typeface and size changed.

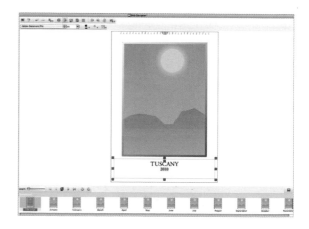

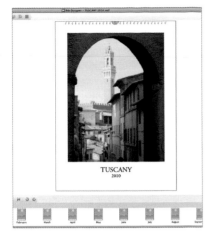

7. Drag and drop your selected cover image on to the image box on the title page and it will be automatically sized and aligned.

8. Do the same for the January page: drag and drop your image on to it then double click the text box if you want to change the typeface and type size.

9. I also decided to put the month in the center of the image, rather than on the left where it appeared by default.

10. Repeat this process for the remaining months of the year then preview the whole calendar page by page to check that you're happy with how it looks.

11. Once you're happy with the whole thing, click on the Shopping Basket icon then click "Yes" in the window that appears to start the purchase process.

12. Enter your address and credit card information while the calendar is being uploaded to Bob Books. Now sit back and wait for your calendar to arrive!

top tips

■ If you want to show your images at their best, stick to simple calendar designs.

■ Select your images in advance so you know what you're working with.

■ Choose a series of images that work well on their own and as a collection. Don't worry about making the images seasonal—that's all rather old-fashioned.

■ If you're planning to purchase a number of copies of the same calendar, it might be worth having one printed first to see how it turns out, rather than receiving a whole batch that you're not happy with.

■ If you have the option to pay a little extra for premium paper, it will be money well spent.

CANDID CAMERA

While some people feel completely at ease when posing for pictures, the majority of us feel uncomfortable if a camera is pointed in our direction, and tend to put on a false expression or silly pose to mask our embarrassment.

The idea of candid photography is to avoid this by photographing people when they're unaware of the camera's presence, so you can capture them as they really are. If you get it right, the results can be incredibly revealing. No more stiff, starchy poses and forced smiles, but instead photographs that really capture the energy and humour that many people have. Family and friends will love the pictures you take of them at parties and special occasions but, because the idea of candid photography is that you remain unseen by your subject, you can also use the technique to capture the trials and tribulations of life on the streets as strangers go about their everyday business, unaware that somewhere out there an eagle-eyed photographer is waiting to take their picture.

WHAT YOU NEED

CAMERA: Digital SLRs are ideal for candid photography because they're quick and easy to use, have fast, accurate autofocusing and allow you to fit a wide range of lenses and accessories. Compact cameras with a zoom lens can also be used with success as they're smaller and more discreet. Also, people don't associate compacts with serious photographers so you're less likely to be noticed.

LENSES: Telezooms (70–200mm, 75–300mm etc.) are generally the best choice as they allow you to bring distant subjects close and fill the frame without your subject knowing. Telephoto lenses also give limited depth of field at wide apertures such as f/4 or f/5.6, so you can throw distracting backgrounds out of focus.

Wide-angle lenses can also be useful for close-range candid shots taken in crowd situations. Because the angle of view of a 28mm or 24mm is so great, your subject probably won't even know they're being photographed, even if they spot you pointing a camera in their general direction.

HOW IT'S DONE

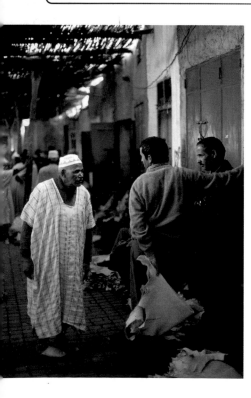

Anywhere that you find people out and about, involved in activities or simply enjoying themselves will provide ample opportunities to shoot candid pictures.

Town and city streets are an obvious place to start. The hustle and bustle of life provides a never-ending flow of subject matter. Mothers struggling with small children, buskers entertaining shoppers, people arguing, pavement artists, workmen—the list goes on and on.

Markets are also ideal haunts for the observant candid photographer. There are lots of places to hide yourself and, because everyone is busy with more important tasks, there's less chance that you'll be spotted. The same applies to street parties, festivals, country fairs and carnivals.

The key to success is being alert and ready to go. Opportunities come and go in the blink of an eye, so you have to learn to concentrate on your subject completely and anticipate the moment, wait for an interesting expression and then act on it.

To be able to do that you have to learn to use your camera instinctively. You

Markets and bazaars are great places to shoot candids as there is so much going on that you're unlikely to be spotted. This is one of a series of pictures I took of a group of men engrossed in a rather boisterous conversation in a Marrakech souk. I stood just a few meters away for several minutes, watching, listening and shooting until the group disbanded and walked away.
Nikon F5 with 50mm lens, 1/60sec at f/5.6, ISO100 film

People sleeping make ideal candid targets because there's less chance of you being spotted! The resulting images also tend to be quite humorous. I grabbed this shot of a man taking 40 winks using a Holga "toy" camera—not the quickest or easiest camera to use, but the soft edges and vignetted corners of the image help to focus attention on the snoozing subject.
Holga 120GN with fixed 60mm lens and Fuji NPS Pro 160, 1/100sec at f/11

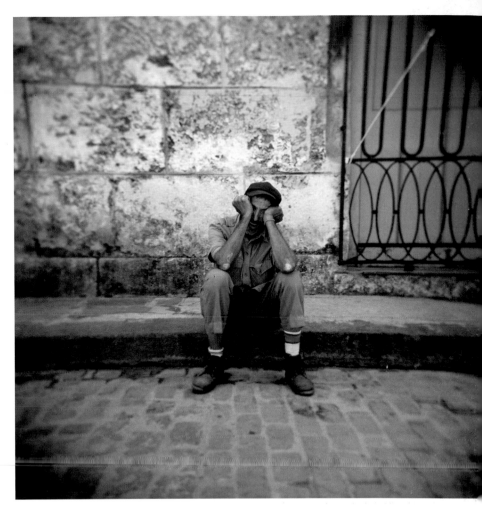

won't shoot successful candids if you're worrying about whether or not the right exposure has been set, or fiddling around with buttons and dials, so you need to make using it second nature. That way, when you come across an interesting subject you can raise the camera, focus and fire in a second or two, before anyone realizes what you're doing.

This is best achieved by setting your camera to an auto exposure mode. Program is the quickest, but Aperture Priority is better because it allows you to control depth of field. The usual approach with candid photography is to set a wide aperture such as f/4 or f/5.6 so the background is thrown out of focus and all attention is directed on your unsuspecting subject.

If you use an autofocus SLR, accurate focusing won't pose any problems providing you keep the AF target area in the viewfinder over your subject. If not, practice your fast focusing skills until confident, or learn how to estimate distance so that in tricky candid situations you can pre-focus on an object that's as far away from the camera as your subject.

Finally, to be successful at candid photography you need to learn how to blend in with your surroundings. So avoid wearing bright, attention-attracting clothes and don't carry your equipment in a bag that's obviously designed for photography. In fact, if you just carry one camera and lens, you won't need a bag.

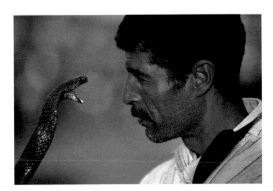

This snake charmer in Marrakech was far too busy to take notice of me shooting away with a tele-zoom. Annoyingly, his friend wasn't and moments later I was being tapped for money! Still, the shot was worth paying for and captures a perfect moment between snake and charmer. Shooting at f/2.8 ensured the background was thrown well out of focus.
Nikon F5 with 80–200mm zoom, 1/250sec at f/2.8, ISO100 film

top tips

■ Keep a camera with you at all times so you never miss any good candid opportunities.

■ Always try to remain as inconspicuous as possible so there's less chance of

being spotted. If you are spotted, and your subject confronts you, politely explain what you were doing and why. Not everyone likes the idea of being photographed and you should always respect that.

ENHANCE YOUR IMAGE

Contrast has always been the enemy of photographers. Whether you shoot film or digital, the brightness range your camera can record has its limits, so in situations where contrast is high, you either have to let the highlights burn out or the shadows block up. As blown highlights are a no-no among digital shooters it tends to be the shadows that suffer, then attempts are made later to rescue them and reveal more detail—with varying degrees of success.

Fortunately, I've found a handy solution to this problem, in the form of a software plug-in called Akvis Enhancer.

WHAT YOU NEED

AKVIS ENHANCER is available as a download from www.akvis.com and can be purchased as either a stand-alone application or a plug-in for Photoshop. There are both Mac and Windows versions available and it's compatible with Photoshop 6 CS2 and CS3 to CS4 and Elements 1–4 and 6–8. I used the plug-in version on my Mac with Photoshop CS3 and it's accessed in the Filters menu. If you want to try before you buy, a 15-day free trial download is available from the website.

HOW IT'S DONE

The main purpose of using Akvis Enhancer is to reveal more detail in the shadow areas of an image. I find it ideal for landscapes shot at dawn and dusk where contrast is especially high and also on photographs that contains dark areas, such as woodland or hills, as it's difficult to reveal detail in those areas when trying to control the sky using ND grads (see page 92).

Here's a quick step-by-step guide to using it.

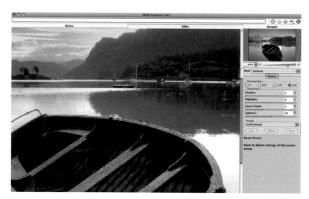

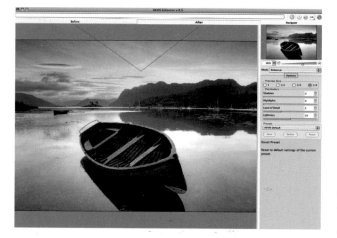

1. Open the image your want to work on in Photoshop then go to Filter>Akvis>Enhancer and the Akvis Enhancer interface will open. A preview image will appear after a few seconds showing you how the image will look once enhanced and you can click on Before and After tabs at the top of screen to see what a difference the software makes.

2. To the right side of the interface you'll find a series of controls. The first one allows you to vary the size of the main preview image using presets or a sliding scale. The navigator on the smaller preview image allows you to look at different areas of the bigger image. I tend to stick with Fit Image so the main preview image fills the interface.

3. In default mode the preview size is at 1/8 but you can choose from 1/4, 1/2 and 1 as well. This doesn't change the actual size of the image you're working on but it speeds up

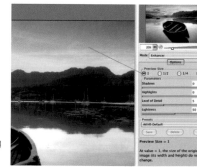

the processing time so that if you want to try different levels of enhancement on an image, it doesn't take a long time. I tend to use Preview Size 1 all the time so the preview image is sharp.

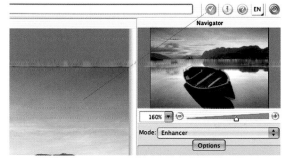

4. Below Preview Size you'll find Parameters, where you can change the level of enhancement using four controls: Shadows, Highlights, Level of Detail and Lightness. The default settings of 0, 0, 5 and 50, respectively, work fine on most images but it's worth experimenting with others, which you can then save for future use.

5. Once you're happy with the effect, click on the green circle above the Navigator and Akvis will process the image and apply the enhancement. When this is complete, the interface disappears and the enhanced image is revealed. Save the changes, but remember that they are applied directly to the main image, not a layer, so the effect can't be reversed once it's saved.

ADD A LAYER

Although the above method works perfectly well, it's safer if you apply the enhancer to a duplicate layer of the main image. That way, you can delete the layer if you don't like the effect, or vary the opacity between the two layers to play down the effect if it's too strong. Better still, if you then add a layer mask to the duplicate layer you can use the Eraser tool in Photoshop to "rub out" selected areas of the enhanced layer to reveal the original image behind it. Akvis Enhancer can make some areas of the image quite "noisy", so by using a layer mask in this way you can

enhance the parts you want and leave the rest of the image unaffected. Here's how:

1. Open your chosen image in Photoshop then go to Layer>Duplicate Layer to create a copy layer of the main image. This will be automatically named Background Copy. You don't

want to change this layer though, so click on the Background icon, which is the main image.

2. Apply Akvis Enhancer to the Background layer (not Background Copy layer) as explained earlier. You won't see the effects of the enhancer at this stage. Now click on the Background Copy layer icon in the Layers window, then click on the Layer Mask icon at the bottom of the Layers window.

3. Click back on to the Background layer then click on the Eraser tool in the Photoshop tool palette. You can now use the Eraser tool to "rub out" areas of the unaffected duplicate to reveal parts of the original image beneath that have been affected by Akvis Enhancer. Use a large brush for big areas, then a small brush to reveal small areas.

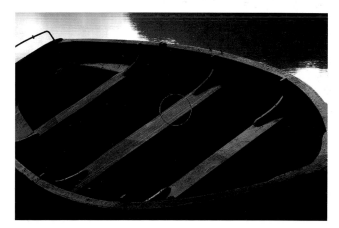

ENHANCE YOUR IMAGE

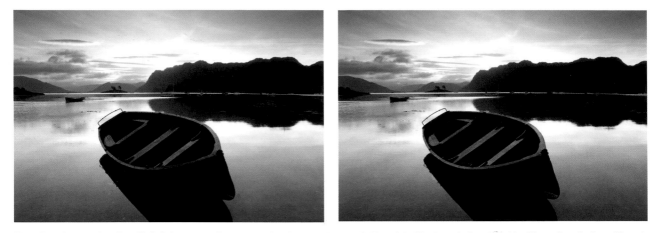

These three images show how Akvis Enhancer can improve an already great photograph. The original is about the best I could achieve when dealing with such a contrasty situation. I used a strong ND grad to hold detail in the sky, but knew that the boat in the foreground would come out dark. Giving extra exposure would have revealed more detail in the boat but overexposed the brighter patches of water, so there was a limit to what I could do. Applying Akvis Enhancer to the whole image made a big difference to the boat, but I wasn't too keen on the way it affected the rest of the scene, which looked fine in the original. Consequently, I used the Layer Mask technique outlined on page 33, so that only the boat was affected and this gave me the best of both worlds.
Canon EOS 1DS MKIII with 24–70mm zoom and 0.9ND hard grad, 1/8sec at f/16, ISO100

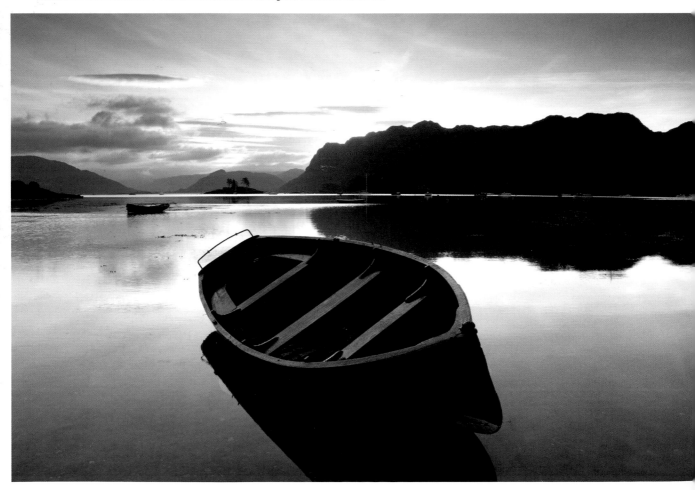

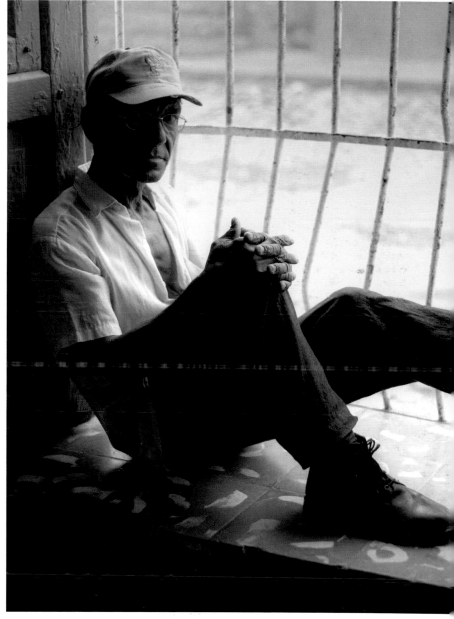

top tips

■ Don't use Akvis Enhancer as a substitute for solid camera work. Try to get everything right before you go near a computer and only use it to improve an already fantastic image rather than to make a silk purse from a sow's ear!

■ It's easy to overdo it when using software like Akvis Enhancer, so tread lightly and be subtle, otherwise you may do more harm than good.

■ Get into the habit of applying plug-ins like this to a layer, even if you intend to affect the whole image. That way, you can always delete the layer if you don't like the effect.

These two portraits may look like completely different shots, but the one on the right is a copy of the one on the left with Akvis Enhancer applied. As you can see, not only is there more detail visible in the man's face and hands, but there is also detail in the blue shutter behind him and the ledge he's sitting on. The lightest tones in the background remain unchanged.
Canon EOS 1DS MKIII with 50mm f/1.8 lens, 1/320sec at f/2.0, ISO400

ENVIRONMENTAL PORTRAITS

The main aim of portraiture is to try and capture the character of your subject—or at least some aspect of it. More often than not we do this by moving in close to our subject and concentrating on their head and shoulders to produce a tightly composed portrait that includes little or no extraneous detail.

However, while this approach can result in very revealing photographs, it can be limiting. For example, if you photograph an old man whose face is wrinkled and weather-worn, you may well achieve an interesting character portrait, but if you only show his head and shoulders, the picture will reveal no clues about why his skin is wrinkled and worn. Is it because he has spent his life outdoors working the land? Perhaps he's a fisherman? Who knows?

An easy way to avoid this dilemma and produce portraits that tell a much more interesting story is by standing back and including the subject's natural environment in the picture. A portrait of a boat builder surrounded by the tools of his trade will be far more effective than a simple head and shoulder study. Similarly, an avid gardener captured in his potting shed or greenhouse will speak volumes about that person.

Photographing your subjects in familiar environments also has another advantage—it will almost certainly help them feel more relaxed and at home in front of a camera than they would in the stuffy confines of a studio. This, in turn, should result in more natural, revealing images.

WHAT YOU NEED

CAMERA: Any type or format of camera can be used for environmental portraits

LENSES: As the idea of this technique is to include your subject's surroundings in the picture, shorter focal lengths are normally chosen, instead of telephotos. If the location offers restricted space, such as a small room, then a 28–35mm wide-angle will be ideal, while a 50–70mm can be used if there's more space to move around.

ACCESSORIES: A tripod if light levels are low and you're using a low ISO. An electronic flash can also be handy for adding extra light, though available light is always more effective.

HOW IT'S DONE

Before taking any photographs, have a good look at the location and decide on the best place to shoot. In cramped situations you may simply have to make the best of what you have, but if there's plenty of space to move around in, look at all the possibilities.

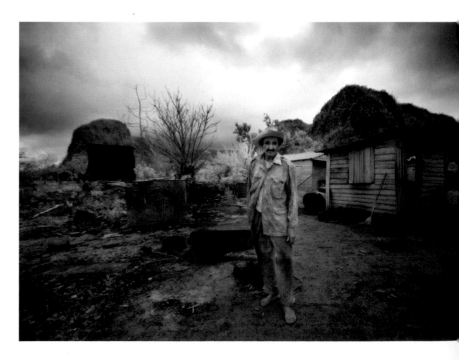

Taken at the same location as the main image (far right), this portrait shows the head farmer posing for the camera among the clutter of his farmyard. The information provided by this wider view tells us a lot about the subject and his life while the use of an infrared camera gives the image a mysterious feel.
Infrared-modified Canon EOS 20D with 10–20mm zoom, 1/60sec at f/8, ISO100

Often it's a good idea to compose the picture without your subject, so you can spend a little time fine-tuning the viewpoint, deciding what to exclude and include and perhaps moving the odd item around to make sure there are no distracting features in the scene. You can then introduce your subject to the picture, knowing immediately where you want them to pose.

As with all portraits, try to keep the background as simple as possible and avoid having objects growing out of your subject's head or body as it will look odd. If you're using a wide-angle lens, it's also important to keep your subject away from the edges of the frame. Otherwise, they may be distorted, especially if you have to tilt the camera up or down to get the shot you want.

Once your subjects are introduced to the picture, help them get into position. Most people feel awkward standing for pictures, so suggest they sit or lean on something. Giving them something to hold that relates to the environment can also help to put them at ease, and prevent their hands hanging limply in the picture; body language in a portrait is as important as facial expression.

Finally, while wide lens apertures are normally used for conventional portraiture, to throw the background out of focus and isolate your main subject, with environmental portraiture the background and surroundings are important parts of the portrait, so they should be recorded in sharp focus. To ensure this happens, set your lens to a small aperture of f/11 or f/16.

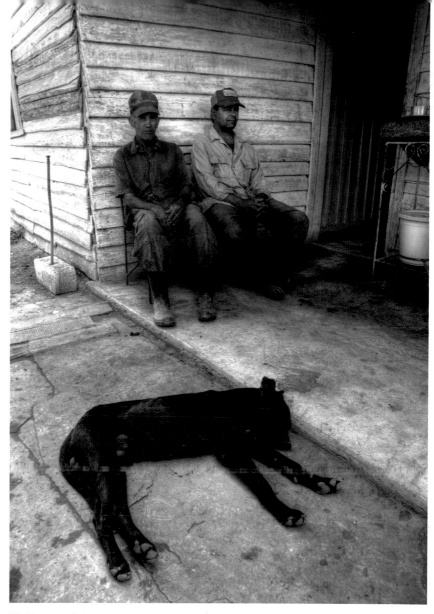

I had been wandering around a small tobacco farm in the Cuban countryside, photographing the people and the crops, when I happened upon these two men taking a break from working the fields. Instead of moving in close with a telezoom lens to take frame-filling character portraits, I decided to use a wide-angle zoom and capture them in their environment, using their snoozing dog as foreground interest! The resulting portrait tells a far more interesting story than a classic head-and-shoulder study.
Canon EOS 1DS MKIII with 24–70mm zoom at 24mm, 1/30sec at f/8, ISO100

top tips

■ Most people have some aspect of their working or personal life that would make a good subject for environmental portraiture, so chat with them about hobbies and interests before taking any pictures.

■ When you're out and about, look for situations that could make interesting environmental portraits—old village shops with their shelves crammed full of cans and boxes make perfect locations, as do building sites, community gardens, scrap yards and so on.

■ Take your camera to work and shoot environmental portraits of your colleagues. Whether you work in an office or on a production line, it's possible to produce interesting images.

FILM FUN

If you've become interested in photography in the last few years, there's a very strong possibility that you immediately jumped on the digital bandwagon and have only ever taken "serious" photographs with a digital camera. Consequently, the complete history of photography and its film-based heritage may have passed you by and you may have no idea what it's like to produce successful images using traditional equipment and materials.

The purpose of this project is to tempt you to do exactly that, partly so you have a better understanding of how photographers had to work prior to the advent of digital technology, and partly to help you appreciate just how fortunate you are to have access to the latest equipment—which makes life for the enthusiastic photographer easier than ever before.

Who knows, you might like it so much that you decide to stick with film. But if you don't, I guarantee the experience of using it will make you a better photographer.

WHAT YOU NEED

CAMERA: Because the whole world is going mad for digital, there has never been a better time to bag yourself a film camera bargain. Once-expensive models can now be picked up for peanuts on eBay. Just to prove it, the images here were all shot using a Russian Cosmic Symbol 35mm rangefinder camera that cost just £6 ($10)—the price of two or three rolls of film!

FILM: If you've never used it, you won't have a clue what to buy. For black and white I suggest Ilford XP2 Super or Fuji Neopan 400CN, both of which can be developed by your local minilab like normal C41 color negative film. If you want to shoot color, go for a negative film such as Fujicolor Superior 100.

HOW IT'S DONE

Load the film, go out and take some photographs—that's all there is to it!

Of course, it's easy for me to say that because I worked with film of all brands, speeds and formats for 25 years before switching to digital capture, so it became a way of life—and leaving it behind was a strange and painful experience! But for you, the opposite will apply, and using a film camera for the first time will seem rather alien.

First shock—no little screen that lets you look at each shot as you take it, delete any you don't like, identify mistakes and correct them. With a film camera, every time you trip the shutter there's no going back—but you won't know if a shot has worked until days or weeks later, when it's too late to do anything about it.

Actually, that's a good thing. Why? Because it's easy to get lazy and sloppy when you shoot digitally. Shots can be "rescued" later when they're downloaded to a computer and, because it doesn't cost anything to take digital photographs once you've bought your camera, lenses and memory cards, it's easy to get snap-happy and shoot far more pictures than you need to, which then take a long time to go through so you can select the best few.

With film, every shot you take costs money—not only the cost of the film,

top tips

- When you take the film to the lab to be developed, have the negatives scanned as well so that you can load them on to your computer and print them using an inkjet printer, just like you can with your digital images.

- If you want to learn more about film photography, why not enroll in a college course or evening class in the subject?

- Photography doesn't have to be film *or* digital. If you enjoy using film you can always carry a film camera alongside your digital gear.

A camera like the Russian Cosmic Symbol 35mm rangefinder is ideal as an introduction to the world of film photography. It's relatively compact, easy to use, has a fixed lens and takes surprisingly good photographs as you can see. Not bad for $10 (£6)!
Cosmic Symbol with fixed 40mm f/4 lens, various on Ilford XP2 Super ISO400 film

but processing later—so you're less likely to fire away like a photomaniac. Also, because you can't see the shots straight away, it tends to make you think more about each one and you make more effort to get it right in-camera instead of relying on Photoshop later. This is a very useful skill to learn and if you continue using it when you go back to using a digital camera, not only will your photography improve but you'll spend far less time at a computer trying to "finish off" your photographs.

Another great benefit to shooting with film, which digital photographers aren't aware of, is anticipation. Not knowing if a shot has turned out well or not and having to wait a while before you get to find out, is actually part of the fun. It's exciting, but nerve-racking. Remember when you were a child on Christmas Eve, crazy with excitement and anticipation, not knowing what Santa was going to leave for you and hoping it was what you wanted? Well shooting film is like that—every day is like Christmas Eve for grown-ups.

Shooting digitally, on the other hand, is like writing a letter to Santa with a list of things you'd like, knowing full well that you're going to get them all. Come Christmas Day morning, there's nothing to get excited about because the outcome is inevitable.

That's not to say I'm putting down digital, of course. The vast majority of photographs in this book were shot with a digital camera and switching from film to digital has undoubtedly breathed new life into my own photography.

But there's still something special about shooting film because it's what photography has been all about for more than a century. Film photographers feel more like artists than technicians and the whole idea of creating images by exposing silver-based materials to light somehow seems more involved, more organic, than using a sophisticated electronic gadget that turns light into millions of colored dots whizzing around in cyberspace!

So why not try a roll or two of film and see how you like it? Who knows where it might lead.

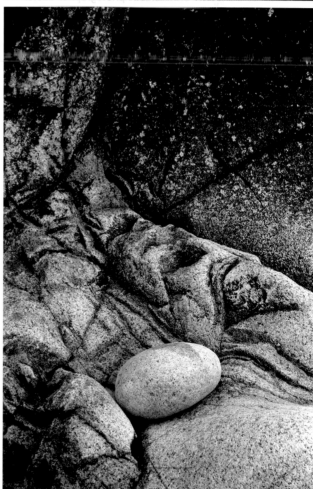

FOREGROUND INTEREST

The late, great war photographer Robert Capa once said, "If your photographs aren't good enough, you're not close enough." He was talking about capturing the drama of human conflict, of course, and the need to be in the heart of the action—an approach that eventually cost him his life. The same maxim could be applied to landscape photography, however, because if you want to capture the drama of a great scene, you need to move in close and make the most of the foreground. It's one of the important elements you need to create a dynamic composition.

WHAT YOU NEED

CAMERA: You can make the most of foreground interest using any type of camera, SLR or compact, though, as you will mainly use wide-angle lenses to do this, an SLR will be more versatile than a compact.

LENSES: Wide-angle lenses are crucial.

A zoom covering a focal length of 16–35mm or 17–40mm would be the perfect choice.

ACCESSORIES: A tripod to steady your camera so you can use small lens apertures to maximize depth of field without worrying about camera shake.

HOW IT'S DONE

Foreground interest is useful for a number of reasons.

Firstly, it contains more information than the rest of the scene, and being closest to the camera allows you to record fine detail that isn't affected by haze, mist and fog-like features that are more distant.

Secondly, emphasizing the foreground will help to give your photographs a strong sense of distance and scale due to the effects of perspective. They will look three-dimensional, even though they only have two.

Thirdly, the foreground provides a convenient entry point into the picture for the viewer's eye, which will naturally travel up through the scene to the focal point or the background.

The strength of the foreground can be controlled by both lens choice and your viewpoint.

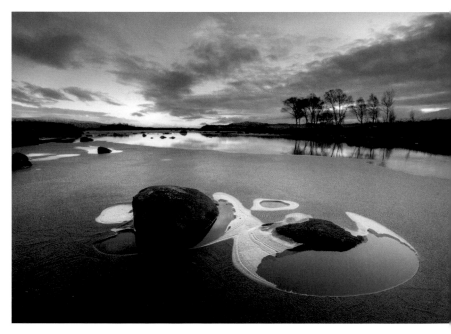

Wide-angle lenses are the most popular choice as they allow you to include elements in a photograph that are literally at your feet. The way wide-angle lenses "stretch" perspective also makes those elements loom large in the frame while everything else seems to rush away into the distance. The lower the viewpoint you adopt, the more the foreground will dominate. That's the key—close and low. Repeat it and remember it.

Foreground interest can make or break a composition. In this shot I was aware that an empty expanse of gray ice would do little to capture the drama and beauty of the scene, so I wandered up and down the shoreline in search of interesting features. These boulders and ice patterns did the job perfectly.
Canon EOS 1DS MKIII with 17–40mm zoom at 17mm and 0.6 ND hard grad, 0.8sec at f/16, ISO100

The way wide-angle lenses exaggerate perspective means you can turn relatively small features into dramatic foreground interest and transform the composition. Just remember, close and low!
Canon EOS 1DS MKIII with 16–35mm zoom at 19mm and 0.6ND hard grad, 0.4sec at f/22, ISO100

I find a wide-angle focal length of 21–24mm on a full-frame digital SLR is ideal for this as it produces "classic" compositions that capture a strong sense of place. Wide lenses can also produce amazing results; I often use the wide end of a 17–40mm zoom. Just be aware that the wider you go, the closer you need to be to the foreground. Otherwise it will pale into insignificance and you'll be looking for artistic excuses for all that empty space. I'll save you the effort. There aren't any.

Telephoto lenses are less dynamic in this respect, as the foreground interest you include is formed by elements or features in the scene that are obviously farther away, while the foreshortening of perspective "squeezes" the elements together. Nevertheless, the effect can still be strong, with a single feature dominating the foreground.

What can be used as foreground interest? Pretty much anything really: rocks, rivers, walls, gates, fences, trees, moored boats, sand ripples, reflections, people. Features and elements in the scene that create natural or assumed lines work the best of all as they lead the viewer's eye into the scene.

The main thing to remember, when shooting wide-angle landscapes in particular, is that the foreground must be interesting or it will look boring. Equally, avoid foregrounds that are too fussy or they will overwhelm the rest of the scene. Also, foreground interest is of little use if it isn't sharp, so make sure you use a small lens aperture such as f/16 and focus carefully to give maximum depth of field. I usually achieve this using a technique known as hyperfocal focusing (see page 64).

top tips

- If you want to make the most of foreground interest, move in close and low with a wide-angle lens. That's all there is to it.

- Shoot at small apertures to maximize depth of field so sharpness front-to-back is achieved.

- Look for a foreground containing lines that help to lead the viewer's eye into the scene.

Foreground interest doesn't have to be bold and brash. Subtle features can also work well, like the ripples on this sandy beach that have been emphasized, first by the low winter sun and second by getting in really close to exaggerate perspective.
Canon EOS 1DS MKIII with 17–40mm zoom at 29mm and polarizing filter, 1/5sec at f/22, ISO100

FOUND STILL LIFE

If you don't like the idea of setting up still-life shots from scratch, why not try your hand at "found" still-life photography instead? As the name implies, this involves looking for interesting still lifes that already exist and are ready to shoot, saving you the bother of choosing props and trying to arrange them to create an interesting composition. The subject matter can be both natural and man-made and on a large or small scale. There are no "rules" really, it's just a case of seeking out ready-made shots.

WHAT YOU NEED

CAMERA: An SLR is the most versatile tool for the job. But a compact camera is also suitable and you're more likely to carry one with you so you never miss a great still-life opportunity.

LENSES: A standard zoom,

24–70mm, say, should cover most eventualities.

ACCESSORIES: A tripod and cable release to keep the camera steady and prevent camera shake, and maybe a white reflector to bounce light into the shadows.

HOW IT'S DONE

Easy—just pick up your camera bag and tripod and go in search of subjects!

Location is key. There's no point just wandering around aimlessly. Instead, think about places where you might find interesting objects.

How about the garden shed? A shed can be an Aladdin's cave, especially if it belongs to a handyman or gardener

who's been using the same shed for decades. Rusting implements covered in cobwebs, stacks of old terracotta pots, tins of screws and nails, rows of neatly arranged tools—you could spend hours taking photographs.

Abandoned buildings provide another perfect hunting ground. Deserted cottages in remote areas may still have lots of possessions inside, gathering dust. Old hospitals and factories are worth exploring, too, but be aware of the dangers and that you may be trespassing.

If you live in an old house, it might be worth taking a look in the attic. We tend to consign unwanted items to the attic then forget about them, but after years of gathering dust they could suddenly be highly photogenic—old toys, piles of books or magazines, ancient vinyl records, tattered old suitcases

Away from home, markets and souks are worth checking out as the items arranged on sale create endless ready-made images. Harbors and boatyards are worthwhile hunting grounds, too.

Basically, anywhere you'll find repeated activity and lots of clutter—and the older the place is, the more characterful the details are likely to be.

Ideally, shoot your found still life in available light. Daylight streaming in through windows or open doors is ideal. So is the warm glow you get from tungsten bulbs. Leave your flash at home—the harsh light from it will destroy the atmosphere of the situation. You're much better off mounting your camera on a tripod and using long exposures to work in the available light; the images you produce will be much better for it.

In terms of composition, well, go with your instinct. The hard bit, putting the objects together, has been done for you, so all that remains is to move in close and fill the frame. Exclude anything that doesn't contribute to the main composition, either by adjusting focal length on your zoom or moving the camera closer. And remember to keep things simple—that's the key to any type of still-life photography.

Here's a selection of found still lifes I've photographed while on my travels. They show how the subject matter can be diverse, and that "still life" can be interpreted however you choose. Why is an interesting old bicycle resting against a shed any less a still life than a flower vase on a windowsill? What all the images have in common is that I photographed the objects as I found them, without any interference from me.
Canon EOS 1DS MKIII, infrared-modified Canon EOS 20D, Polaroid SX-70, Holga 120GN, exposure various

CREATE YOUR OWN

Although the whole idea of found still-life photography is that you shoot things you happen upon, there's no reason why you can't give yourself a head start by setting up the makings of an interesting image then leaving it to evolve.

For example, you could arrange some old keys or other metal objects then leave them outside in the elements to rust. Or how about taking a bunch of dead flowers and leaving them outdoors on a winter's night so they end up covered in frost?

Taking this idea a step further, you could actually entomb subject matter such as leaves and flowers in ice by arranging them on a tray then pouring water over them and freezing them for a few hours.

43

FRAMING A SCENE

One of the most effective ways of producing a tight, structured composition is by framing your main subject in some way. Not only does this help to direct the viewer's eye toward the most important part of the picture, but frames can also be used to cover up uninteresting areas in a scene, such as a broad expanse of empty sky, or to hide annoying details that would only serve as a distraction if they were visible, such as a car parked in an awkward position, or road signs in a landscape.

Frames can be both natural or man-made. Natural frames include the overhanging branches of a tree, the entrance to a cave and ivy growing around a door, while man-made frames comprise things such as doorways, archways, bridges and open windows.

WHAT YOU NEED

CAMERA: No single type of camera is better than any other really, though SLRs with through-the-lens (TTL) viewing make accurate composition easier.

LENSES: All focal lengths can be used to exploit frames, but the one you use will depend on the situation you're in. Wide-angles lenses allow you to make use of frames that are nearby—if you stand close to an archway, doorway or window you can use it to surround the edges of the picture. Telephoto lenses are more useful for exploiting frames that are farther away, such as a gap between tall buildings or trees.

HOW IT'S DONE

When using frames in a photograph you must consider a number of factors if you want to produce successful results.

First, lighting direction. If the sun is behind you, light will be falling onto the frame and the scene beyond it, so everything will be of a similar brightness and should record more or less as you see it. If you are shooting into the light, however, or the sun is to the side of the camera position, the main part of the scene may be well lit, but little or no light will fall directly onto the frame and it will record as a silhouette. Trees at sunset are an obvious example of this, or the view from beneath an underpass or bridge.

Closely allied to this is the way you determine correct exposure. If you're shooting with the sun to your back, so the frame and the scene beyond are evenly lit, you shouldn't experience any problems obtaining well-exposed pictures. More often than not, however, you'll be standing in the shadow of the frame itself and overexposure is likely because the low light levels around you may confuse your camera's metering system.

If this proves to be the case, step beyond the frame and out of the shade, take an exposure reading, set it on your camera and don't change anything once you recompose with the frame included. Alternatively, take a test shot from your shooting position, check the image and histogram then adjust the exposure as required and retake the photograph.

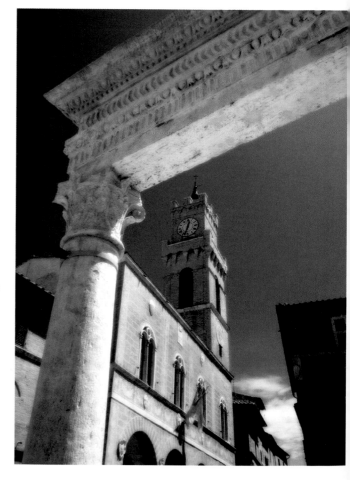

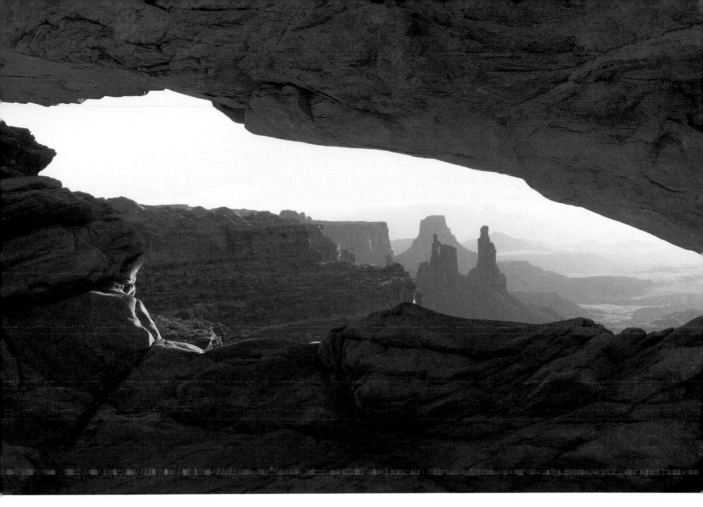

This natural rock arch and the rocky ledge beneath it have created a hole-in-the-wall effect, framing the distant scene and helping to direct the eye toward it. The rich orange glow on the sandstone arch also emphasizes the frame and adds impact to the composition.
Mamiya 7II with 65mm lens, 1/8sec at f/16, ISO50

LEFT: It's easy to find frames when shooting architecture—arches, doorways, open windows; they come in all shapes and sizes. This ornate stone frame was next to a well in the old square of an ancient Tuscan hill town, and by moving in close and shooting with a wide-angle zoom lens I was able to use it to focus attention on the church tower and fill much of the empty cloudless sky.
Infrared-modified Canon EOS 20D with 10–20mm zoom, 1/125sec at f/8, ISO100

Finally, the lens aperture you use will have a major effect on how the frame records. If you want the frame and the scene beyond to be rendered in sharp focus, set a small lens aperture, such as f/16, and use hyperfocal focusing (see page 64) to ensure that everything in the scene records in sharp focus. Alternatively, by setting a wide aperture such as f/4 and focusing on the scene or subject beyond the frame, depth of field will be reduced to such a level that the frame itself is thrown out of focus and all attention is directed toward your main subject. This effect is best achieved with a telephoto lens, and can produce striking results, especially if you're using an unstructured frame, such as the branches of a tree.

top tips

■ Landscape and architectural pictures lend themselves to the inclusion of frames, so look out for suitable features when you're exploring a location.

■ Frames can be created when none appear to exist by adopting an unusual viewpoint. If you crouch down low among a bed of tulips, for example, the tall flowers will frame the scene beyond.

■ Use frames to cover up annoying details in a scene, such a trash cans, colorful signs and other features that would catch the eye and cause an unwanted distraction.

GLASS CAN LOOK GOOD

One of the things I find most enjoyable and satisfying about photography is trying my hand at different subjects and techniques. Though I mainly think of myself as a landscape and travel photographer, I've shot pretty much every subject imaginable over the last 25 years—portraits, sports, nudes, nature, even weddings!

If I have a least favorite, it's probably still life, and the same tends to apply to many other photographers. Why? Because still life is perhaps the ultimate test of skill, creativity and imagination. You start out with a completely blank canvas and in order to produce successful images you have to fill that canvas with objects of your own choosing, compose them in an interesting way and light them.

Compared to landscape photography, where the scene already exists and daylight provides the illumination, it's a tall order. But if you rise to the challenge, you may be pleasantly surprised with the results—and if you can take a great still-life shot, anything's possible!

To give you an idea of what can be achieved, I set myself the task of photographing a classic still-life subject matter—a wine glass and bottle.

WHAT YOU NEED

CAMERA: A digital SLR is the best choice as you can assess your progress and correct mistakes as you go, but I've also taken similar shots on film.

LENS: A standard zoom is ideal—I used a 24–70mm.

LIGHTING: Electronic flash. I used a single studio flash unit and 1 x 1m softbox, although a powerful portable flash fired through a tracing paper screen would give a similar effect.

ACCESSORIES: Tripod and remote release, bottle of red wine, wine glass and a piece of black fabric/velvet.

HOW IT'S DONE

Glass is a notoriously tricky subject to shoot well because it's reflective. But that reflectivity can be a blessing as well as a curse if you use it to your advantage.

I decided to create a simple rim lighting effect to highlight the gentle curves of the glass objects. This meant that the glass and bottle had to be positioned against a black background but also lit from behind.

Initially, I thought about setting up two flash heads, each fitted with a softbox, and positioning one on either side of a sheet of black cardstock. But as a glass and bottle are small in comparison to a 1 x 1m softbox I decided that I could probably manage with just one light and keep the set-up nice and simple. To achieve this, a piece of black velvet was draped down the center of the softbox to create a narrow black background and effectively split the softbox in two so I was left with a narrow striplight on either side of the velvet.

1. The wine bottle chosen for use in the shots was soaked in warm water to remove the label, then dried with a clean cloth. Wine was poured into the glass, then I positioned both the glass and the bottle in front of the softbox on a stool that had been draped with a sheet of black fabric.

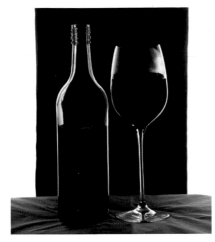

2. To check the lighting effect and exposure, I made a test shot with the camera set to manual exposure mode—1/125 sec. at f/8. The image on the preview screen told me several things: the props were too far away from the background, the wine glass needed a good clean and the exposure could be reduced. I also decided that a full wine bottle would look better than the part-full one I was using.

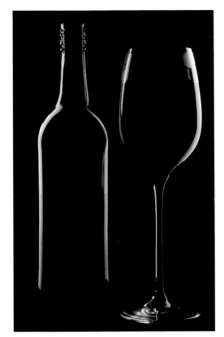

3. With a second bottle de-labelled, I moved the glass and bottle closer to the softbox—they ended up about 30cm in front of it. This gave me a better rim-lit effect. I also took shots with the flash head set to ¼, ½ and full power and varied the lens aperture between f/22 and f/4. The wider I went, the more color and detail I could see, and the smaller the aperture the more graphic the image.

4. After a little more adjustment to exposure and composition I started to achieve the look I wanted—a fine white outline around the bottle, created by light from the softbox passing through the very edges of the bottle but not the body of it due to the density of the red wine, and patches of deep red where wine in the glass had been backlit.

Shooting digitally proved to be invaluable because it confirmed when I'd gotten the position of the props, the lighting and the exposure just right. From that point on I was able to experiment with different compositions and produce a range of stylish images. I tried shooting just the glass on its own, then the bottle, then the glass and bottle together, first side-by-side then the bottle behind the glass.

The final stage was to download and process the raw files. In each case, I used the Tone Curve sliders in Adobe Camera Raw to adjust the contrast, followed by Levels in Photoshop to darken the blacks and highlight both the white outline and the areas where the red of the wine was visible. The Healing Brush and Clone Stamp tools were also used to remove unwanted highlights and blemishes from the glass so the images appeared clean, simple and graphic.

So, you have a series of stylish images created using just one light, a piece of black velvet, some simple props and a bit of imagination. If a ham-fisted landscape photographer can do it, anyone can.

top tips

- Make sure the props are clean and scratch-free, as every blemish will show up. Those you can't avoid can be removed during post-production.

- Keep things simple—not just the props, but also the lighting. Photographers are put off shooting still life because it seems over-complicated, but it doesn't have to be.

- Take an idea and run with it—the final image may be far better than the one you set out to achieve. That was certainly the case here.

GLASS CAN LOOK GOOD

ABOVE: **Once I had a mastered the lighting and exposure, it was then a case of experimenting with different compositions. Being able to see the results immediately on my camera's preview screen definitely made a difference as it boosted my confidence and inspired me to keep trying.** Canon EOS 1DS MKIII with 24–70mm zoom, 1/125sec at f/5.6 and f/11, ISO100

RIGHT: **This shot came about by accident when I moved the glass of wine to one side to shoot the bottle on its own and noticed how part of the softbox crept into the background. The black/white background works well and adds another twist to the image.** Canon EOS 1DS MKIII with 24–70mm zoom, 1/125sec at f/13, ISO100

OPPOSITE: **I felt that the most effective compositions were created when both the bottle and glass were photographed together to create a series of overlapping shapes and tones. This composition was my favorite and shows how with a little imagination, simple props can be turned into striking still–life images.** Canon EOS 1DS MKIII with 24–70mm zoom, 1/125sec at f/11, ISO100

GRAIN IS GOOD

Back in the good old days of film, the majority of photographers saw grain as a negative rather than positive element and would often go to great lengths to minimize it by using slow-speed film or bigger film formats. However, if you use it creatively, grain can enhance an image no end and, when intentionally exaggerated, it can produce beautiful effects, adding a stark, gritty feel to black-and-white images and a pleasing "impressionistic" look to color photographs—especially if you combine grain with soft focus effects (see page 128).

WHAT YOU NEED

IMAGES: A selection of color or black-and-white images that will suit the addition of grain.

SOFTWARE: Adobe Photoshop offers various grain filters. Plug-ins such as Nik Software Silver Efex Pro (see page 86) can also be used to add grain or mimic the characteristics of well-known black-and-white films.

HOW IT'S DONE

I've been a fan of grain for as long as I've been interested in photography and over the years tried pretty much every way of creating it, from using ultra-fast film such as Fuji Neopan 1600 to uprating and push-processing film (ISO 25000 was the highest I ever got) and selective enlargement of images.

In this digital age, grain isn't something we have to deal with. Instead we have "noise," which is caused by hot pixels or unwanted electronic interference. It mainly occurs when shooting at high ISOs such as 1600 or 3200, or using long exposures in low light. Though it can look like grain in some cases, if you want to mimic the characteristic look of film grain, you need to add it during post-processing.

Fortunately, this is quick and easy thanks to Photoshop and, as with all things digital, it's far more controllable than film grain ever was because you can add it only to those images that will benefit and vary the level of grain with great precision. Grain doesn't suit all subjects, so choose your images carefully.

ADD NOISE FILTER

Ironically, given that camera makers are trying their hardest to banish noise from digital images, my preferred method of adding grain is with the Add Noise filter (Filter>Noise>Add Noise). Not only does the effect look more like proper film grain, but you also have more precise control than with the other Photoshop filters, Film Grain and Texture Grain.

The main factor to consider is whether to choose Uniform or Gaussian Distribution. I find that the former works well on color images but for black and white, Gaussian gives a better effect as it produces a wider range of light and dark pixels. Don't be mistaken into thinking you need to check the Monochrome box when working on black-and-white images though. All that does is ensure that grain is evenly distributed across all channels so it can be used for color images as well as black-and-white images that are still in RGB mode rather than Grayscale.

■ Applying grain

As with any digital effect, you're best off applying grain to a layer so you have more control.

1. Open your image and open the Layers palette (Window>Layers) then create a new layer on top of the main image (Layer>New Layer). Now fill the layer with a neutral gray color by going to Edit>Fill, clicking on Color and entering #777777.

2. Go to Filter>Noise> Add Noise. Experiment with the Amount slider—15–25% is usually enough. It's tempting to add too much grain, but this can have a detrimental effect on image quality, so be subtle. Click on the Gaussian and Monochrome boxes.

3. To make the grain more realistic, go to Filter>Blur> Gaussian Blur and set Radius to 0.5 pixels.

4. In the layers palette, change the Blending Mode from Normal to Overlay and you'll see how the grain looks. Reduce Opacity if it's too strong.

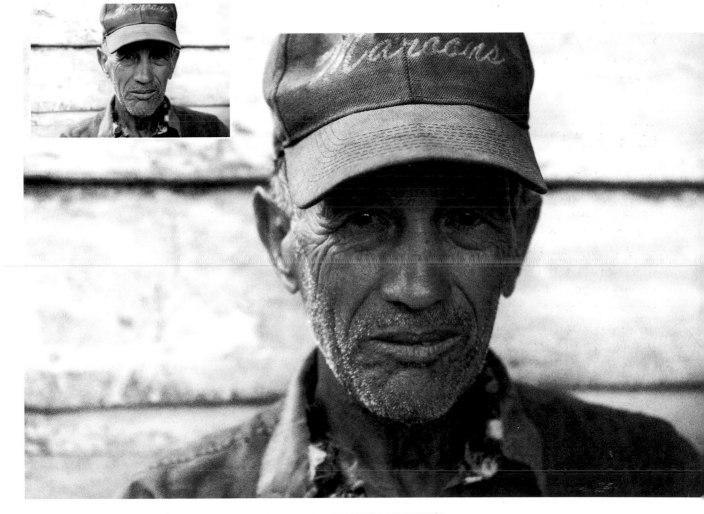

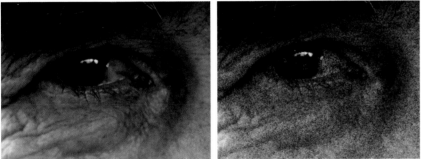

By adding noise using the method outlined in the step-by-step, the final image looks like it was shot on high-speed black-and-white film rather than with a digital camera, which is exactly what I was trying to achieve. The 100% crops from the portrait before (far left) and after grain was added (left) give a much clearer idea of how the grain affects the image.
Canon EOS 1DS MKIII with 24–70mm zoom, 1/160sec at f/4, ISO200

HANDS

I was looking through a collection of my photographs recently and it suddenly occurred to me that I have a thing about photographing hands. Not my hands, you understand, but the hands of strangers I meet on my travels.

This may seem like an unusual choice of subject matter, but in a way it makes perfect sense because hands tell us a great deal about their owners, in the same way that their faces do. If a person's hands are wrinkled and calloused, it's pretty obvious that they've had a hard life. If they're dirty, you could hazard a guess that they're used for physical labor. If they're holding something, the objects will tell you something about that person.

The more I thought about it, the more interested I became in the idea of hands being a subject in their own right.

WHAT YOU NEED

CAMERA: Any camera, provided it will focus close enough. I used a 35mm film SLR for the images here, but a digital compact would let you take similar shots.

LENSES: In the days before I switched from film to digital capture, I always had a 50mm standard in my lens collection. It proved invaluable for shots like this, being small and light, easy to handhold and with a short minimum focusing distance, which meant that I could get in nice and close and fill the frame with my subject's hands.

These days it's a 24–70mm standard zoom, just as effective but bigger and heavier.

HOW IT'S DONE

I am pretty sure my collection of hand portraits began during a trip to Morocco. I was in the souks of Marrakech, in the dyers' quarter, where workers dye silks and other fabrics in medieval conditions, hand-dipping their wares in vats of colorful liquids. Not all of these folks were keen to have their portrait taken, but I found their hands to be more interesting than their faces because they were colored by the dyes they were using and looked highly unusual in bright red, green, even purple in one case. They didn't mind me photographing their hands. In fact, they found the whole thing highly amusing, which proved to be a great icebreaker. Everyone was happy!

Soon after that, on a trip to Cuba, I was visiting a family who owns a tiny tobacco farm in the Vinales Valley and the aging head of the family, a sprightly

octogenarian named Zoilo, was keen to show me the seeds from which his prized tobacco plants grow. He did this by pouring some into his cupped hand, and as the seeds were so small I had no choice but to ignore his face and move in close to his hands. Result? Another fascinating faceless portrait.

CLOSER TO HOME

Of course, you don't have to travel to exotic foreign lands to try this for yourself. Everyone knows someone with interesting and photogenic hands. Older people are a good start because their hands show signs of a life well lived. Anyone involved in manual labor is a sure bet, too—mechanics, miners, painters and decorators, gardeners, builders. In fact, why not shoot a whole series of "people at work" portraits, but instead of photographing your subjects' faces, focus on their hands instead, maybe asking each person to hold something

that's representative of what they do?

The great thing about photographing hands instead of faces is that your subject is far less likely to feel awkward or nervous and even if they are, you won't see signs of it in your photographs. You can explain to them what to do with their hands to make sure you get the shot just right.

I favor available light whether I'm indoors or out. Indoors, light flooding in through a window or open door is ideal, while outdoors you can avoid hard shadows by stepping into the shade where the light is softer. Use a reflector if necessary, to bounce light onto your subject's hands, or simply ask them to move closer to the source of light.

It's important that you fill the frame, so don't be afraid to move in nice and close with the camera—or zoom in if you're using a zoom lens. If your subject

is holding something in their hands, focus on that and don't worry if parts of their hands aren't in sharp focus—that won't matter provided that whatever the viewer is going to look at is sharply focused.

Watch the background, too. If it's cluttered and distracting you can shoot at a wide aperture to throw it out of focus. Alternatively, ask your subject to move position so his or her hands are against a better background.

Here are a few of the hand portraits I've shot, in places as diverse as Cuba. Morocco and Zanzibar. As well as being interesting and unusual images, they each say something about the person depicted——Zoilo the tobacco farmer showing off his tobacco seeds (opposite), a Muslim woman having her Henna tattoo applied, a fisherman bringing his tropical catch ashore and dyers in the souks of Marrakech.
Nikon F5 with 50mm prime lens, various at ISO 50 and 100

top tips

- If you see someone with interesting hands, don't be afraid to ask them if you can take a few photographs—chances are they will find your request amusing.

- Build up a collection of hand portraits of people of different ages, from

different walks of life and with different occupations. The images will offer a fascinating insight into your subjects.

- Fill the frame and keep the compositions simple so all attention is focused where it should be.

HARMONY AND DISCORD

When we raise a camera to our eye, more often than not it's the scene or subject that encourages us to take a photograph. We tend to see things for what they are—a beautiful landscape or an interesting building—rather than the elements of which they are comprised. However, being able to take a step back from reality and look at the world in a more lateral way can be a great benefit to us as photographers because it allows us to peel away the superficial surface layer and get to the real bones of the subject.

One of the most important "bones" in a photograph is color. As well as making everything look realistic, color can provoke a strong subconscious response in the viewer. Color can be exciting, unsettling or calming. It can create tension and jar the senses, but equally it can sooth and relax us.

You only have to look at the way we use color to describe our mood—"red with rage," "green with envy," "blue with cold"—and the way color is used to evoke a certain mood or response. For example when we need to be alerted to danger, there's only one color that can do it—red; the most powerful color of all.

WHAT YOU NEED

CAMERA: Any type of camera can be used to exploit color—a digital compact is ideal because you can carry it with you at all times so you never miss the chance to capture color.

LENSES: Use wide-angle lenses to fill the frame with color from close range or juxtapose elements against the sky. Telephoto or tele-zoom lenses allow you to pick out colors that are farther away or compress perspective so that areas of color appear closer together.

ACCESSORIES: A polarizing filter to maximize color strength.

HOW IT'S DONE

A good way to understand how color works is by studying a color "wheel," which contains all the colors of the spectrum—like a rainbow.

- Primary colors are pure hues—red, green and blue.
- Complementary colors lie opposite the primaries on a color wheel—cyan, magenta and yellow.
- Secondary colors are formed by mixing two other colors together to form things like orange and violet.

Another important fact you can glean from the color wheel is that some colors go well together or, harmonize, while others clash or contrast, which will have an effect on your compositions.

COLOR HARMONY

Those colors that lie close to each other on the color wheel harmonize. Blue and green, green and yellow, red and magenta, orange and yellow—all are immediate neighbors so they harmonize. Also, any of the colors on the warm side of the color wheel— magenta, red, orange and yellow—work well together, as do all colors on the cooler side—blue, violet, green.

Pictures containing harmonious colors are more relaxing to look at and easier on the eye—they have a calming effect rather than challenging our visual senses. Think of the beautiful, warm reds, yellows, oranges and browns of a deciduous woodland in autumn, or the soft hues in the landscape created when mist or haze

scatters the light and reduces all colors to soft tones.

You can also take successful pictures of scenes comprising just one color, or the same color in different shades. Soft, hazy light tends to create this effect in nature by bringing the colors in a scene closer together, especially during early evening when the light is warm. Before sunrise and in dull, overcast weather you can witness a similar effect, only this time the light is diffuse, so colors appear more muted and tend to take on the cool color temperature of the light itself. You will also find man-made evidence of this—a building painted in different shades of the same color, for example, can make a great study in color harmony.

In situations where color saturation is

Misty weather scatters the light, reducing color saturation to the point that scenes appear almost monochromatic—especially at dawn, when the warmth of the light creates delicate pastel hues. This results in a very harmonious effect, as can be witnessed in this rolling Tuscan landscape.
Canon EOS 1DS MKIII with 70–200mm zoom and 0.9 ND hard grad, 1/13sec at f/16, ISO100

Harmony is created when a scene or subject contains colors that are close together in the color wheel. In this Cuban street, the predominant colors are green and blue in various shades and strengths, while the other colors, though warmer and not necessarily harmonious, are weak enough to add to the effect.
Canon EOS 1DS MKIII with 70–200mm zoom, 1/15sec at f/14.1, ISO100

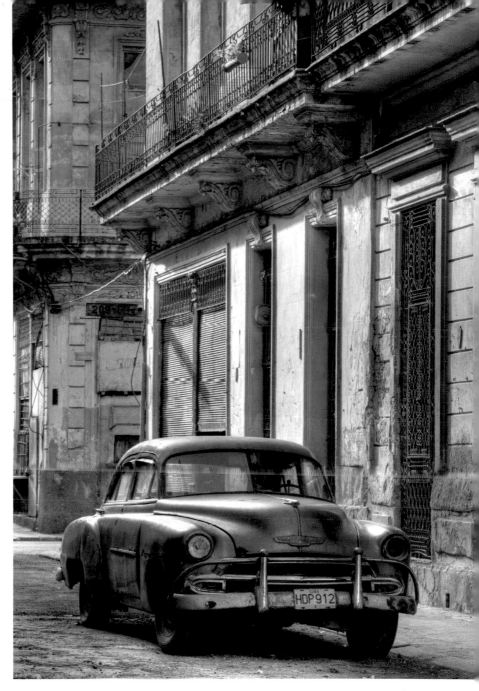

reduced, either by the quality of light or through use of soft hues by man, even colors that normally contrast will appear to harmonize so we are encouraged to feel relaxed by the colors rather than challenged and tense.

The softer the colors, the more pronounced this harmony becomes, until we reach a stage where the overall effect is almost monochromatic. Pictures that make use of this can be highly evocative.

Weather conditions create this effect more than anything else in the natural world. When the sun is obscured by haze

top tips

■ Use the Hue/Saturation control in Adobe Photoshop to boost or reduce color saturation—but don't go over the top otherwise the effect will look odd.

■ You're more likely to find vibrant color contrasts in urban areas where scenes are ever-changing and color is used to attract attention or alert us to danger.

■ The countryside and coastline are places to look for harmonious color combinations—most of nature's color harmonize.

■ Most colors will contrast with each other when they are strong but harmonize when they're weak.

HARMONY AND DISCORD

or pollution in the morning or evening, the landscape takes on a delicate golden glow that looks beautiful in its subtlety.

Mist and fog have a similar effect, draining strength from the colors in a scene, though the tone created is usually cool rather than warm because light at the red end of the spectrum is filtered out.

Of course, in these situations, where color is naturally reduced to monochromatic tones, you can emphasize the effect using filters. Keep them subtle, though. Otherwise you will destroy the effect. The 81-series warm-up filters are ideal for adding to the warmth of a scene, while the 82-series of pale blue filters will do a similar job on cooler scenes.

COLOR CONTRAST

While color harmony helps us to produce soothing, relaxing pictures, contrasting color does the opposite—

producing bold, dramatic effects that attract our attention and challenge our visual senses. Strong colors excite and stimulate, so when you include two strong colors that clash and compete for attention, the effect is amplified.

The key is to keep things simple. Ideally, stick to just two colors, certainly no more than three, or the effect will be weakened. And make sure those colors are opposite each other on the color wheel—any warm color such as red or yellow will clash violently with any cool color such as blue or green.

The strongest color contrast you can get is blue and yellow, but with any combination, the more vibrant and saturated those colors, the more potent the contrast will be, especially if all are of the same or a similar brightness. For example, deep blue against pale yellow won't work as well as deep blue against deep yellow, and vice-versa.

These contrasts are usually the easiest

to find on a small scale—a red flower surrounded by the rich green of sunlit grass; a yellow building against the bright blue sky. You can also set them up quite easily by placing a yellow bucket against a blue door, or a red car against a green hedge, for example.

The effect works best when the cooler color is in the background and the warmer color up front. Cooler colors are said to recede, because they remind us of the sky, sea and open space, whereas warmer colors advance and appear to leap from the picture.

For the best results, shoot in bright, sunny weather and use a polarizing filter to reduce glare so saturation is increased (see page 116). The light around midday is the harshest and most intense with short, black shadows, but when it comes to color contrast, this time of day can be the most effective, especially in towns and cities where you will find color in bold, graphic blocks.

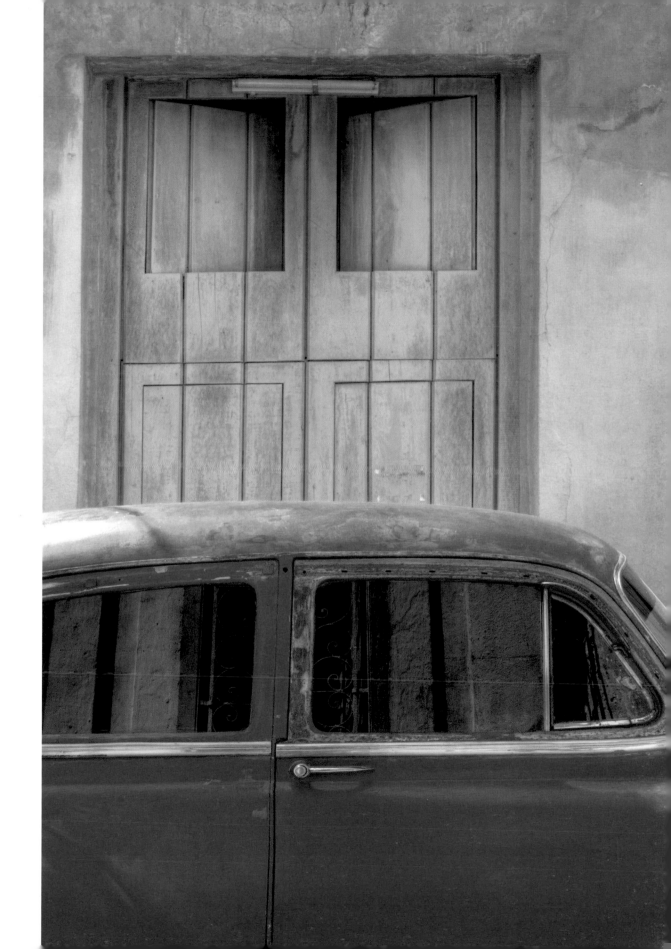

HIGH-KEY / LOW-KEY

Most of the photographs we take are average. I'm not suggesting for a second that they lack interest or impact, but rather that they're average in terms of their tonal balance. Cameras are designed to correctly expose scenes that have a fairly even mix of light and dark tones and if you look around you, most things fall into that category. Unless you happen to be standing in the middle of a snowfield right now. Or a coal cellar! However, just because the world tends to look average, and our cameras try to record everything as though it were average, your photographs don't have to be!

WHAT YOU NEED

CAMERA: Any type of camera will be suitable providing you have some degree of control over the exposure it sets. Saying that, I've taken some successful shots with the camera in my cell phone.

LENSES: There are no specific requirements here as any subject can be the basis of a high-key or low-key image, from a close-up of a delicate flower to a magnificent landscape.

HOW IT'S DONE

It's all down to interpretation and visualization. The scenes and subjects you shoot don't have to look the same in a photograph as they do in reality.

Mood is everything. You can use your imagination and skill to make an image say what you want it to say, which may not always be the truth, the whole truth and nothing but the truth. Who ever said it had to? We might think "the camera never lies," but that's nonsense. Of course a camera lies—it only records what we want it to record, in the way we want to record it.

For example, if you purposely overexpose an image it will make whatever is depicted lighter than it was in reality. Conversely, if you purposely underexpose an image, whatever is depicted comes out darker than it was in reality. These extreme departures from "the truth" have great emotive power, allowing us to manipulate the mood of an image and, in doing so, control the way the viewer responds to it.

HIGH-KEY IMAGES

Images that consist of predominantly light tones are usually referred to as "high key." They're bright, positive and evocative, symbolizing life and light. It's impossible to look at a high-key image and not feel cheerful—it's like opening the curtains on a beautiful day and feeling the sunlight warm your face.

High-key subjects rarely occur naturally. The only exception, as hinted at earlier, is when the landscape is covered in snow because darker tones are hidden beneath it and contrast is suppressed. When sunlight shines on freshly fallen snow it can be blindingly bright— literally. The rest of the time, we have to use a little artistic license in pursuit of high-key excellence.

Intentionally overexposing an image at the taking stage is perhaps the easiest way to create a high-key photograph. However, since the digital revolution, this is no longer necessary. Instead, shoot in raw format then lighten the image while processing the file. Simply increasing the

This abstract image is actually a long exposure of a set of posts partially submerged by the sea. The image I set out to create was relatively high-key, but there was tone and detail in both the sky and water, if only a little. However, while experimenting with Curves in Photoshop I decided to see what would happen if I gave the contrast a big boost. This is what happened!
Canon EOS 1DS MKIII with 70–200mm zoom and ND 3.0 filter, 50secs at f/11, ISO50

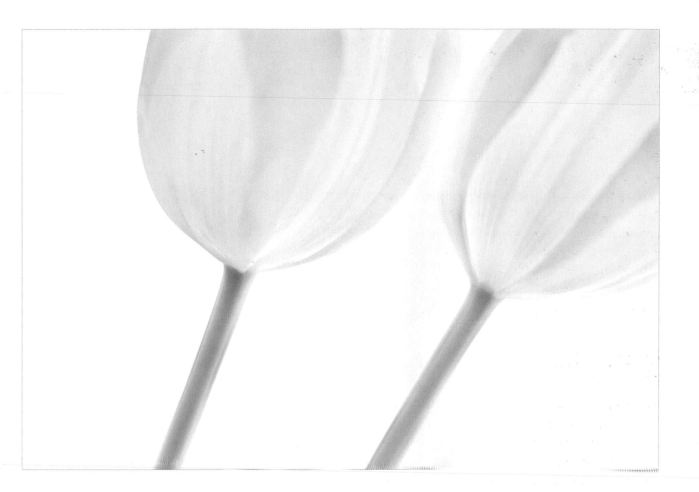

These tulips were in a vase on my kitchen table and one day I happened to notice how they were backlit by patio doors at the far end of the room. I immediately visualized a simple, high-key still life of two of the flowers, and after a few minutes trying different compositions I settled on this one. I shot a series of frames, increasing the exposure by +1/3 stop each time until I got the effect I wanted at +2 stops over the metered exposure. The raw file was processed immediately and all I needed to do to get the finished image was adjust curves and convert to black and white.
Canon EOS 1DS MKIII with Zeiss 50mm macro lens, 1sec at f/2.8, ISO100

exposure rarely produces satisfactory results—it's too heavy-handed. But there are more subtle ways. Experiment with Levels and Curves in Photoshop, or the Brightness/Contrast slider. Channel Mixer can also be used—by adjusting the different color channels individually, you can alter the tonal balance of the image entirely, rather like shooting black-and-white film with different colored filters on the lens.

Speaking of which, in the more recent versions of Photoshop there's the Black & White tool (Image>Adjustments>Black & White), which allows you to mimic the effects of common black-and-white filters—red, yellow, orange, green, etc. The High Contrast Red preset is handy for creating high-key images when the original image contains warm colors and is worth trying out. The Maximum

White preset can help as well. It's unlikely you'll get what you're looking for in a single hit, but this first step will get part of the job done.

The type of lighting you use can make a big difference at the taking stage. High-key portraits are easy to create in a studio—pose your subject against a white background, light the background separately, and flood your subject's face with light from a softbox or umbrella. Once the images are in your computer it's then a simple case of boosting contrast while processing the raw file so the lighter tones almost burn out.

If your subject is translucent, backlighting works well. Flowers are a good example—if you place a vase of flowers in front of a window so the petals are backlit, you can overexpose the shots so that the background burns out and fine detail in the petals are emphasized. This is an easy job if you're shooting digitally because you can gradually increase the exposure using your camera's exposure compensation facility, checking the preview image and histogram after each shot, until you've got just the effect you want.

HIGH-KEY / LOW-KEY

LOW-KEY IMAGES

Think moody and mysterious. That's what low-key images are all about. They give shadows center stage and celebrate the darkness.

Bad weather lends a low-key feel to the landscape—dark, stormy skies and a lack of direct light reduce scenes to somber impressions. Sea views and landscapes containing water are especially suited to the low-key treatment because the smallest glint of brightness in the sky will be reflected to emphasize the low-key feel. You need light tones in a low-key image to break up the darkness and create definition, but only in small amounts.

Of course, it's easy to emphasize the

Weather conditions can make it easy to create low-key landscapes—just head out with your camera on the darkest, dreariest day when the sky is heavy with rain and you can't go wrong. Don't bother underexposing the image to make it moodier—you can do that later.
Canon EOS 1DS MKIII with 70–200mm zoom and ND 3.0 filter, 180secs at f/16, ISO100

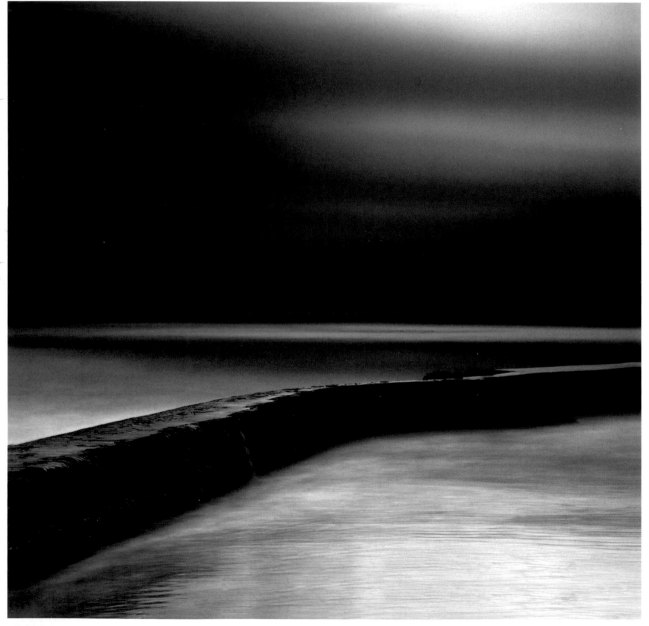

This photograph was always destined to be low-key. In fact, the mood of the whole woodland where I took it was low-key—dark and menacing. Just as well I wasn't alone: I've seen *The Blair Witch Project*! It took little work to achieve the feel I wanted—this is pretty much just as the image looked when the original negative was scanned.
Holga 120GN "toy" camera with fixed lens, 1/100sec at f/11, ISO400 film

effect if the image is initially too upbeat. In Photoshop, Levels and Curves will allow you to change the tonal balance. Watch what happens as you push the mid-tone slider to the right in Levels. The image not only becomes very dark very quickly, but the range of tones is also compressed.

I also often find that selecting the sky with the Polygonal Lasso tool then applying Auto Levels really brings out the drama of shots taken in bad weather. Noise is often enhanced when you do this, but in low-key images I can live with noise as I think it adds to the overall mood of the image.

If you want to avoid noise, however, shoot in raw, give the shot as much exposure as you can without "clipping" the highlights—it won't look anything like a low-key image at this stage—then do the dark deed when you process the raw file. I use Adobe Camera Raw in Photoshop CS3 to process my raw files and make Tone Curve adjustments to get the effect I want.

If you're setting up a shot, lighting can be used to create a low-key effect. This is often referred to as "chiaroscuro" lighting, an Italian word that translates as "light-dark" and refers to a style of painting that makes use of dramatic

contrast to give an impression of depth and create volume.

In photography you can mimic this effect by positioning your subject against a dark or black background, then placing a single light behind and to one side of them. The light will emphasize certain parts of the subject's body, but very selectively, and by exposing for the lighter tones, much of the subject will fade into the shadows, creating a successful low-key effect. This works well with nude studies as it emphasizes the shape of the subject's body without revealing much of it—adding to the sense of mystery and allure.

top tips

- Experiment. Thanks to digital technology it's easier now than ever before to take full control and achieve exactly the effect you have in mind. Take creative risks. Anyone can take average photographs of average subjects—make your work above average.

- High-key and low-key images make great wall art. Why not print and frame your favorite images so they can be fully appreciated?

- Try both approaches on different subjects—landscapes, portraits, nudes and still life.

HIT THE STREETS

If you're a country boy like me, heading for the big city with a camera can be a daunting experience. People rushing. Traffic racing. Buildings touching the sky. Roadworks. Traffic lights. Noise! So much noise. Buskers. Hookers and hustlers. Scaffolding. Glass and steel. Street lights. Bold colors. Strong shapes.

Wherever you look there's something going on and, more importantly, another great picture to be taken. Towns and cities are magical, intoxicating places and if you allow yourself to fall into their rhythm and get under their skin, you'll find inspiration at every turn, 24 hours a day, seven days a week.

WHAT YOU NEED

CAMERA: A digital SLR or compact—something that's quick and easy to use but gives you control.

LENSES: Wide-angle to telephoto—you'll find a use for any focal length. Ultra-wides are especially useful because they stretch and distort everything.

ACCESSORIES: In low light or when you want to use long exposures, a tripod will be essential. Otherwise, travel light and shoot handheld.

HOW IT'S DONE

Start early, when the streets are quiet, and capture buildings basking in the warmth of the rising sun. Come rush hour, shoot suited and booted commuters spilling off trains and hurrying along streets. On sunny, blue sky days use bold shapes and strong colors to create stunning abstracts. Get a worm's eye view by getting down on the ground, or a bird's eye view from skyscrapers. Explore markets for patterns and details. Shoot portraits of people at work or street entertainers.

You wouldn't want it on the side of your house, but there's no denying that graffiti can look stunning. Move in close to capture colorful abstracts, or step back and use the graffiti as a backdrop. Capture a passing car, or a passing pedestrian, to give your pictures an extra element and maybe use a slow shutter speed around 1/4 sec. to introduce blur. Alternatively, pose people against it when shooting urban portraits. Strong sunlight reveals graffiti at its best, especially if shadows are thrown across it to add depth. Some cities have areas where graffiti is permitted and contained—that's where you'll find the best shots.

A BRIDGE TOO FAR

Modern road and rail networks are becoming more adventurous in their design, which is great news for photographers. Bridges and overpasses are especially dramatic. Surprisingly, it's not hard to produce powerful images— all you need is an ultra-wide lens (the latest 12–24mm or similar-range zoom is ideal) and a low viewpoint. Shoot at dawn or dusk to capture the structure against a colorful sky, or wait until the middle of the day when the light's at its strongest

Graffiti not only makes an interesting subject in its own right but can also be used as an eye-catching background. This shot, taken in Havana, Cuba, is made much more interesting by the graffiti—without it the backdrop would have been rather drab.
Canon EOS1DS MKIII with 24–70mm zoom, 1/60sec at f/11.3, ISO400

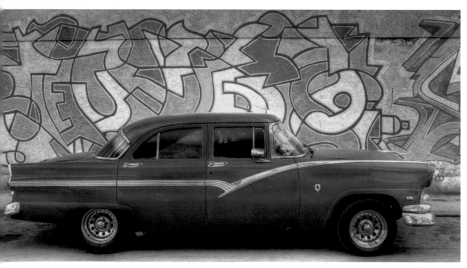

to heighten the graphic feel of your compositions, and use a polarizer to deepen the sky.

Towering glass and steel office blocks are one of the main attractions offered by our cities, though photographing them can be tricky, simply because they're so high. Converging verticals are often unavoidable, so make the most of this phenomenon and use your widest lens from close range to create dynamic compositions, or shoot with a tele-zoom so you can fill the frame with eye-catching patterns. Taking an alternative approach, look for reflections of buildings in puddles, the bodywork of parked cars—black cabs are ideal—or the mirrored windows of other buildings.

Modern architecture can be the source of amazing images if you approach it in a creative and imaginative way. This building—the Selfridges department store in Birmingham, UK—is popular with photographers due to its radical design and offers endless potential. Here I captured it using a plastic "toy" camera and cross-processed the film to give weird colors. A similar effect can be achieved digitally by changing the hue of the image.
Holga 120GN with fixed 60mm lens, 1/100sec at f/11, Fuji Provia 100 film

This bridge was photographed using an infrared-modified digital SLR to create a stark monochrome image. The bird caught mid-flight was a stroke of luck, adding an extra element to the composition.
Infrared-modified Nikon D70 with 10–20mm zoom, 1/125sec at f/8, ISO200

Road signs and street furniture are a good source of abstract images—just move in close and experiment with unusual angles. This sign was captured against the sky to make use of the intense blues.
Sony Cybershot 6mp compact with 6.3–18.9mm integral zoom, 1/100sec at f/13, ISO80

top tips

- Take care at night—towns and cities can be dangerous places after dark.

- Experiment with your widest and longest lenses and shoot from unusual viewpoints.

- Night shots are best taken while there's still color in the sky.

- Digital cameras are perfect for low-light photography so make the most of yours.

- Towns and cities are full of bold colors and strong shapes—perfect for eye-catching abstracts.

HYPERFOCAL FOCUSING

Picture the scene. You're out in the countryside, on a perfect summer's day, faced with the most breathtaking landscape you've ever seen. The light's fantastic, your picture's composed and a meter reading taken. All you have to do now is focus and fire. Just one snag: where, exactly, do you focus the lens when shooting landscapes to ensure that everything in the scene is recorded in sharp focus?

For many, the answer is to stop the lens down to f/22, set focus at infinity and say a little prayer, hoping that such a small aperture will give sufficient depth of field (the zone of sharp focus) for front-to-back sharpness. However, the very fact that photographers use such a limited approach suggests that they don't really understand how to assess depth of field properly, so they won't know if everything is sharply focused until they view the shots on the computer screen—by which time it's too late.

If you want to eliminate this risk, and guarantee front-to-back sharpness every time, it's essential to take control of depth of field instead of letting it control you.

WHAT YOU NEED

CAMERA: Ideally an SLR with lenses that can be switched to manual focus so you can decide exactly where to focus.

LENSES: Those that can be focused manually and that have a distance scale etched on the barrel so you can control the focusing distance.

HOW IT'S DONE

In practice, the "f/22 and infinity" rule often works perfectly well, especially when using wide-angle lenses that give lots of depth of field at small apertures. If you stop a 28mm lens down to f/22 and focus on infinity, for example, everything in the scene will record in sharp focus from about 1m to infinity. With a 24mm lens at f/22 and infinity, depth of field will extend from around 0.7m to infinity, and a 20mm lens stopped down to f/22 and focused on infinity will record everything in sharp focus from just 50cm to infinity.

Providing you don't include anything in your pictures that's closer than this, you'll get front-to-back sharpness every time. The problems begin when you want to include something that is closer, as you'll end up with an out-of-focus foreground.

This is more likely to happen with a standard or telephoto lens because they give far less depth of field compared to wide-angle lenses, even at minimum

aperture. A 135mm lens (or zoom set to 135mm) focused on infinity and stopped down to f/22 will record everything in sharp focus from around 23m to infinity, for example. With a 200mm at f/22 and infinity this is reduced to 50m to infinity, and with a 300mm telephoto it's down to 113m to infinity—a significant difference.

Religiously stopping down to f/22 for every shot also has technical drawbacks. First, it means you'll need to use longer exposures, making the need for a tripod more likely if you want to shoot at low ISO and avoid camera shake. Second, lenses tend to give their poorest optical performance at minimum aperture, with the sharpest results obtained around f/11. So by stopping down to f/22 all the time, instead of only when you really need to, you're sacrificing image sharpness unnecessarily.

Fortunately, there's an easy way to overcome this problem and obtain more

depth of field in the process—using a technique known as hyperfocal focusing. Here's what you do:

■ If you look at a typical lens barrel you'll see that either side of the main focusing index there's a series of f/numbers. This is the lens's depth of field scale.

■ To maximize depth of field, focus the lens on infinity then check the depth-of-field scale to see what the nearest point of sharp focus will be at the aperture set—the distance opposite the relevant f/number on the scale. This is the hyperfocal distance. In the picture below, of a Zeiss 28mm prime lens, you can see that at f/16 with focus set at infinity, the hyperfocal distance is just

Hyperfocal focusing is the only reliable way to maximize depth of field using modern autofocus zoom lenses. Fortunately, the latest digital SLRs have superb high-resolution preview screens, so having taken a shot you can immediately zoom into it and check that the nearest and farthest points are sharply focused. If not, adjust the focus slightly or stop the lens down to the next smallest aperture and reshoot.

Canon EOS 1DS MKIII with 17–40mm zoom at 17mm and 0.9ND hard grad, 4secs at f/22, ISO50

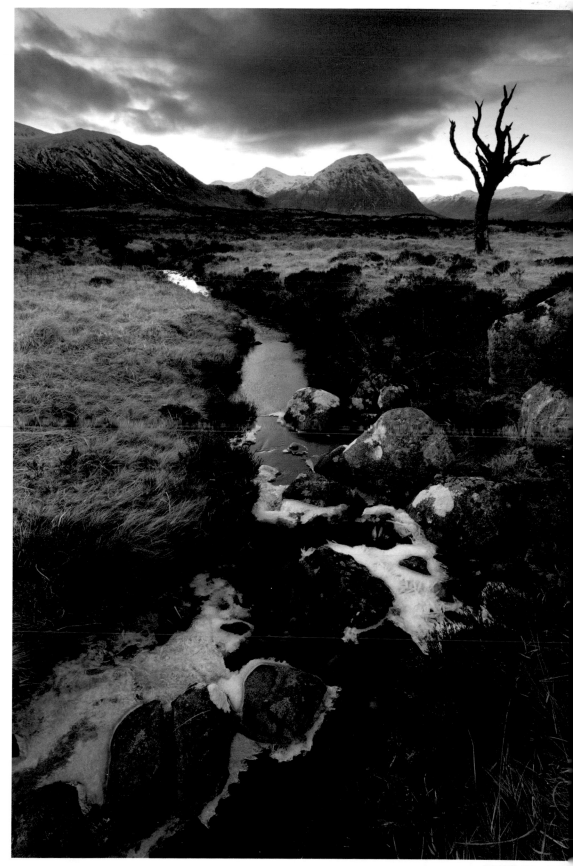

HYPERFOCAL FOCUSING

under 2m, so with the lens focused on infinity, depth of field will extend from around 2m to infinity.

■ By refocusing the lens on the hyperfocal distance, depth of field will extend from half the hyperfocal distance to infinity. If you do this then peer through your camera's viewfinder, pretty much everything appears to be blurred, but ignore this—the final shot will be sharp from front to back. In the picture below you can see how

this works— the same lens has been refocused on just under 2m, and if you look at the depth-of-field scale you can see that sharp focus will now be obtained from just under 1m to infinity.

The only downside to this approach is that most of us use modern autofocus zoom lenses these days and they lack decent depth-of-field scales, partly due to lack of space on the lens barrel and partly because camera manufacturers, wrongly as it happens, don't feel the need to provide them.

Also, even if a lens does have a depth-of-field scale, it may not be especially accurate, so if you follow the above advice you may find that the farthest reaches of the photograph aren't pin sharp.

The only way to establish this is by taking test shots with your lenses. Follow the steps outlined above and if you find that the nearest or farthest points of the photographs aren't totally sharp, adapt the technique and make sure that the infinity symbol on the lens falls just to the

left of the desired f/number on the depth-of-field scale.

In the photograph below, for example, infinity has been placed slightly to the left of f/16 on the depth-of-field scale rather than directly opposite it, on the basis that the scale may not be totally accurate. Some lenses need this adjustment, others don't.

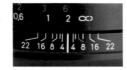

IMAGE CALCULATIONS

A more reliable technique if your lenses have poor depth-of-field scales, or none at all, is to calculate the hyperfocal distance using this simple equation:

Hyperfocal distance = F (squared)/(fxc) where:

F= lens focal length in mm
f= lens aperture used, eg, f/16
c= circle of confusion (a constant value is used for circle of confusion—0.036 for 35mm format lenses and 0.127 for medium-format)

For example:
A 28mm lens set to f/16, the hyperfocal distance is 28 x 28/(16 x 0.036)
= 784/0.576
= 1.361m, rounded up to 1.4m

By focusing the lens on roughly 1.4m, depth-of-field will extend from half that distance (0.7m) to infinity.

This is too fiddly to do every time you take a picture, of course, so to save you the trouble, here's a table (below) showing the hyperfocal distances for lenses from 17–200mm and apertures from f/8 to f/32. These values apply for zoom lenses set to the relevant focal lengths, as well as prime (fixed focal length) lenses. They are also based on effective focal length, so if you use a full-frame digital SLR, actual focal length and effective focal length are the same, but if your SLR is not full-frame and a magnification factor has to be applied to find effective focal length, remember to do that first before referring to this table.

To use the table, simply find the focal length you're using along the top, your chosen aperture down the side, then read across to find the hyperfocal distance.

For example, if focal length is 20mm and aperture f/16, the hyperfocal distance is 0.75m. By focusing the lens on 0.75m (approx.), depth of field will extend from half the hyperfocal distance (0.375m approx.) to infinity.

To check if this is sufficient, focus on the nearest point you want to include in the picture then look at the distance scale on the lens barrel to see how far away that point is.

HYPERFOCAL DISTANCES

APERTURE (f/stop)	LENS FOCAL LENGTH (mm)								
	17mm	20mm	24mm	28mm	35mm	50mm	70mm	100mm	200mm
f/8	1.0m	1.4m	2.0m	2.8m	4.2m	8.5m	17.0m	35.0m	140m
f/11	0.75m	1.0m	1.5m	2.0m	3.0m	6.3m	12.3m	25.0m	100m
f/16	0.5m	0.75m	1.0m	1.4m	2.1m	4.3m	8.5m	17.5m	70m
f/22	0.35m	0.5m	0.7m	1.0m	1.5m	3.1m	6.2m	12.5m	50m
f/32	0.25m	0.35m	0.5m	0.7m	1.0m	2.2m	4.2m	8.5m	35m

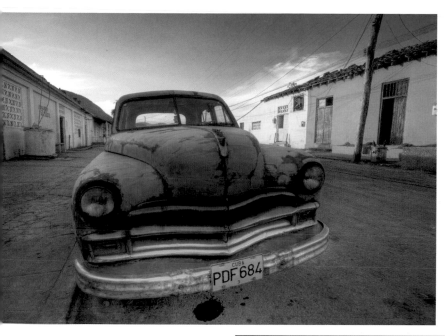

The great thing about hyperfocal focusing is that it allows you to achieve sufficient depth of field without necessarily having to stop the lens right down to its minimum aperture, which usually compromises image quality. In this shot, the front bumper of the car was only inches from my lens, but I still managed to record everything in sharp focus at f/16.
Canon EOS 1DS MKIII with 17–40mm zoom at 17mm and polarizing filter, 1/8sec at f/16, ISO100

BELOW: Once you get used to using hyperfocal focusing it will quickly become second nature and you'll be able to push depth of field to the very limits to produce stunning images.
Canon EOS 1DS MKIII with 16–35mm zoom at 16mm and 0.9ND hard grad filter, 40secs at f/16, ISO100

If it's more than the nearest point of sharp focus you've just determined, you can fire away safe in the knowledge that you will get front-to-back sharpness. If it's less than the nearest point of sharp focus, there's a danger that the immediate foreground won't be sharp, so refer back to the table and stop your lens down to a smaller aperture.

This probably sounds very complicated right now, but if you read through the information several times and refer to the table while handling your own lenses, it will soon become clear and you will never again take a landscape picture that suffers from a fuzzy foreground.

Even better, why not copy the table on to a sheet of white cardstock, or photocopy this page, then slip it into a clear plastic wallet so you can refer to it in the field?

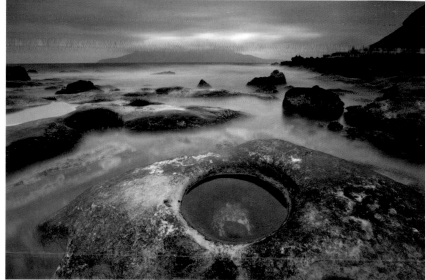

top tips

■ Practice using hyperfocal focusing so you get the hang of it—it may seem complicated initially but eventually it will become second nature.

■ Examine your photographs in detail—enlarge them to 100% on the computer monitor and check to see if the nearest and farther points are in sharp focus. If they're not, revise your

technique—stopping down to the next smallest f/number should do the trick.

■ Don't be afraid to shoot at minimum aperture—f/22 or f/32. Sometimes it's necessary to achieve sufficient depth-of-field or a long exposure. What you shouldn't do is stop right down as a matter of course.

LINE OUT

Whenever you compose a picture, your aim should be to arrange the elements of the scene in such a way that they form a visually pleasing whole so the viewer's eye is carried naturally through the scene, from foreground to background. This is of particular importance, as a composition only works if it grabs and holds the viewer's attention for as long as possible.

One of the easiest ways to achieve this is by including lines in a picture. These could be obvious lines such as roads, walls, hedges, rivers, paths and fences, the furrows created by a ploughed field, straight rivers and ditches, or the shadows cast by lamp posts and trees. Including lines helps to give the composition direction and stability. We are inquisitive, so when we see a line our eye naturally follows to find out where it goes. If you use those lines creatively, the viewer's eye is taken on a journey around the picture.

Lines can also be assumed rather than real. A row of trees stretching off into the distance will form a line, even though there's a gap between each tree, because our brain joins up the gaps. Similarly, the direction a person is looking in a photograph will create an imaginary line because our eye naturally follows the direction of their gaze.

HOW IT'S DONE

Different types of lines create a different effect compositionally, so it's worth bearing this in mind.

HORIZONTAL LINES

Created by shadows, fences, walls, hedges and the natural planes in the landscape, horizontal lines are restful and easy to look at because they suggest repose and echo the horizon. They also carry the eye from left to right in a picture.

VERTICAL LINES

These are more powerful and energetic because they suggest upward movement and the eye follows them from bottom to top. Think of trees standing sentry-like in a forest, or the sides of a tall building stretching up to the sky—tension is created when you look at them.

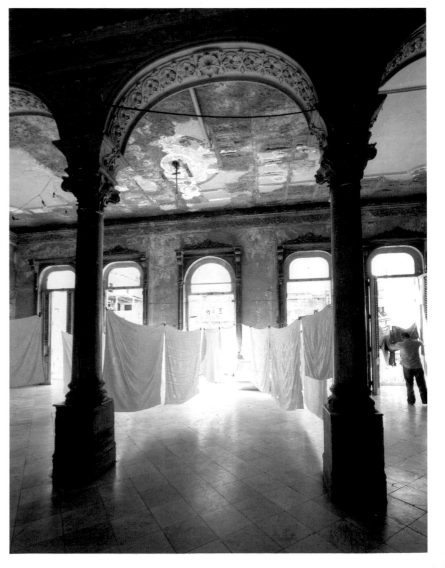

The towering columns in this interior view create strong vertical lines that add tension to the composition. They also dwarf the person in the background to create a strong sense of scale. Turning your camera on its side will make the most of vertical lines.
Canon EOS 1DS MKIII with 14mm lens, 1/5sec at f/11, ISO100

Diagonal lines are as effective as converging lines when it comes to creating a sense of depth and scale in a composition. Here, the wooden fence winds its way through the scene from bottom left to top right and carries your eye toward the main focal point—the castle. Canon EOS 5D MKII with 24–70mm zoom and polarizing filter, 1/15sec at f/18, ISO100

BELOW: **In this photograph you can see how the tidal causeway forms a strong converging line that carries your eye from the immediate foreground of the scene to the offshore island and the lighthouse standing proudly on it, which acts as the main focal point.** Canon EOS 1DS MKIII with 24–70mm zoom and 0.6ND hard grad, 30secs at f/16, ISO100

DIAGONAL LINES

Created by a river, road or fence cutting through a scene, these lines cover more ground, so they're ideal for carrying the eye up through a picture, taking in the other elements as it goes. Our eye naturally moves from bottom left to top right, so a diagonal line moving in this direction will have the greatest effect.

top tips

- Why not put together a series of pictures showing the use of lines? Whenever you see a long, straight road, for example, you could take a picture of it with a wide-angle lens.

- Learn to look for lines in a scene, and don't always expect them to be obvious. Repeated features such as trees, electrical towers and telephone poles can all add impact to a composition, but at first glance their effect may not be seen.

- You can vary the effect lines have on a composition by altering camera format. If you hold the camera horizontally, for example, horizontal lines will be emphasized, whereas turning the camera on its side will make better use of vertical lines.

CONVERGING LINES

The most powerful lines of all create a strong impression of depth. If you stand in the middle of a long, straight road and look down it, you'll see that the parallel sides move closer together—converge—with distance. Because we know the road or path is roughly the same width all the way along, our brain automatically registers that it must be moving into the distance. The same effect can be created using railway tracks, the furrows in a field, a river or drainage ditch, a path,

or any feature that has parallel lines.

To make the most of this, use a wide-angle focal length such as a 28mm or 24mm to exaggerate the effect, and stop the lens down to its smallest aperture—usually f/16 or f/22—to ensure there's enough depth of field to render the whole scene in sharp focus.

The effect of converging lines is also heightened if you include the vanishing point—the point where the lines appear to meet on the horizon—as it provides a natural resting place for the eye.

LONG SHOTS

Tele-photo. The title says it all really—photos taken at a distance. That's what telephoto lenses do. They pull things in; magnify; let you get up close and personal. Telephoto lenses allow you to be selective; to decide exactly what you want in a picture and what you don't. They let you sort the wheat from the chaff so you're left with pure magic. And that makes them incredibly powerful for all kinds of subject, from landscapes to portraits.

I actually shoot far more wide-angle images than telephoto, but I do carry a 70–200mm telezoom with me whenever I'm out shooting, and I regularly encounter situations where no other lens would do, simply because the characteristics of a tele-lens are totally opposite to those of a wide-angle.

WHAT YOU NEED

CAMERA: Ideally, an SLR so you can fit interchangeable lenses—as long as 800mm!

LENSES: The type of telephoto you use will depend on what subjects you intend to shoot, but for general use I find a 70–200mm ideal on a full-frame digital SLR.

ACCESSORIES: If you're using long, heavy telephotos, a monopod or tripod will be handy for keeping it steady. A teleconverter is also useful for extending the focal length of a telephoto lens or zoom (see panel below).

HOW IT'S DONE

The most obvious characteristic of telephoto lenses—their ability to magnify your subject—is directly proportional to focal length. A 300mm lens magnifies six times compared to a standard 50mm; a 600mm lens 12 times. Not surprisingly, the majority of photographers buy telephoto lenses for this ability to make a subject bigger in the frame, as it allows pictures to be taken in situations where access is restricted, such as at major sporting venues, or when photographing timid wildlife. They're also ideal for isolating part of a scene to make it the main element and produce simple, uncluttered images.

However, there's much more to telephotos, and often it's the lesser known characteristics that end up being the most useful.

For starters, they restrict depth of field, especially when set to wide apertures such as f/2.8 or f/4. The longer the lens, the less depth of field you get—a 200mm lens set to f/4 will give a much smaller zone of sharp focus than an 85mm lens set to the same aperture.

This factor gives rise to a technique

ADD A TELECONVERTER

If you want to extend the optical versatility of your telezoom even more, consider buying yourself a teleconverter. This handy accessory looks like a short lens and sandwiches between the zoom and camera body, increasing the focal length range of your zoom.

There are two options available—1.4x and 2x. A 1.4x teleconverter increases focal length by 40%, turning an 80–200mm zoom into a 112–280mm optic, for example. A 2x doubles it, turning the same zoom into a more capable 160–400mm.

Teleconverters have tended to receive bad press over the years because optically they weren't particularly good—unless you spent hundreds of dollars on models from the main camera manufacturers. However, optical technology has developed in leaps and bounds and teleconverters offer excellent quality now.

The key is to spend as much as you can afford and look for models that are matched to specific lenses or zooms as they give the best results. To get the sharpest results you also need to work at apertures around f/8 or f/11, though this won't always be possible, especially if you're shooting subjects such as nature or sports.

One thing to remember when using a teleconverter is that it loses light—a 1.4x loses one stop and a 2x loses two stops. This basically means you end up using slower shutter speeds, increasing the risk of camera shake and making it harder to freeze fast-moving subjects. Mounting your camera on a tripod, or supporting it with a monopod, will overcome the first problem. Alternatively, increase the ISO to 200 or 400 so you can use a faster shutter speed.

One great benefit of teleconverters that's often overlooked is that fact that they don't affect the minimum focusing distance of the lens or zoom they're fitted to, so if you use a 2x teleconverter on a 75–300mm zoom, for example, you can use its original close-focusing even at the new maximum focal length of 600mm, which is just what you want for frame-filling shots.

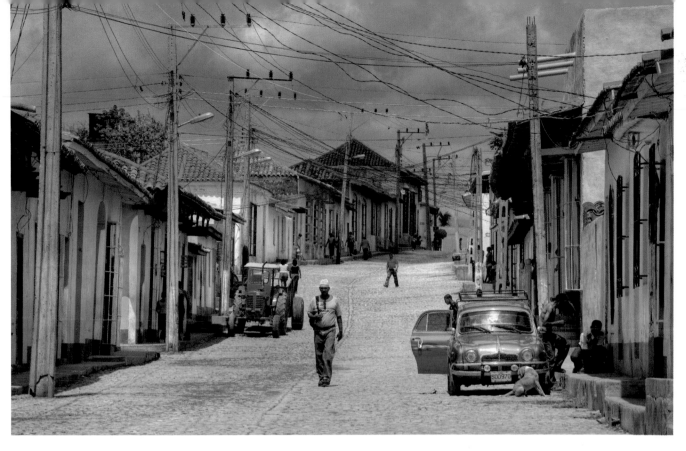

known as "differential" or "selective" focusing, where the lens is set to a wide aperture—often its widest so little more than the main point of focus comes out sharp and everything else is reduced to an indistinguishable blur.

Photographers often use differential focusing when shooting portraits, wildlife or sport to throw the background out of focus so the main subject stands out boldly. But you can use it in more creative ways—to capture a single poppy in a sea of golden corn or a horse in a grassy meadow backlit by the setting sun.

The less depth of field you have, the more care you need to put into focusing, of course. This is particularly important with focal lengths from 200mm up, where depth of field at maximum aperture can be just a few centimeters. Timing, too, becomes crucial when shooting moving subjects because it only takes a fraction of a second for them to pass in and out of the small zone of sharp focus.

FORESHORTENING

The third main characteristic of a telephoto lens is its ability to compress perspective

so the elements in a scene appear closer together than they are in reality.

Often referred to as "stacking" or "foreshortening", this effect can be used to emphasize the patterns created by repeated shapes. To witness it for yourself, find a scene that contains similar features, such as a row of houses or an avenue of trees, then photograph it from an acute angle with a 200mm or 300mm lens—you'll clearly see the way those features seem crowded together. Compression increases with focal length, so a 500mm lens will give a much bolder effect than a 200mm.

LONG SHOTS

Telephoto and tele-zoom lenses are invaluable when it comes to emphasizing the effects of haze and mist as the compression of perspective crowds the receding layers in the scene together so the fall-off in color and increase in brightness with distance is much more obvious.
Canon EOS 1DS MKIII with 70–200 zoom at 200mm, 1/15sec at f/16, ISO100

300mm, 400mm or 500mm and so on.

Alternatively, support the lens so you can use a much slower shutter speed. Any convenient flat surface—the top of a wall or fence, the open window of your car—will be fine, though stability will be increased if you use a gadget bag, rolled-up jacket or beanbag to cushion the lens. Monopods are also ideal for long-lens photography, providing lots of support whether you're shooting at eye-level or kneeling, plus the freedom of movement you need to follow your subject.

For ultimate stability, nothing beats a tripod, but only if it's a solid, sturdy model. Many long lenses have a tripod socket on the barrel so you can fix the lens, rather than the camera, to the tripod. This is done to give a more balanced set-up.

Telephoto lenses also emphasize the effects of aerial perspective caused by haze, mist and fog to make ranges of hills and mountains appear like cardboard cutouts. Aerial perspective causes colors and tones to become lighter with distance, and the effect can look incredibly moody when you use a long lens to pull in distant parts of the scene.

Despite modern telephoto lenses being relatively compact, camera shake is an ever-present risk. To avoid this, the slowest shutter speed you use should roughly match the focal length of the lens: 1/250sec for a 200mm, 1/500sec for a

MAGNIFICATION FACTORS

The vast majority of digital SLRs in use don't have a full-frame sensor so when you attach a lens to the camera, the effective focal length of that lens is different to what it would be on a full-frame digital SLR or a 35mm film SLR.

The most common sensor size used in digital SLRs requires you to apply a multiplication factor of 1.5 to the actual focal length to find the effective focal length. With wide-angle lenses, this is a nuisance because the angle of view is reduced—a 17mm lens effectively becomes a 28mm, for example. However, when it comes to using telephoto lenses, this multiplication factor is a benefit because it increases effective focal length and all the characteristics you get from a tele-lens. A modest 70–200mm zoom becomes a 105–300mm, for example, a 75–300mm becomes a 112.5–450mm and a 100–400mm becomes a 150–600mm. This means that subjects such as nature and sport photography are more accessible using popular and affordable zoom lenses. Throw a teleconverter into the mix and your telephoto options will be increased further.

SUBJECT MATTERS

The telephoto lenses you decide to buy will depend on the type of subjects you tend to photograph.

The shorter focal lengths from 85–135mm are ideal for portraiture as the slight foreshortening of perspective they give is flattering to the human face. Depth of field is also reasonably shallow at wide apertures, making it easy to throw distracting backgrounds out of focus.

From 135–200mm you've got the perfect focal lengths for isolating interesting features in the landscape, picking out architectural details that are high on buildings and shooting candids from a fairly safe distance so there's less chance of you being spotted. These moderate focal lengths are also ideal for day-to-day use when you want to fill the frame with anything that's a reasonable distance from the camera, to emphasize

patterns in a scene, isolate colors, textures and abstracts such as reflections, and, if your zoom has a close focus setting, fill the frame with small subjects.

Beyond 300mm you're into specialist territory reserved mainly for serious sport and wildlife photographers, where 500mm or 600mm lenses are almost standard issue—though even then it's surprising how close you need to get to an average-sized bird or mammal to take a frame-filling picture!

I use my 70–200mm telezoom often to isolate interesting details in landscape scenes so they dominate the composition. This winding Tuscan road is a good example—when you gaze across the valley, the wonderful shape of the road isn't at all obvious as it only occurs over a short distance. However, once you zoom in and exclude other unwanted details, the shot really comes to life. Using a zoom instead of a telephoto prime lens also made it easier to perfect the composition by fine-tuning focal length—you simply can't buy a 155mm lens! Canon EOS 1DS MKIII with 70–200 zoom at 155mm, 1/5sec at f/16, ISO50

top tips

■ An increasing number of telezoom lenses have internal image stabilization, which drastically reduces the risk of camera shake—it's a feature well worth having if you're thinking of buying a new lens.

■ Careful focusing is vital with telephoto

lenses due to reduced depth of field. I prefer to focus manually so I can control exactly what I focus on and I don't have to worry about the focus shifting unexpectedly. The way a lens renders out of focus areas is known as its *bokeh* (pronounced "bo-kay"). It differs from lens to lens.

LOW-LIGHT SHOOTING

I was searching through a collection of color photographs recently when it struck me that almost without exception, my personal favorites have all been taken either at dusk, dawn or somewhere in between—but never in the middle of the day.

An image from the Isle of Lewis reminded me of a trip to the Outer Hebrides last year when my alarm was set for 2:50 am every day so I'd have enough time to get up, out and on location in time for the 4:15 am sunrise. Another, from the same trip, took me back to a beach on Harris where I was shooting at 11:30 pm—and it was still twilight!

Clearly, there's no time for slumber if you want to make the most of the light. But even when the daylight does eventually disappear, sleep can wait, because there's always the urban landscape to keep you inspired, basking in the super-saturated technicolor glow of man-made illumination. You don't even need "light" in the way we normally think of it in order to create amazing images—the night sky is full of opportunities. If you can keep your eyes open!

WHAT YOU NEED

CAMERA: A digital SLR is the most versatile camera for low-light shooting as you can use different lenses, set high ISO for handholding, assess your results and take full control.

LENSES: I use 17–40mm, 24–70mm and 70–200mm zooms. This range copes with all subjects and situations.

FILTERS: Neutral-density graduated filters are essential at dawn and dusk for balancing sky and landscape.

ACCESSORIES: Tripod and cable release, flashlight, compass and warm clothes.

HOW IT'S DONE

Here's how a perfect day's photography might unfold, and what I'd shoot to make the most of it. As you'll discover, "day" is lacking from much of it, but fantastic photo opportunities certainly aren't.

START AT SUNSET

I've always been a big sunset fan. It's such a privilege to be in a beautiful place, watching the sun dip toward the horizon, and taking successful shots as it does is a blast. That's a win-win situation in my book.

The simplest option is to go for silhouettes. Position an interesting feature between you and the sky, which will hopefully be full of color, and fire away. Your camera's meter will correctly expose the sky and bingo, the feature silhouettes. Trees, buildings, people, monuments, fountains, mountains—anything with an interesting shape will work.

Sunsets can vary enormously. On a clear day the sky may glow with a soft orange while a cloudy sky can erupt with vibrant, fiery hues. It all depends on the weather conditions that immediately precede sunset, but at least you can see how things are progressing. watch the sun slowly sink to the horizon and be ready when something magical happens.
Canon EOS 1DS MKIII with 70–200mm zoom and 0.6ND hard grad, 1/30sec at f/16, ISO100

Option two is to head for water so you've got something to reflect the colors in the sky. Harbors are ideal as you can include things like boats in the foreground, or rocky beaches where you can capture waves breaking over rocks and blur them using an exposure of 20–30 seconds. Rivers and streams snaking into the distance also work well as they create a strong lead-in line and break-up what could otherwise be a dark, featureless foreground.

Use a wide-angle lens to make the most of foreground interest and a strong ND grad filter to tone down the sky. Usually a 0.9 (3-stop) grad will be required. If you don't have one, combine 0.6 and 0.3 grads to get the same effect as a 0.9.

The sun's orb often appears bigger and less intense as it nears the horizon at the end of the day because atmospheric haze scatters the light. This is your cue to dig out a tele-zoom and

Once the sun has set, any warm colors in the sky gradually fade to cold purples and blues and darkness approaches, marking the start of nightfall. This is a wonderfully atmospheric time of day to shoot, especially near water so you can capture reflections of the rich color overhead.
Canon EOS 1DS MKIII with 17–40mm zoom and 0.9ND hard grad, 30secs at f/8, ISO100

make a feature of the sun—the longer the lens the better. If it's bright, use a wide-angle lens instead to reduce its apparent size and the risk of flare spoiling your pictures.

What happens once the sun finally drops below the horizon is down to prevailing weather conditions. If it's clear, hang around and expect a colorful afterglow, which is a great consolation if the sun itself was too bright to shoot a few minutes earlier. If it's cloudy, cross your fingers and hope for the best. Even if clouds snuffed out the sun as it set, it may still light up the sky from below. Watch for telltale signs of color clipping the edges of clouds. It may take ten minutes or more after sunset for this to happen, so be patient. Cloudy winter afternoons can produce the most colorful sunsets you're

likely to see. Just make sure you're not stuck in a traffic jam when it happens.

THE TWILIGHT ZONE

Once the colors of sunset start to fade, twilight begins. It's difficult to separate one from the other really as they merge seamlessly, but twilight is a much more subtle affair than sunset. It's the quiet encore that ends the day's performance before the curtains of nightfall are pulled and the audience heads home. That doesn't include you, of course.

On a clear night, the twilight sky merges through subtle pinks and reds to blues and magentas as diffuse light from the invisible sun is refracted by the atmosphere. Occasional clouds pick up color like cotton candy while the landscape glows under the soft, reflected

LOW-LIGHT SHOOTING

light from the sky that acts like a giant studio softbox. No shadows now, but plenty of detail and lots of atmosphere. Time to reach for the ND grad again if you want to hold that color.

Twilight is short during the winter, like the rest of the day, so don't expect to cover more than one location and keep shooting until all color fades. Digital cameras are far more capable than film when it comes to squeezing the last drop of color from a twilight sky, and even when it appears to have died to the naked eye, you see images pop up on the camera's preview screen and go "Wow!" Color you didn't even know existed will light up your face and you'll be glad that the action has only just begun.

AFTER HOURS

If you want to shoot urban scenes in the evening, the time to do it is while there's still color in the sky, enough daylight to prevent shadow areas from coming out black, but dark enough for the effects of man-made illumination to be seen.

This crossover period doesn't last long—no more than 20 minutes in winter—so you need to get yourself on location soon after sunset and be ready when the prime time comes. If in doubt, start shooting sooner rather than later— you can always delete the frames that don't work.

Street scenes in busy towns and cities make great "night" subjects at this time of year as dusk occurs early so there's lots of activity and color to capture—glowing signs, window displays, floodlit buildings…. It's also safer to shoot urban scenes with lots of people around as you're less likely to be hassled.

Look for a viewpoint where you can look down over a busy shopping street or beltway and use a long exposure of

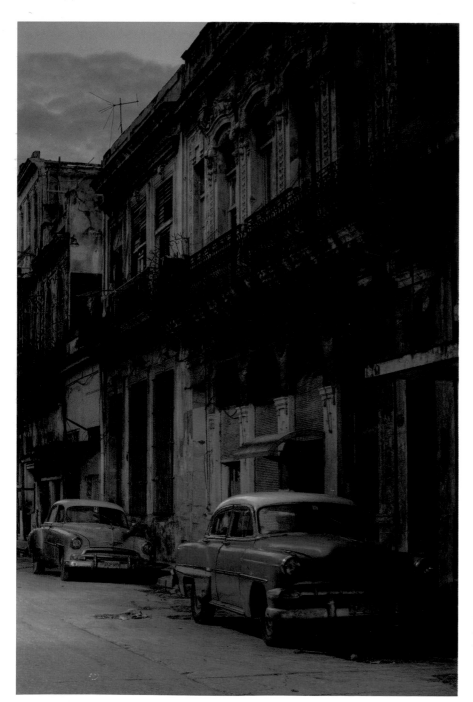

As daylight fades, the urban landscape comes to life under the sombre glow of artificial illumination. Shoot while there's still color in the sky for the best results—once the sky turns black, contrast rises and atmosphere drops. This window of opportunity doesn't last long though, so recce during the day and arrive with time to spare.
Canon EOS 1DS MKIII with 70–200mm zoom and 0.9ND hard grad, 30secs at f/11.3, ISO200

30 seconds or more to record passing traffic as colorful light trails. If you set your SLR to Aperture Priority (AV) mode it will sort out the exposure automatically, providing it falls within the permissible shutter speed range—usually up to 30 seconds. If the required exposure is longer than that, either open up the aperture or increase the ISO to reduce the exposure duration until it falls within range, or set the shutter to bulb (B) and use a longer timed exposure.

Modern metering systems are so good that your camera will usually get the exposure spot on first time, but if it doesn't you can always use the exposure compensation to increase or reduce it. The key is to avoid blowing the highlights, so as well as checking the image on your camera's preview screen, also check the histogram and make sure it hasn't move too far to the right.

HEAVENS ABOVE

I'm no Sir Patrick Moore when it comes to appreciating celestial bodies, but there are some great photo opportunities to be had up there in the sky at night.

On a clear, dark night, the moon creates a shimmering slither of silver on inky black water. Use an exposure of a second or two at f/11 to contrast the light and dark and create images of graphic simplicity.

Another approach is to think of the moon as a weaker version of the sun and use it as a light source for landscapes. Under a full moon, try an exposure of 12 minutes at f/8 and ISO100 as a starting point, or six minutes at f/8 and ISO200 if you're impatient. Don't be surprised if the results look as if taken in broad daylight— sky that's black to the eye comes out blue,

If you want to shoot successful star trails, get yourself as far from human habitation as you can to minimize the risk of light pollution. This shot was taken in the Sahara Desert of southern Morocco, several miles from the nearest village on a crystal clear night. I set up my tripod, composed the scene, set focus to infinity, locked the shutter open on bulb and returned two hours later. I only made the one exposure and as it was on film I had to wait almost two weeks to find out if it worked. Just as well it did!
Nikon F5 with 20mm lens, 2 hours at f/2.8, ISO50 film

shadows cast by the moon look like those cast by the sun. It's only stars in the sky that give the game away.

For the best results, make sure you're well away from urban areas where light pollution will spoil the effect and avoid including any other light source as it will burn out horribly during the long exposure. Keep the moon out of shot, too, as it will not only overexpose, but blur as it moves a distance equivalent to its own diameter every two minutes. Oh, and set your lens to manual focus as light levels will probably be too low for the camera's AF system to work.

If you want to shoot the moon itself, try an exposure of 1/125sec at f/11 or f/16 and ISO100 for a full moon. This will be far too brief to record detail anywhere else in a night scene, so if you want the moon to

be sharp and well exposed and you also want to correctly expose the rest of the scene, there's only one solution—take one shot of the moon, another of the scene, then combine them.

Doing this with film is tricky because you need to expose the same frame twice and create an in-camera double exposure. But doing it digitally is a snap—just select the moon using the Lasso tool in Photoshop, copy and paste it on to the night scene and use the Move tool to position it. Use your longest lens to shoot the moon—300mm is ideal, 500–600mm better, though you can make a small moon bigger in Photoshop if necessary before you superimpose it on your night scene.

My favorite sky-at-night shot involves using long exposures to record star trails created as the earth rotates on its

polar axis. You need to be in the middle of nowhere for this to work properly as light pollution from towns and cities will spoil the effect, so head for the wilds of Scotland, the Lakeland Fells or the Sahara Desert. Use a compass to locate north so you can include the North Star, around which all other stars appear to rotate, set your widest zoom to its widest focal length and widest aperture, focus on infinity, include some hills at the bottom of the frame for scale and lock the shutter open on bulb for a couple of hours.

Make sure your batteries are fully charged and keep the ISO low on digital cameras to minimize noise. You will get some hot pixels, but they can be cloned out later. It's that simple!

PRE-DAWN CHORUS

By the time your star trail exposure comes to an end it will almost be time to get ready for pre-dawn, the period when night slowly turns to day.

Post-sunset twilight and pre-dawn twilight may look similar in photographs, but each demands a different approach. At the end of the day you're reacting to changes in the light as they happen— the sun dips below the horizon, twilight develops then slowly fades to black. At the beginning of the day, you start out in darkness and wait for the light to come so it's predictive rather than reactive, which is why you need to be in the right place with time to spare. No point showing up at a location 10 minutes before the sun's due to appear, either, as the colors tend to be at their richest well before sunrise. Ideally, be there a good hour before, so you can get

Pre-dawn is a magical time of day. Most sane people are still in bed, the world is quiet and the atmosphere clean and still. It's worth getting up just to experience the dawn of a new day, though when faced with a scene like this, it's hard to resist a few (dozen) photographs! It's also a wonderful feeling knowing that you've bagged some great shots even before breakfast. Canon EOS 1DS MKIII with 70–200mm zoom and 0.6ND hard grad, 20secs at f/11, ISO100

organized then stand back and wait for the magic to happen.

Pre-dawn is by far my favorite time of day for coastal landscape photography, and winter has always been the season when I've bagged my best shots—good news if you're not an early starter.

An ideal pre-dawn scenario would involve the tide going out overnight so you're presented with clean sand that's devoid of footprints and still wet so it reflects the vibrant colors in the sky. Throw in a few ripples and rock pools to break up the foreground and you can't go wrong. Alternatively, head for rocks where you can contrast their stark, dark shapes with crashing or lapping waves turned misty by a long exposure.

Pre-dawn is all about color. On a clear,

cloudless morning you'll have a vibrant palette of primaries to work with—yellows and reds close to the horizon, graduating to deep blue. Broken clouds underlit by the sun can make the sky look like it's on fire and you'll be winding down saturation in Photoshop, not up. Dense cloud will snuff out any warmth in the sky, but replace it with a deep blue cast that can be emphasized using a long exposure.

Inland, head for a location containing water so there's something in the foreground to reflect color in the sky. Winter landscapes covered in snow work brilliantly at pre-dawn as the snow is so reflective. Alternatively, find a high viewpoint where you can look down over the landscape—with any luck it'll be shrouded in mist that turns blue because

it's lit by reflected light from the sky.

Wherever you are, a strong ND grad filter will be required to prevent the sky from overexposing and all that lovely color being lost. I favor a 0.9ND hard grad, which tones down then sky by three stops so I can record plenty of detail in the foreground.

ALL RISE

At this time of year, the sun rises far south of east, so remember that when scouting for locations. Better still, stay in the same area you shot at pre-dawn and see how the sunrise develops.

Weather conditions play a pivotal role here. On a clear morning you may get fantastic pre-dawn color, but the second the sun peeps over the horizon we're talking flare city. You'll get a few wide angle shots in the bag as the sun will be tiny, but forget about reaching for a telephoto—it's dangerous, if nothing else, as the sun's power will be magnified and can damage your eyesight.

One solution is to hide the sun's orb behind a feature in the scene, such as a tree. I've found myself stretched flat on the ground with the tripod at its lowest setting on many a morning for this very reason. The feature you use to block the sun will record in silhouette, creating a strong focal point in the composition.

Alternatively, turn your back on the sun. By doing this you can capture scenery bathed in golden light and the sun's intensity works for you rather than against you. It's always worth doing a 360° at dawn and dusk because there might be something better going on behind you.

If the start of the day errs on the cloudy side, sunrise can be more spectacular than pre-dawn—so don't be too hasty to head back for your breakfast. I've lost count of the times I've stood around for an hour staring at a grey sky only to find that as soon as I start packing up, it explodes with color and blind panic ensues.

Again, locations near water will make the most of this by filling the foreground with color and giving you features to silhouette—boats, piers, jetties, offshore rocks or islands. But provided that you use a strong ND grad to hold back the sky, any landscape scene can work. Town and cityscapes also look stunning at sunrise—shoot east to capture skyscrapers in silhouette, or turn 90° and focus on structures grazed by golden light.

Winter sunrises can be especially stunning after a cold night as the atmosphere is clear, rising mist is common and, most important of all, you don't have to crawl out of bed at some ungodly hour to capture it. So why not make an effort to get out sometime soon—maybe even take your camera to work so you can shoot en-route?

top tips

- Why not plan a full dusk-to-dawn photography session with some friends—and see who comes up with the best shots?

- Take care when outdoors at night, especially on deserted streets— personal safety should always come first.

- During each of the periods covered in this section there's a great variety of different photographs to take, so don't expect to get them all in one shoot.

Sunrise, like sunset, can be infinitely variable. On this occasion, the sun's golden orb burst over the distant hills straight into clear sky and the light was immediately intense. My only option was to hide it behind a nearby tree, which involved positioning the camera just inches above the ground then craning my neck to see through the viewfinder.
Mamiya 7II with 65mm lens and 0.9ND hard grad, 1/2sec at f/22, ISO50

MERGING EXPOSURES

Despite making the big switch from film a couple of years ago, I still shoot like a film photographer in that, when possible, I try to get the shot right in-camera. It's a case of old habits dying hard I suppose, and though I know there are a million and one things you can do to a digital file during post-production to improve it, I'd rather be on location than glued to a computer screen.

That said, one area where I'm increasingly relying on digital technology and post-production these days is as a substitute for neutral density (ND) grad filters (see page 92). I've been using ND grads religiously for many years to control the contrast between sky and land when shooting landscapes, so it was natural to continue relying on them when I switched to digital capture.

However, I've always been aware of their limitations. ND grads are fine when the horizon is relatively unbroken, but as soon as bold features extend into the sky, a strong grad will leave tell-tale signs by darkening those features above the horizon but leaving them unaffected below it.

One solution is to mount your camera on a tripod, take two shots of the same scene—one correctly exposing for the sky, the other for the scene—then merge them in Photoshop using layers. This technique is effective, but it's also time consuming and complicated if the features breaking into the sky have complex outlines. Fortunately, I've discovered a much more sophisticated method—using software to blend a series of frames shot at different exposures.

HOW IT'S DONE

Although Photomatix Pro is mainly used to create HDR images (see page 120), it also gives you an Exposure Blending option. This works in a similar way to the HDR control but the final image is much more realistic.

I first made use of this feature during a trip to Cuba where I struggled to produce successful images of street scenes in a single exposure. The problem was that, often, all I could see was a "V" of sky, with buildings rising up on either side of the frame to the top corners of the image. Using an ND grad to tone down the sky didn't work because it also darkened the tops of the buildings. At dawn or dusk,

when contrast is very high, this can look very odd indeed, and while it may be possible to select the darkened parts of the building during post-production and lighten them, this rarely produces convincing results.

To overcome this, I got into the habit of shooting a sequence of frames, usually from -2 stop to +2 stops in full stop increments, with the intention of combining them using Photomatix Pro when I returned home. It solved the problem and I now used this technique on a regular basis.

Exposure blending also works really well at dawn and dusk, even if the scene

you're shooting isn't difficult to shoot using an ND grad. Digital cameras don't handle high contrast as well as film, so I often find that even with a 0.9ND hard grad on my lens (the strongest I ever needed with film), bright areas of the sky are still overexposed and the whole

Urban scenes are notoriously difficult to photograph in contrasty light because the brightness range is vast and often the sky is impossible to control with an ND grad filter. I faced that problem when photographing this Cuban street scene at dawn, but by shooting a sequence of exposures from –2 stops to +2 stops then merging them using Photomatix 3.0, I was able to achieve a satisfactory result. Turn the page to find out how it was done.
Canon EOS 1DS MKIII with 16–35mm zoom at 21mm, various at f/8, ISO100

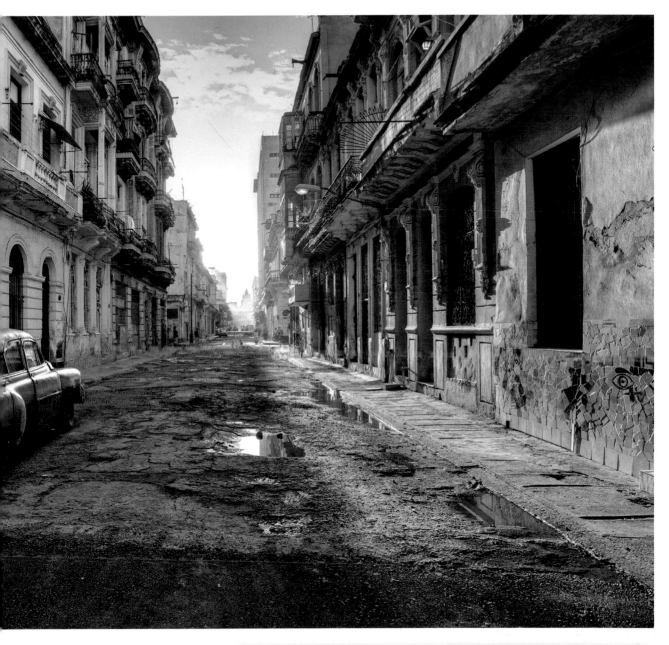

image appears overly contrasty. By shooting a sequence of exposures and merging them in Photomatix Pro, this problem is solved, contrast is balanced out and the final image looks much better for it.

If you use this technique in dull

WHAT YOU NEED

EQUIPMENT: A digital camera that allows you to control and vary the exposure.

ACCESSORIES: A tripod and cable release.

SOFTWARE: I use Photomatix Pro 3.0 for this technique. Go to www.hdrsoft.com for more information about it.

MERGING EXPOSURES

weather, when the light is soft and contrast low, the final blended image has a tendency to look rather flat. But this can easily be remedied in Photoshop, using Curves to boost the contrast.

STEP BY STEP

To show you how easy it is to achieve perfect results, here's a step-by-step guide.

1. Mount your camera on a sturdy tripod and compose the scene. Set the exposure mode to Aperture Priority, exposure compensation to -2 stops and take a shot. Adjust exposure compensation to -1 stop, take another shot and repeat with exposure compensation at 0, +1 and +2 stops. This gives you a series of five frames from -2 stops to +2 stops, which in the majority of situations will give you a well-exposed sky at one end of the sequence and well-exposed shadows at the other.

2. Open Photomatix Pro 3.0 software and click on Exposure Blending. A dialogue box appears and requires you to select the files for blending. You can work straight from unprocessed raw files and simply drag and drop the source images on the dialogue box, or batch process the images and save them as TIFFs or JPEGs. Once ready, click OK, then sit back and let the software do its job.

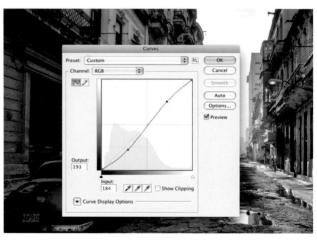

3. Once the images have been merged—it takes about a minute—you'll see a preview of how the final blended image will look and also have the option to make changes. Adjust the sliders for Strength and Blending Point and see how it affects the look of the image. There are no hard and fast rules here—it comes down to taste and also the kind of images you're working with, though I find that the initial image always needs to be tweaked.

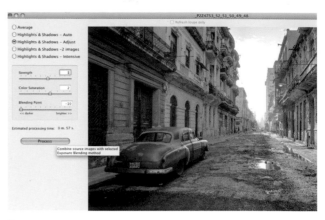

4. When you're satisfied with the effect, click Process and the software will combine the images for you. This usually takes 30–60 seconds. When processing is complete the blended image appears and you then need to save it—ideally as a 16-bit TIFF. The image can then be opened in Photoshop like any other digital image and any final tweaks applied using controls such as Levels and Curves. If you blended the raw files you may also need to remove any sensor blemishes.

82

There was no way that I could use an ND grad filter to prevent the sky from overexposing here due to the cliffs extending to the top of the image. Turning my filter holder on its side, so that the grad missed the cliffs, wasn't an option because it would have affected the left side of the foreground. Merging a series of exposures was the only practical solution.

Canon EOS 1DS MKIII with 17–40mm zoom at 17mm, various at f/16, ISO100

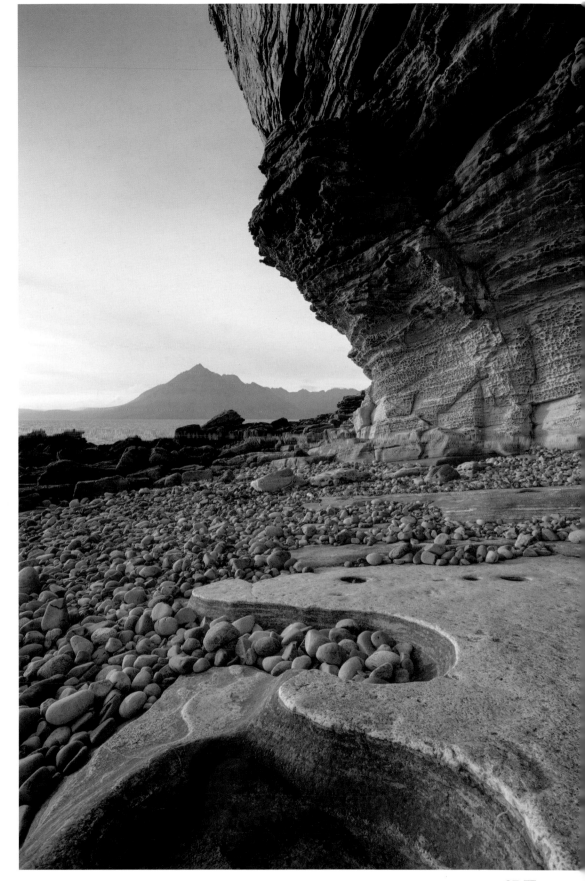

MIRROR IMAGE

Recent reports have suggested that people with symmetrical faces are not only more attractive to the opposite sex, but also tend to be healthier and so less likely to suffer from ailments such as the common cold, flu and asthma.

Whether or not this is true or not remains to be seen, but if you want to find out just how symmetrical your own face is, or anyone else's, and create some unusual images in the process, here's an interesting Photoshop technique worth trying out.

WHAT YOU NEED

PORTRAIT: Either shoot a self-portrait, ask someone to take your photograph or work with a portrait you've already taken of someone else.

SOFTWARE: You'll need a version of Adobe Photoshop or Photoshop Elements to follow the steps outlined below.

HOW IT'S DONE

1. Ideally you need a portrait where the subject—you, or anyone else— is square-on to the camera and looking directly at the camera.

4. Go to Image>Canvas Size, click on the central Anchor point on the left edge of the anchor box, double the width of the canvas and click OK.

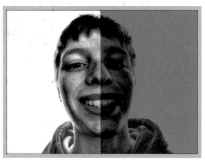

2. Using the Crop tool, crop the image so only one half of the image remains. In this case I chose the side of the face that was in the best light.

5. Open the original cropped half of the face by double-clicking it, then using the Move Tool in Photoshop, drag and drop it onto the extended canvas.

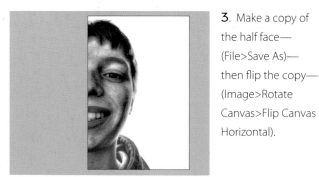

3. Make a copy of the half face— (File>Save As)— then flip the copy— (Image>Rotate Canvas>Flip Canvas Horizontal).

6. Carefully align the two halves of the face so they join neatly. Use the direction arrow keys on your computer keyboard to fine-tune the alignment.

7. To disguise the fact that the image is a composite, use the Clone Stamp tool to paste pixels over any tell-tale marks—like the line down the nose in this image.

top tips

- Choose subjects who clearly don't have a symmetrical face, so that the difference between the original portrait and the final image will be obvious and amusing!

- Try the idea on family and friends—they will be amazed by the results.

- If you shoot portraits specifically for this technique, make them unusual—use a wide-angle lens from close range, or ask your subject to pull a silly face.

And here is the final symmetrical image. The subject is my son, Noah, and when I showed it to him and his younger sister they were both shocked by how weird and slightly demonic he looked! Canon EOS 1DS MKIII with Zeiss 85mm lens, 1/320sec at f/1.4, ISO200

For the shots of my son above and top right I took the initial portraits using a wide-angle zoom (see page 147) so that his face was already distorted. I also used HDR software to make the final images even more unreal. Canon EOS 1DS MKIII with 17–40mm zoom, 1/125sec at f/8, ISO100

MONO MAGIC

There are more ways to turn a digital photograph from color to black and white than there are to skin a cat. With the aid of Adobe Photoshop you can convert to grayscale, desaturate, use Channel Mixer to control the way different colors record as gray tones, employ fancy layer techniques—the list goes on. Oh, and a growing number of digital cameras have a black-and-white mode that converts images to mono immediately, in-camera.

Unfortunately, having tried them all in recent years, I can say categorically that the simple methods tend to be unsuccessful (rather like having machine prints made from black-and-white negatives) and the most effective ones are complicated and time-consuming, so if you're a newcomer to digital imaging, chances are your black-and-white work will be disappointing.

Fortunately, there is a solution—software! Numerous plug-ins and stand-alone applications now exist that allow you to produce stunning black-and-white images from color digital files, with little or no prior experience. Read on and all will be revealed.

WHAT YOU NEED

SOFTWARE: My favorite software for black-and-white conversion is Nik Software Silver Efex Pro (www.niksoftware.com). As well as being quick and easy to use, it's also incredibly effective, offering a wide range of tools and creative effects that will transform your black-and-white photography—even if you've never taken or printed a black-and-white shot before. Available as a plug-in for Adobe Photoshop CS2 or later, Adobe Lightroom 2.3 or later or Apple Aperture 2.1 or later, you can download a free 15-day trial if you prefer to try before you buy. Be warned though—when the trial ends, you'll want the full version, so start saving!

SYSTEM REQUIREMENTS:
PC: Windows 2000, XP and Vista, AMD or Intel processor, 512MB RAM (1GB recommended), Photoshop 7.0 onward, Elements 2.0-6.0

Mac: OS 10.4 or later, G4, G5 Intel Core, Intel Core Duo, Intel Xeon, 512MB RAM (1GB recommended), Photoshop CS2/3/4, Elements 4.0 and 6.0, Aperture 2.1 or later, Lightroom 2.3 or later.

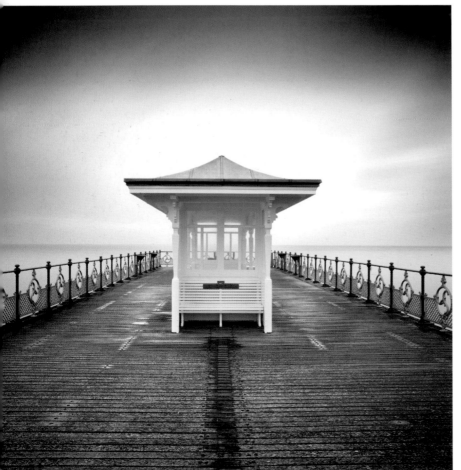

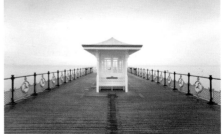

The weather was so gray and flat when this photograph was taken that there was hardly any natural colour to it. My natural reaction, therefore, was to convert it to black and white and make the most of the delicate tones. Cropping to a square also simplified the composition and made it look less like a digital image.
Canon EOS 1DS MK111 with Zeiss 21mm lens, 0.6ND hard grad and ND3.0 filters, 3mins at f/11

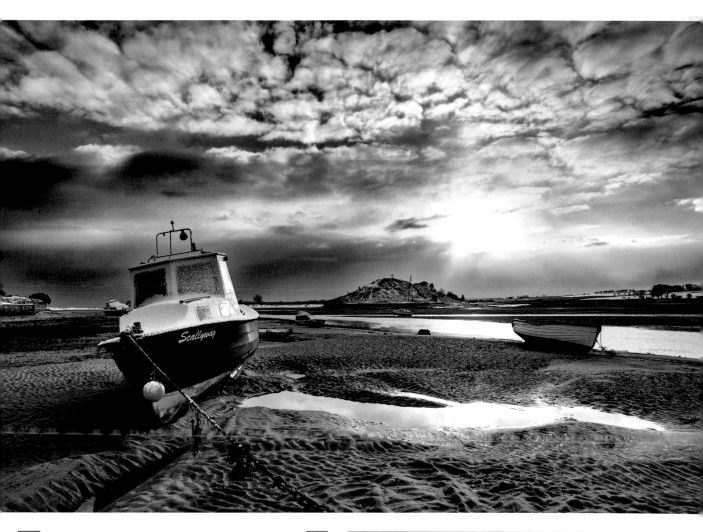

top tips

- Experiment with the presets (I find High Structure works well) but don't rely on them too much—Silver Efex Pro has many controls that allow you to achieve exactly the effect you're after.

- Don't assume that every color photograph you take will also make a great black-and-white image—some will, some won't, so choose carefully.

- Black-and-white conversion software like Silver Efex Pro isn't designed to make a silk purse from a sow's ear, but in creative hands it's incredibly powerful.

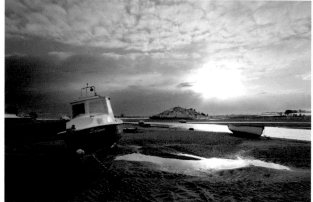

Would you guess this dramatic image (top) started life as a color digital file if I hadn't shown you? Probably not, because despite taking just a few minutes to create using Nik Software Silver Efex Pro, it bears all the hallmarks of a skillfully produced darkroom image.
Canon EOS 1DS MKIII with Zeiss 21mm lens and 0.9ND hard grad, 1/30sec at f/11.3, ISO100

MONO MAGIC

HOW IT'S DONE

To give you an idea of how it works, and what's on offer in the way of features, here's a quick step-by-step, using the Photoshop version.

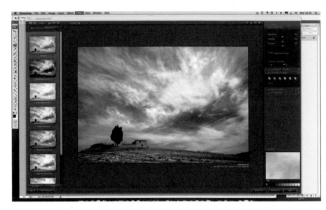

1. Open your chosen image in Photoshop as normal, then either go to File>Automate>Nik Selective Tool and click on Silver Efex Pro or go to Filter>Nik Software>Silver Efex Pro. Once the interface opens you'll see a live preview of the image with a series of presets to the left and tools over to the right.

2. You can customize the workspace if you wish—hiding the presets, for example and/or changing the image view so it's half color and half black-and-white, or so the image appears twice, in its original color form and the black-and-white version, as shown here.

3. The presets on the left of the workspace are handy as quick fix options (see panel on page 90). There are filter effects, toning effects, push/pull processing, infrared, and even options to mimic the effects of Holga and pinhole cameras. Just click on

one or more to see how the image is transformed and if you don't like it, click on Neutral.

4. Moving over to the right of the interface, at the top of the panel there are three sliders for Brightness, Contrast and Structure. All three are set to 0% in default mode. If you click on a preset, automatic adjustments to these sliders will be made, or you can adjust them manually to get the effect you want.

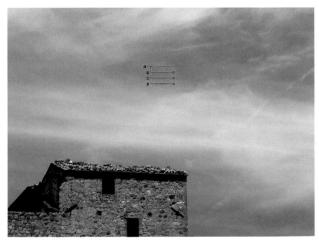

5. Next down you'll see Add Control Point. This is perhaps the most useful tool because it allows you to make adjustments to specific areas. Click on the icon then click on the image to create a control point and move it to where you want it by clicking on the red dot and dragging it. Use the zoom tool to enlarge the image to make it easier to work.

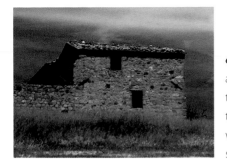

6. The top slider allows you to adjust the size of the area to be adjusted, while the other sliders control Brightness, Contrast and Structure. You can have as many control points as you like. They do the same job as dodging and burning but are more precise because you can adjust the opacity of each point or turn selected points off.

7. Photographers often use colored filters to alter the way a color scene records on black-and-white film. You can do the same with Silver Efex Pro using the Color Filter option. Just click on one of the icons for a red, orange, yellow, green or blue filter and if you don't like the effect you just click on the first icon— No Filter.

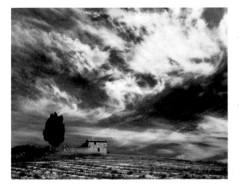

8. Select Film Types to mimic the look of 18 different films— just drag the sensor over a film type to see how it changes the main image. This is Ilford Delta 3200. Use the Grain, Sensitivity and Tone Curve sliders to make further adjustments until the effect is just right and use the Loupe tool to inspect the image in more detail.

9. Under the Stylizing banner there are three options. Toning gives you endless control to add toning effects to the image, using the presets and sliders for fine-tuning, while Vignette and Burn Edges allow you to lighten or darken the corners or edges of the image as a final touch. Beats chemical toning any day!

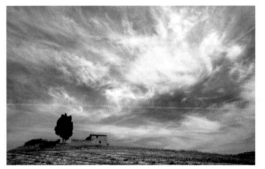

Once you're happy with the look of the image, click OK and you're back in Photoshop with all the changes applied to an adjustment layer—which means that you can revert to the original color image if you like just by making the Silver Efex Pro layer invisible. Comparing the before and after images, you can see how effective Silver Efex Pro is. Not bad for five minute's work.
Canon EOS 1DS MKIII with 17–40mm zoom and polarizing filter, 1/125sec at f/8, ISO100

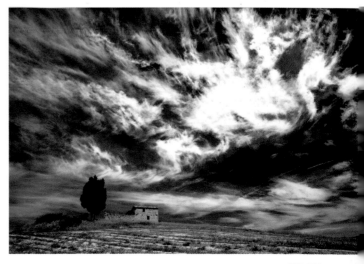

MONO MAGIC

PLAYING WITH THE PRESETS

The presets offered by Silver Efex Pro are hard to resist and you'll probably find yourself turning to them time and time again to see how they change the look of an image. You may also find that you want to create several versions of some images simply because the effects work so well. Don't go overboard though—match images and effects carefully and avoid applying effects just because you can! Here are just some of the options that are offered.

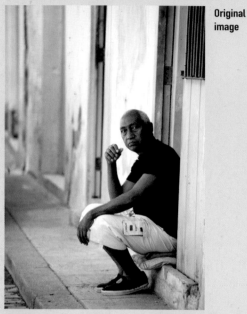

Original image

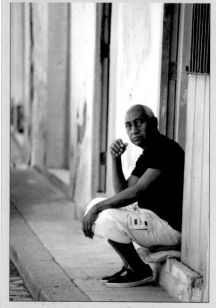

Basic black-and-white conversion

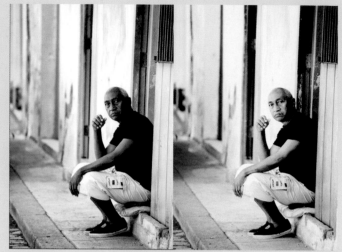

High Structure **Infrared Film Normal**

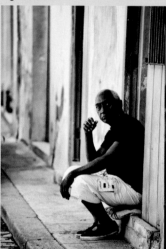
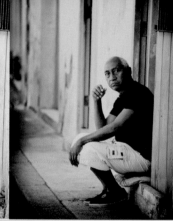

Wet Rocks **Antique Plate I**

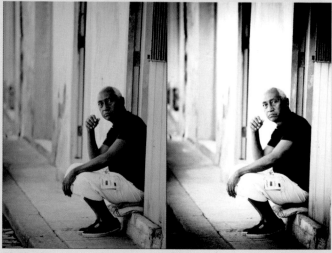

Tin Type **Holga**

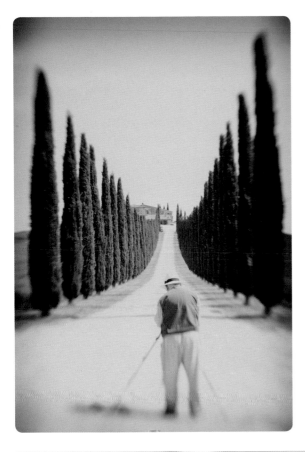

The Antique Plate presets in Silver Efex Pro are ideal for giving modern images an ancient look. This photograph was taken in Tuscany in 2009 and yet could easily have been shot a century ago. Canon EOS 1DS MKIII with Lensbaby Composer (see page 20), 1/800sec at f/4, ISO400

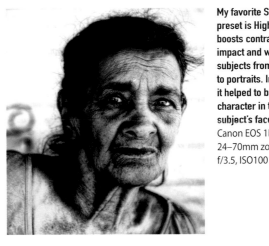

My favorite Silver Efex Pro preset is High Structure—it boosts contrast, adds impact and works well on all subjects from landscapes to portraits. In this image, it helped to bring out the character in the elderly subject's face. Canon EOS 1DS MKIII with 24–70mm zoom, 1/250sec at f/3.5, ISO100

THE BRUSH TOOL

An additional feature of Silver Efex Pro is a Brush tool, which allows you to selectively apply any of the effects it's capable of creating to specific parts of the image. So, for example, you can leave some areas as color while others are rendered black and white. Similarly, you can selectively tone an image, or selectively apply contrast and exposure adjustment.

To use the Brush tool, open Silver Efex Pro as normal and apply any changes/effects to the whole image. When you've done that, click on Brush at the bottom right corner of the workspace. The image will open in Photoshop as the original color version. You then have four options: Paint, Erase, Fill, Clear.

If you choose Paint, you can use the Brush tool in Photoshop to paint away areas of the color image to reveal the black-and-white effect you applied in Silver Efex Pro.

If you choose Fill, it applies the black-and-white effect to the entire image, then you can use Erase to remove the effect from selected areas so the original color is revealed. The end result is the same but whether you choose Paint or Fill/Erase depends how big the area you need to work on is.

In either case you can vary the brush size and opacity and fix mistakes by clicking on Clear, which allows you to start again, or by going from Paint to Erase, and vice-versa, to reverse a smaller error.

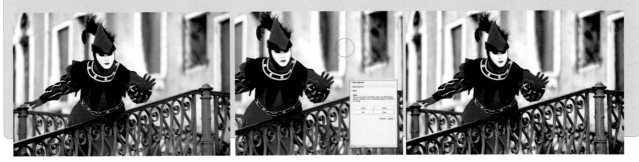

ND GRADS

One of the most common problems encountered by beginners to landscape photography is wishy-washy sky syndrome. You know what I'm talking about—you compose a great scene, the sky above it is colorful and dramatic, but when you check the picture you've taken of it, the landscape itself looks fine but the sky is overexposed and washed out.

Fortunately, there's an easy solution, and it comes in the form of a filter—a neutral density graduated filter, or ND grad as it's more commonly known.

ND grads are gray on the top half—that's the neutral density part of the filter—and clear on the bottom. The idea is that the gray part of the grad tones down the brightness of the sky so that when you correctly expose the landscape, the sky is also correctly exposed instead of completely blown out.

WHAT YOU NEED

CAMERA: An SLR with TTL (through-the-lens) viewing makes it easier to use grads, though they can be used with compacts and rangefinders.

LENSES: ND grads can be used with any type of lens, though they are generally used with wide-angle focal lengths.

ACCESSORIES: It's easier to use ND grads if your camera is mounted on a tripod.

FILTERS: ND grads come in different strengths or densities, expressed as the number of f/stops by which they reduce sky brightness—0.3 gives a one-stop reduction, 0.6 a two-stop reduction and 0.9 a three-stop reduction. It's worth having a set of all three, so you can produce perfect results no matter how bright the sky is. Some manufacturers also produce intermediate densities—0.45 (1½ stops) and 0.75 (2½ stops).

HOW IT'S DONE

To produce a convincing result you need to choose the right density of ND grad—if it's too weak it won't tone down the sky enough, and if it's too strong it will make the sky look unnaturally dark.

Fortunately, making the right choice isn't as difficult as it seems. There are only three main densities to choose from—0.3, 0.6 and 0.9. The weakest, 0.3, is only useful when you need a very subtle effect—I hardly ever use one—while the strongest 0.9, is mainly used at dawn and dusk when the sky's really bright but there's no direct light on the landscape. That just leaves the 0.6 ND grad, which is the best choice for general use. If in doubt, take a test shot with a 0.6 grad, check the image on your camera's preview screen, then switch to either a 0.3 or, more likely, a 0.9, if the effect isn't right.

If necessary, you can also combine two grads for a stronger effect. Digital cameras seem less able to cope with high contrast than film, so while the strongest ND grad I ever use when shooting film is a 0.9 density, sometimes it's necessary to combine it with a 0.3 or even 0.6 ND grad when shooting digitally, to stop the sky from overexposing.

That said, it's also easy to over-grad a sky, so be careful. If the sky ends up a little brighter in the image than it was in reality, you can always darken it during post-processing. Providing there are no serious highlight warnings flashing to tell you that areas of the sky are blown out,

HARD OR SOFT GRADS?

There are two types of ND grads—"hard" and "soft". This refers to the way in which the neutral density (gray) part of the filter graduates down to clear—with hard grads the change is quite sudden whereas with soft grads it's gentle.

Beginners to ND grads assume that soft grads are easier because if you align them incorrectly it's less likely that you'll see the line of the grad in your picture. However, hard grads (shown) are quite forgiving in this respect, and also give a more defined effect, so you're better off sticking to hard grads and learning how to use them properly.

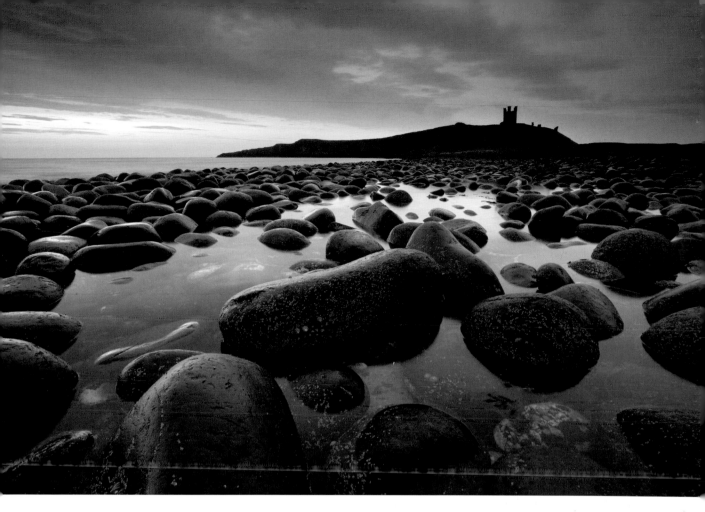

you're better off darkening a sky that's too light than lightening a sky that's too dark.

ND GRADS AND EXPOSURE

It used to be that a meter reading had to be taken and set manually on your camera before an ND grad was placed on the lens, otherwise exposure error would result because the camera's metering system would be fooled by the dark area of the filter and overexpose.

In today's digital SLRs, however, the metering systems are so clever that you can compose the shot, align the grad ready for use and meter with it on the lens. This is because "intelligent" metering patterns take a number of exposure readings from different areas of the image area, so the darkness of the filter doesn't influence the final

exposure set in a negative way. Also, if you think about it, when an ND grad filter is placed on your lens it should make it easier for your camera to set the correct exposure because the ND part of the filter is darkening the sky area so that the contrast between the sky and foreground is reduced.

Remember, too, that by shooting digitally you can check the shot you've just taken, so if the ND grad filter is too strong or weak, or the camera hasn't exposed the

Neutral Density (ND) grad filters are essential for landscape photography. It is possible to manage without them when shooting digitally (see page 92) but you'll spend less time at your computer if you do use them. This dawn seascape is a good example of the difference an ND grad can make—the stunning colors in the sky have been retained but the foreground is also perfectly exposed and full of detail. The smaller image shows the same scene without an ND grad on the lens—there's no comparison.
Canon EOS 1DS MKIII with 17–40mm zoom and 0.9ND hard grad, 15secs at f/22, ISO100

shot correctly, you can adjust the settings and then quickly shoot again.

I always use my Canon dSLR in Aperture Priority (AV) mode and meter with the ND grad in place. A test shot is taken to check for correct grad alignment, density and exposure, any necessary adjustments are made, then I take the final shot—easy!

ND GRADS

ACCURATE ALIGNMENT

The key to success when using a grad is correct alignment, so that it does its job without leaving any tell-tale signs. Many photographers struggle with this and assume there must be some magic formula that they're unaware of, but really it's just a case of taking your time and being careful. Like most things in life, practice makes perfect.

Here's a quick step-by-step guide to how it's done:

1. Mount your camera on a tripod and compose the scene as you want to shoot it. Next, place an ND grad filter in the filter holder on your lens and, while peering through the camera's viewfinder, slowly push the grad down in the filter holder.

2. As you slide the grad down, you should see the top part of the picture appear to get darker. It won't be blatantly obvious, even if you're using a strong ND grad, so watch carefully and when you think you've got the grad in the right position, stop sliding it.

3. Take a meter reading with the grad in place. Try to avoid stopping the lens down beyond f/16 if you can, as very small apertures may make it more obvious where the line of the grad is across the picture due to the way it increases depth of field.

4. A common mistake is to push the grad too far down in the holder. This means the grad will behave like a "solid" ND filter and simply cause an exposure increase. The sky will still be overexposed and the line of the grad in the foreground may be visible.

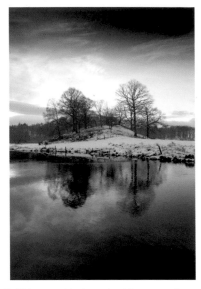

5. If the grad isn't pushed far enough down into the holder, the top part of the sky is toned down by the filter but the sky closer to the horizon is unaffected so it comes out overexposed and looks odd—especially when using a strong ND grad.

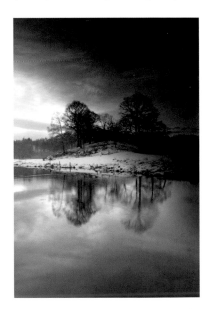

6. Make sure the filter holder is angled correctly, otherwise you'll see uneven graduation across the image. Sometimes it's necessary to angle the holder if the horizon is sloping, but generally the line of the ND grad should run horizontally.

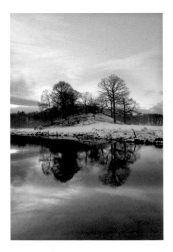

WHICH FILTER SYSTEM?

Square, slot-in grads are far more versatile than circular screw-in grads as you can't adjust the position of the latter type.

I use the Lee Filter system (www.leefilters.com) which is based on 100 x 100mm square filters and 100 x 150mm grad filters. Image quality is superb, the ND grads are neutral so they don't change the color of the sky—something that often happens with cheaper filter brands—and you can use the Lee Filter holder on lenses as wide as 16mm on a full-frame DSLR without vignetting (shading of the image corners).

Cokin (www.cokin.com) is another popular brand—the Z-Pro range is the same size as Lee Filters but not quite as expensive, while the 84mm-wide Cokin P-system offers a much more economical alternative but is only suitable for lenses as wide as 20mm on full-frame before vignetting becomes an issue. Lesser-known Hitech Filters (www.formatt.co.uk) also produce 100mm- and 85mm-wide filter kits.

Lee and Hitech specify their ND grads in terms of f/stop density—0.3, 0.6, 0.9—and Hard or Soft. Cokin, on the other hand, use filter factors to express density—ND2 is the same as 0.3, ND4 is 0.6 and ND8 is 0.9. All three densities in the Cokin range have a relatively soft graduation while the Neutral Density Grad Full ND8 is the equivalent of a 0.9 ND hard grad.

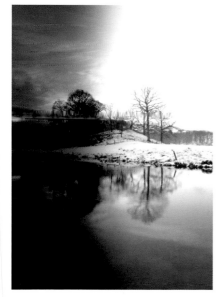

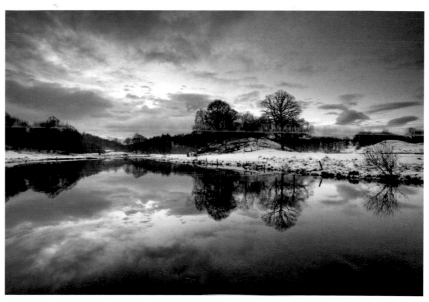

7. An easy mistake to make is to take a series of the shots with the camera in landscape format, then decide to turn the camera on its side to shoot some upright pictures, but forget to turn the filter holder 90° as well. This is what happens!

And here's the final result—the ND grad was perfectly aligned and of the correct density to retain the drama and subtle colors in the sky while also allowing me to correctly expose the foreground.
Canon EOS 1DS MKIII with 16–35mm zoom and 0.6ND hard grad, 1/6sec at f/11, ISO100

top tips

- If your digital camera has Live View, this can be used to help you correctly align ND grad filters—compose the scene, activate Live View then carefully push the grad down in the filter holder while looking at the camera's preview screen.

- Always buy the best filters you can afford—there's no point investing in expensive lenses then putting cheap filters in front of them as image quality will suffer.

- Always keep your grad filters clean— use a microfiber cloth to remove dust, finger marks and raindrops, and store them in soft pouches or cases to reduce the risk of them being scratched.

ORDER FROM CHAOS

When you arrive at a location for the first time, don't expect to pinpoint the most effective viewpoint and camera angle straight away. Be prepared to spend time exploring and observing, so you get a better feel for the place and what it has to offer—that's when the great shots will start to happen.

I never ignore my first impressions—usually they're pretty good—but I consider the first shots I take as warm-ups, to get my creative "eye in," and I expect the final images be noticeably better as I fine-tune the composition to make the best of what's before me.

WHAT YOU NEED

CAMERA: An SLR (film or digital) is the most versatile choice, but compact cameras with a zoom lens are also highly capable.

LENSES: A range of lenses covering focal lengths from 17–200mm will allow you to make the most of any kind of location.

ACCESSORIES: Tripod and cable release, polarizing filter and ND grad filters.

HOW IT'S DONE

To show how this works in practice, I headed to a fishing village near my home. There I found a group of dilapidated fishermen's huts and a few old fishing boats lying in the grass and looking like they hadn't been on the sea for decades. There was certainly a lot going on and the makings of some great pictures, but trying to capture the essence of this location in a single, defining image, would be tricky.

I began, as I always do, by putting down my backpack and tripod and spending a few minutes looking around to see exactly what I had to work with. The main features were the huts and the boats, so I wandered among them, trying to find an angle where the shapes, colors and textures would work well together and allow me to create a strong but uncluttered composition.

There are no hard and fast rules here, it's simply a case of exploring different angles and viewpoints until you find one that works. Stand on your tiptoes, or use features around you to check the view

from a slightly higher position. Bend your knees to see if a lower viewpoint works. Move in close to bold foreground features and see how they can be used to add a sense of scale and lead the eye into the scene.

Lens choice can make a big difference because it allows you to alter perspective and the way features in a scene relate to each other. Wide-angle zooms are particularly handy in cramped and cluttered locations because they "stretch" perspective so things appear more widely spaced out, and it's surprising how even a slight change of camera angle can dramatically change a wide-angle composition.

The preview screen of your DSLR is also a great ally as it allows you to analyze the composition more effectively than when looking through the camera's viewfinder. So use it, and don't be afraid to shoot a whole series of images as you explore the locations. Eventually, an image will appear on the screen that does the trick, and your effort will have paid off.

1. While you're getting a feel for the location and searching for interesting viewpoints, leave the tripod to one side and use the camera handheld so you can move around more freely. I sometimes use my DSLR like a visual notebook, to record quick impressions as I wander around that I can look at before taking the final tripod-mounted shots.

2. Initially I decided to use this blue and white boat as foreground interest and

place the two huts in the background. I liked the way the planks inside the boat created lead-in lines that carried the eye through the scene. I can't see the sea from this angle though, and there aren't enough layers in the composition, or variations in color.

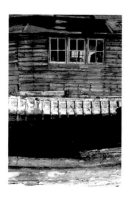

3. As I looked around I was aware of lots of lines in the scene— horizontal lines created by the planks in the shed, vertical lines in the hull of the boat, so I tried to make a feature of these by excluding the sky and filling the frame. The three windows in the hut break-up the composition and balance the shadow in the boat. Still not there yet.

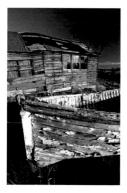

4. Shooting at an angle brought the scene to life, not only by making the shapes and lines more dynamic— diagonal lines are more powerful than horizontal or vertical lines—but also changing the camera angle in relation to the sun so my polarizing filter was more effective. This deepened the blue sky and emphasized texture on the boat.

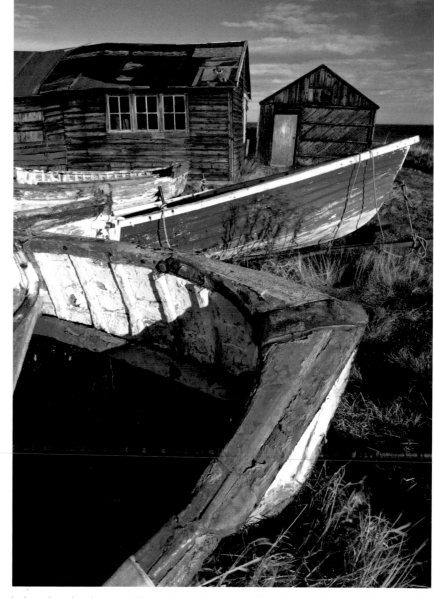

In the end, my favorite composition was the most complicated, but it proved to be the most successful in terms of visual impact and capturing the character of the location. I like the way the eye hops from one boat to the next until it reaches the two old sheds. The splashes of red also give the composition a lift while the nearest boat adds a strong sense of scale. Order from chaos!
Canon EOS 1DS MKIII with 16–35mm zoom and polarizing filter, 1/6sec at f/22, ISO100

top tips

■ Once the serious shooting begins, mount your camera on a tripod. Not only will it be easier to fine-tune a composition, but you can stop your lens down to a small aperture to maximize depth of field and it doesn't matter if the corresponding shutter speed is slow because you don't have to worry about camera shake.

■ Control over depth of field is vital for shots like this, where the nearest point in the composition is often less than 1m away, so always switch your lens from AF to manual focus. That way, you decide where the lens focuses, not the camera, and depth of field can be maximized.

PAINTING WITH LIGHT

I first tried this technique a decade ago while I was writing a book on night and low-light photography. (You should buy it—it's really rather good!)

The idea is that you use a small pen-type flashlight to selectively illuminate your subject in a blacked-out room while the camera's shutter is locked open on bulb (B), so you can build up light levels gradually and also put the light just where you want it to create surreal effects. There used to be an expensive studio lighting system available known as the Hosemaster that was popular with pro photographers, but you can create similar effects for a fraction of the price with a simple flashlight.

WHAT YOU NEED

CAMERA: Any type of film or digital camera with a bulb (B) setting.

LENSES: Around 50mm will be fine.

ACCESSORIES: Props, black-out material for windows if needed, tripod, remote release, small keyring or pen-type flashlight.

HOW IT'S DONE

When I first tried painting with light I was still shooting with film cameras—so the whole process was rather hit and miss. In order to see if the technique had worked the film had to be processed, which meant waiting until at least the next day, and if the shots weren't quite right you had to repeat the whole process. But thanks to digital technology this is a thing of the past because you can see the effect immediately and tweak it until you get a perfect final image.

Although I chose a bunch of flowers as my subject, you could use anything with an interesting shape. Have a look around and see what you can find.

FLASHLIGHT

As the subject matter is small scale, you only need a small flashlight to create images like this. I used a keyring flashlight from a local hardware store. It proved ideal, benefiting from an adjustable beam so I could focus it down to a narrow, bright spot. If you already have a small flashlight but the beam is too wide, all you need to do is cut a piece of cardstock to the shape and size of the lens, punch a hole around 5mm diameter in the middle, then tape the cardstock over the flashlight so the light shines through the small hole.

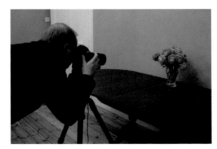

1. With the room lights on, get your props set up and your camera mounted on a tripod. Set focus to manual—otherwise the AF system will probably hunt around in the dark—focus on the props and compose the shot as you want it, leaving some space around the objects.

2. Stop the lens down to f/11 or f/16, set the camera's ISO to 100 or 200 and the shutter to bulb (B), which can usually be found by scrolling through the shutter speed range with the camera set to manual mode, or among the exposure mode settings. Attach a remote release to the camera.

3. Turn the room lights off, make your way to the camera then lock the shutter open using the remote release and start illuminating your props bit by bit with the flashlight. Here I shone the flashlight on individual flowers for 4 seconds at a range of approx. 20cm away. Already you can see how effective the lighting is.

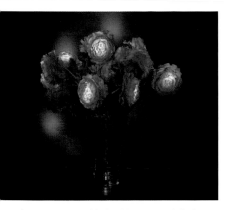

4. Having established how much light I needed to give each flower, I then used the flashlight to add pools of light to the background wall and also to throw some light on the table top—enough to reveal detail but still keep the image low key. It's all rather hit and miss, but with each attempt you learn something useful.

top tips

■ Make a quick sketch of the composition then add notes about what you did and for how long to get certain areas just right. You then take this information and apply it to the final image.

■ If you want to make the effect even more unusual, place a piece of colored plastic over the flashlight to color the light. You could even use a different color for different parts of the shot.

■ Experiment! That's what this technique is all about—the creative options are endless.

It took half a dozen attempts to get an image I was completely happy with, but being able to see the result straight away definitely made it easier compared to when I first tried this technique with film. The shot, left, shows how the flowers looked when photographed under standard room lighting. Canon EOS 1DS MKIII with 24–70mm zoom, tripod and cable release, 144secs at f/11, ISO100

PANNING THE CAMERA

When photographing moving subjects, the normal approach is to set your camera to a high (fast) shutter speed so any traces of movement are frozen. However, while this can produce dramatic pictures in most situations, it can sometimes give the impression that your subject was never moving in the first place and fail to capture the sense of drama and excitement you felt at the time the picture was taken.

A good way of avoiding this is by using a technique known as *panning*, which involves setting a slower shutter speed and tracking the subject with your camera while taking the picture. The idea of panning is to render your subject more or less sharp—though, as you will see, this isn't absolutely necessary—while reducing the background to a blur so a sense of movement is captured.

WHAT YOU NEED

CAMERA: Most sports and action photographers use SLRs as they're quick to operate and easy to handle. A digital SLR is ideal for panning as you can continually assess your images and adapt your technique to get better results.

LENSES: The focal length you choose will depend on how close you are to your subject. Most sporting events take place some distance away, making long telephotos from 300mm up necessary. That said, sports such as cycling, motocross, rallying and athletics tend to be more accessible, so you can take successful pictures with shorter focal lengths— anything from a 28mm wide-angle to a 200mm telephoto. Panning is also a good technique to use on everyday action subjects such as joggers in the park, your children riding their bicycles, even people walking down the street.

HOW IT'S DONE

Subjects that follow a predetermined route are ideal for panning, as you can predict exactly where they will be at a given time and prepare for it.

In terms of viewpoint, a position where you can photograph your subject when it's directly opposite is ideal, though you can also create interesting results by shooting on corners so your subject is at an angle. If you do this, then obviously there will be a higher degree of blur in the pictures.

To show the panning effect clearly, choose a background containing details that will look effective when blurred, such as foliage or the advertising billboards used around race tracks. Plain, neutral backgrounds don't work as well.

An important aspect of panning is setting a shutter speed that is slow enough to produce sufficient blur in the background, but not so slow that everything blurs beyond recognition. Once your panning skills improve, you can experiment with slower shutter speeds, but in the beginning use the following as a guide:

Motorsport racing:	1/250 or 1/500sec
Horse-racing, cycling, sprinting:	1/125sec
Joggers, kids on bicycles:	1/60sec
People walking briskly:	1/30sec

Now here's a simple step-by-step guide to panning with any subject.

1. Set the exposure on your camera, paying close attention to the shutter speed you'll be using, then choose a point where your subject will pass and focus on it.

2. As your subject approaches, track it toward the predetermined point with your camera, making sure you move the camera at the same pace as your subject.

3. Just before your subject reaches the point you've focused on, gently squeeze the camera's shutter release button while swinging the camera to keep your subject in the viewfinder.

4. Continue panning the camera as your subject passes, making sure you move in a steady, even motion so the pan is smooth. Don't jerk the camera. When you hear the camera's shutter close to end the exposure, continue panning to ensure a smooth result.

This sounds very easy, but in reality it's quite tricky and you will probably need a lot of practice before you get it just right. The key to success is in the smoothness of your pan, so adopt a stable stance with your elbows tucked into your side, and swing your whole upper body from the hips rather than just moving the camera.

Don't worry if your first attempts at panning are a little blurred and jerky—as you can see from the pictures here, you can produce powerful images even when your subject is blurred as well as the background.

The panned shots on these pages were both taken from the side of a busy boulevard in the Cuban capital of Havana. I simply found a spot where I could shoot against an uncluttered background then waited for any interesting vehicles to trundle by and photographed them. Though I normally focus manually, on this occasion my camera was set to Continuous AF and I picked up my subject in the viewfinder a second or two before it reached the desired point so the lens could lock focus on it. I then tracked it and shot a rapid series of three or four frames as it passed by. One of the sequences usually looked OK. I'm no panning expert, as you can see, but the results are pretty good, and a little blur can go a long way!
Canon EOS 1DS MKIII with 24–70mm zoom, 1/10–1/20sec at f/11, ISO100

top tips

■ Once you've mastered the basics of panning, try experimenting with slower shutter speeds of 1/4sec, even 1/2sec, so you intentionally introduce more blur into your pictures. This can create dramatic, impressionistic results from even the most everyday moving subjects.

■ You need to have very quick reactions to capture fast-moving subjects such as racing cars, so practice on cars going down the street until you know exactly when to trip the shutter to take a perfectly timed shot.

■ Autofocusing can help to ensure your subject is sharply focused, but most sports and action photographers prefer to focus manually on a predetermined point.

■ Add extra drama to your panning shots by using electronic flash to create "slow-sync" images.

■ You can create a similar effect to panning by moving alongside a moving subject at the same speed and photographing while you're in motion. This technique, commonly referred to as tracking, works particularly well when photographing cars and motorcycles through the open window of another car.

PERSPECTIVE AND SCALE

By its very nature, a photographic image can only record two dimensions—width and height. However, the things we photograph are almost always three-dimensional, so it's important to try to create a sense of that all-important third dimension—depth—in your work.

To a certain extent, the human eye and brain does this automatically, based on our knowledge of distance and the effect it has on the size of an object. If you look at a picture you can usually tell which parts of the scene were close to the camera and which were farther away, due to their size in relation to each other. This "spatial relationship" is more commonly known as *perspective* and, when exploited creatively in a photograph, it can give a strong sense of depth and scale.

WHAT YOU NEED

CAMERA: An SLR or compact.

LENSES: When it comes to exploiting perspective and scale, lenses are the most powerful weapons in your photographic armory. Wide-angle lenses appear to "stretch" perspective so nearby objects loom large in the frame while everything else disappears into the distance. This can produce dramatic results, especially when showing diminishing scale or exploiting foreground interest. Telephoto lenses do the opposite—they "compress" perspective so the elements in a scene appear much closer together. Use this to emphasize aerial perspective, or to create a dramatic sense of scale by juxtaposing small and large elements in the image.

HOW IT'S DONE

There are various forms of perspective to exploit as a photographer, and all are capable of producing effective results.

DIMINISHING SCALE

If you stand outside your house and look up at it, the building will appear very large and imposing. Move 100m away, however, and it suddenly seems much smaller. This isn't because the size of the

Both diminishing scale and linear perspective are shown in this photograph—the former by the rows of cypress trees that get smaller and smaller as the distance between them and the camera increases, and the latter by the way in which the sides of the track converge in the distance. There's even a hint of size recognition due to the inclusion of the farmhouse at the end of the track—it appears small, but as we know that buildings are generally larger than most trees, its small size must mean that it's far away and so depth is implied.
Canon EOS 1DS MKIII with 17–40mm zoom and polarizing filter, 1/25sec at f/11, ISO100

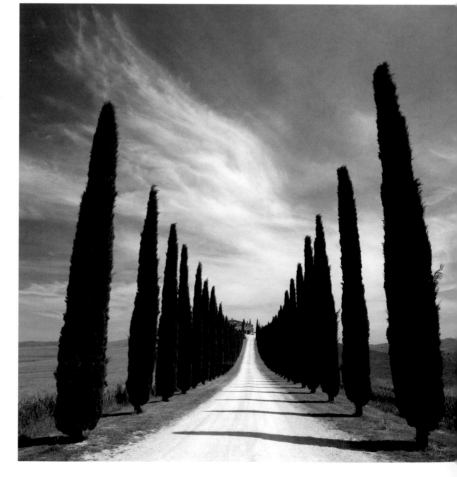

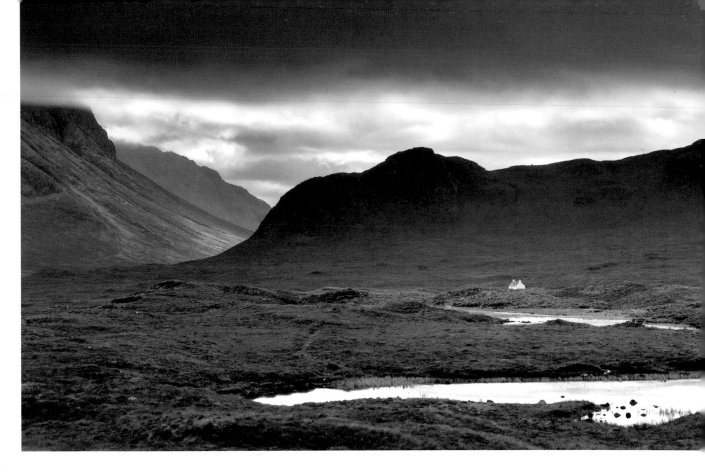

house has changed, but because you are farther away from it. This principle is the basis of diminishing perspective and it can be used in various ways.

If you photograph an avenue of trees, for example, each tree will appear slightly shorter than the last, even though they are all roughly the same size. Depth is therefore implied because we know that if the trees are getting smaller it's because they're stretching off into the distance.

The same effect can be achieved with a row of lamp posts, a long straight wall or any repeated features of a similar size. If you photograph a pebble beach, the pebbles closest to the camera will seem much bigger than those farther away, even though they're all roughly the same size. The same effect would be achieved by photographed rows of gravestones in a churchyard.

To emphasize the diminishing effect,

Including an object or feature that's familiar in your photographs is an easy way to create a sense of scale. In this scene, the lone white cottage does that job well because it appears tiny compared to the mountains and that tells us that the mountains must therefore be enormous. Try covering the cottage with your thumb and see how the impact of the photograph is reduced.
Canon EOS 1DS MKIII with 70–200mm zoom and 0.6ND hard grad, 1/4sec at f/16, ISO100

move up close and use a wide-angle lens. Doing this causes the repeated features to get much smaller, much more quickly. With an avenue of trees, for instance, the first tree will seem enormous and the last one tiny, while the gap between the trees seems to close up very quickly as the avenue stretches off into the distance—to the point that the last trees will appear to be touching.

If you photograph the same type of scene with a telephoto lens the effect is completely different. For a start, you will need to shoot from much farther away and, because telephoto lenses compress perspective, the trees will appear much closer together than they really are, while

the shrinking size is far less pronounced—the last tree in the avenue may not look much smaller than the first.

LINEAR PERSPECTIVE

This type of perspective is clearly shown by the convergence of parallel lines formed by a straight road, railway tracks or the furrows in a plowed field. Although the lines are roughly the same distance apart, they seem to get much closer together with distance, thus suggesting depth.

To maximize the effect, stand between the parallel lines—taking care if they happen to be formed by a road!—and photograph the scene with a wide-

PERSPECTIVE AND SCALE

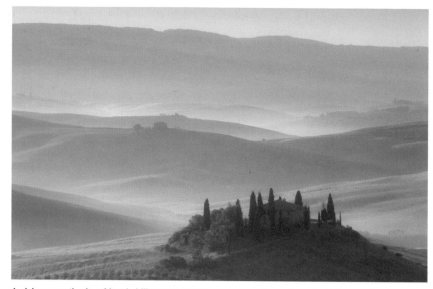

Aerial perspective is evident in hilly or mountainous scenery, where atmospheric haze and early morning mist reduce the distant hills to a series of simple overlapping shapes, while color density is reduced with distance. This effect is best shown by using a telephoto lens to isolate part of the scene.
Canon EOS 1DS MKIII with 70–200mm zoom and 0.6ND hard grad, 1/20sec at f/16, ISO100

angle lens, so the lines converge very quickly and meet on the horizon at the "vanishing" point (see page 69).

SIZE RECOGNITION

Another way to imply scale, depth and distance in a picture is by including subjects that are instantly recognizable.

People are an obvious choice. We know that adults are all more or less the same size, give or take a few inches, so including them in a picture not only gives us an idea of distance—if they're small they must be far away—but also provides an instant size comparison with other features in the scene to suggest scale. Animals and, to a lesser extent, buildings are also useful for this.

For example, if you photograph a landscape scene and in the distance two tiny people can be seen walking up a hill, we can not only deduce that they're far away due to their small size, but also

that the scene in enormous because it dwarfs the figures. Similarly, if you include a lone cottage at the foot of towering cliffs, the viewer can immediately see that those cliffs must be huge because the cottage looks tiny next to them. Without the inclusion of the cottage, it would be difficult to appreciate the size and scale of the cliffs.

Recognizable features can also be used to imply depth in a picture due to diminishing scale. If you include a person in the foreground of a landscape picture, for instance, that person will seem very big compared to the rest of the scene, suggesting that the scene beyond must be much farther way from the camera than the person is.

The same effect can be obtained by using all types of features to provide foreground interest—boats moored by the side of a lake, a gate or fence, rocks, flowers and so on. Wide-angle lenses

are ideal for emphasizing this as they allow you to include nearby features in the picture. They also appear to stretch perspective so size diminishes quickly with distance.

AERIAL PERSPECTIVE

If you stand on a hilltop in perfectly clear weather, it's possible to see for miles around, and features in the distance seem much closer than they really are due to the clarity of the atmosphere. More often than not, however, distant features and fine detail are obscured by atmospheric haze, and bold features in the scene look like flat cardboard cutouts.

This phenomenon, known as *aerial perspective*, is based on the fact that color and tone diminish with distance due to haze, mist and fog. If you photograph a range of hills on a hazy morning, for example, the hills closest to the camera will appear darker in color or tone than those farther away. The same applies with woodland in misty or foggy weather.

To emphasize the effect, use a telephoto lens to fill the frame with more distant parts of the scene, so distant features are crowded together and perspective compressed. Haze tends to be more common in mountainous areas, while morning is the best time of day to photograph it.

Color can also be used to make the effects of aerial perspective more obvious. Warm colors, such as red and yellow, are said to "advance" while cooler colors, such as green and blue, "recede." Cooler colors therefore make ideal backgrounds to warmer colors and

Size recognition is the key to this photograph's success. There are three key elements in the scene—the foreground rock, the cottage and the distant mountain. In real life the rock is the smallest, followed by the cottage, and the mountain the biggest, but here that reality has been reversed quite convincingly. The foreground rock appears bigger than the cottage, which in turn appears bigger that the mountain. There's only one explanation for that—the rock is close to the camera, the cottage farther away and the mountain farther still.
Canon EOS 1DS MKIII with 24–70mm zoom and polarizing filter, 1/15sec at f/16, ISO100

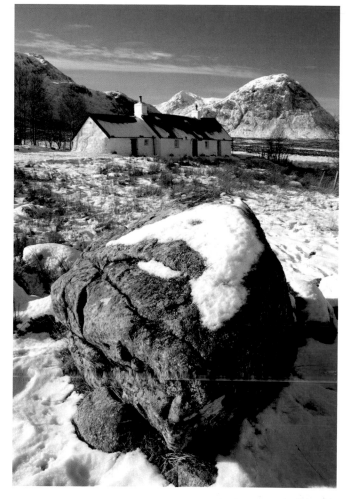

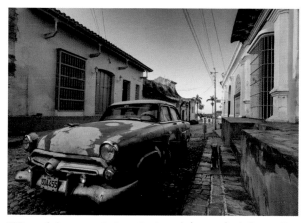

Wide angle lenses create dramatic, dynamic images due to the way they exaggerate perspective so that everything appears to be stretched out. The car in this composition appears bigger at the front than it does at the back. Our brain registers that, as we look into the scene, we're seeing distance. Lines created by the roofs of the buildings, the cobbled street and the pavements also seem to converge into the distance and this further implies depth.
Canon EOS 1DS MKIII with 17–40mm zoom and polarizing filter, 1/15sec at f/16, ISO100

by composing pictures in this way, a feeling of depth will be implied.

OVERLAPPING FORMS

Allied to aerial perspective, but also seen in other situations, is the idea of overlapping shapes or forms. If you gaze across a mountainscape, for example, some part of each mountain will be obscured by the mountain in front of it. This can only be possible if one mountain is closer to the camera than the next, so distance and depth is implied. The same type of effect can be seen in urban areas, where one building obscures part of

another, or in the countryside where a wall close to the camera obscures part of the scene beyond.

There is nothing magical about this—

it's such a simple concept that we take it for granted. However, when used consciously in your work it can make all the difference.

top tips

■ Creating a sense of depth, scale and distance is vitally important—especially in scenic photography—so think carefully about how you can achieve it when composing a picture.

■ If you look around, it's possible to find something to suggest scale or depth in most scenes. Sometimes you may be able to include more than one object.

■ The quality of light can make a big difference to a picture. Strong side-lighting reveals texture and modelling and the inclusion of shadows in a picture suggests depth, whereas pictures taken with the sun behind you tend to look rather flat because shadows fall away from the camera and out of sight.

PHYSIOGRAMS

Photography is all about light, right? But who said that the light source must always illuminate the subject? What would happen if the light source became the subject?

That's the basis of this fun and easy technique—creating eye-catching abstract images using light itself to trace colorful patterns and trails against a background of darkness. I call them *physiograms*, but no such word seems to exist in the English language so maybe you can invent one! Either way, you'll be amazed by the random results possible, and once you start, you just won't want to stop.

WHAT YOU NEED

CAMERA: Any type will be suitable, but it must have a bulb (B) setting so you can lock the shutter open for as long as you like.

LENSES: A moderate wide-angle such as 28mm or 24mm or a wide-angle

zoom. I used a 17–40mm zoom for these images.

ACCESSORIES: Tripod and remote release, colored filters or gels, small penlight flashlight, length of string.

HOW IT'S DONE

The idea behind this technique is that, in a darkened room, you suspend a small flashlight on a piece of string directly over your camera, set it spinning, and use a long exposure to record the patterns traced in the darkness by the bulb.

1. Start by tying a small pen-style flashlight to a length of string then attach the other end to a light fitting on the ceiling so you can suspend the flashlight above ground. The length of the string isn't crucial, but the longer it is, the longer the flashlight will rotate when you set it spinning. Try a length about 1m long and see how you do.

2. To get smooth, even spheres as your flashlight spins, ideally it needs to be suspended along its central axis so it's balanced. If the flashlight doesn't have a central fitting point, create one by taping a loop of string to the rear end then attach the length of string to the loop.

3. Mount your camera on a tripod

approx. 1m beneath the flashlight and tilt it back so the lens is looking straight up. Use a wide-angle focal length around 28mm, set the focus to manual and focus on the front of the flashlight, which will be suspended directly over the lens. Set the camera's shutter speed to bulb (B) and stop the lens down to f/11 or f/16. Attach a remote release so you can lock the shutter open.

4. Turn the flashlight on, the room lights off, then pull back the flashlight about 50cm from its static position over the lens and set it swinging in a circular motion. Now peer through the camera's viewfinder and when the swing of the flashlight is small enough to appear in the viewfinder, lock the shutter open on bulb.

5. Each swing of the flashlight will record as a spherical light trail, but because the motion of the flashlight is gradually slowing down, each sphere will be a slightly different shape and

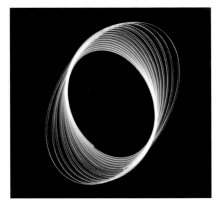

size and if you leave the shutter open for 20–30 seconds you'll record an eye-catching pattern of light.

6. After 20 seconds or so, place a piece of cardstock on the lens to halt the exposure. Grab the flashlight and turn it off, place a colored filter on the lens, cover it with the card again, switch the flashlight back on, set it swinging in a different motion and remove the card from the lens so a second pattern records with a different color. Repeat this step two or three times with different colored filters or gels to build up a complex and multi-colored physiogram.

This is the kind of image you end up with——an intricate pattern of colorful light trails created by the spinning motion of the flashlight. I made it in five stages——first with no filter on the lens, then a green filter, then a red filter, then two final stages with no filters. The flashlight was set spinning in a different way for each stage then the image was cropped to create a tighter composition.

Canon EOS 1DS MKIII and 24–70mm f/2.8 zoom, 152 seconds (total) at f/11, ISO100

top tips

■ If you use a digital camera you can check the images instantly and make any changes to technique, if required, in order to achieve perfect results.

■ Make the colors in the physiograms more vivid by boosting color saturation in Photoshop.

■ Try combining two or more physiogram images in Photoshop to create more complex patterns.

■ Experiment with the Hue slider in Photoshop: Image>Adjustment>Hue/Saturation, and watch how the colors change like a kaleidoscope.

PINHOLE

I have been a big fan of pinhole photography for many years now, and for much of that time have used traditional pinhole cameras loaded with film or photographic paper to create fine art images in both black and white and color.

More recently, however, I've discovered the delights of digital pinhole and instead of using a mahogany and brass camera loaded with 120 negative film, I fit a pinhole body cap (see panel below) to my digital SLR instead of a lens and shoot high resolution, 21 megapixel pinhole images!

The main benefit of digital pinhole compared to using a traditional pinhole camera is that you get instant feedback. With conventional pinhole photography, you can't actually see what you're doing, so composition is really down to guesswork. But with digital pinhole you can use the first shot as a test shot to check composition and exposure, make any necessary adjustments and re-shoot immediately, so you know you've got the shot. Better still, if your digital SLR has Live View, you can use it to see through the pinhole and get a pretty good idea of how the image will look before you've taken it.

It's the ultimate combination of old and new technology, but as you can see from the images here, it's one well worth trying.

WHAT YOU NEED

CAMERA: A digital SLR or rangefinder that accepts interchangeable lenses. Medium-format cameras fitted with a digital back are also suitable.

ACCESSORIES: A pinhole body cap, which can either be purpose-made (see panel below) or have a go at making your own (see panel on pages 110–111). You'll also need a tripod and remote release for stability.

HOW IT'S DONE

As with conventional pinhole photography, digital pinhole requires the use of long exposures to record an image on the camera's sensor as the pinhole itself acts as both lens and aperture. In bright sunlight at ISO100 I find that exposures are usually in the region of 2–3 seconds, while indoors they can be several minutes. Either way, a tripod is essential.

When it comes to determining correct exposure, I simply set my camera to Aperture Priority mode, activate Live View and rely on the camera's integral metering system, which delivers pretty accurate results most of the time. If this method doesn't work for you, set the camera to B (bulb), open the shutter for a couple of seconds using a remote release and see how the image looks. If it's too

dark, give more exposure, if it's too light, give less.

I tend to "expose to the right," which basically means giving the image as much exposure as possible (to record maximum shadow details) without overexposing (blowing) the highlights. To

do this you need to check the histogram for the image and increase the exposure in 1/3 stop increments so the histogram shifts more to the right—but doesn't actually touch the right side of the window, which indicates that you've "clipped" the highlights. The raw files

PURPOSE-MADE PINHOLES

If you don't want to make your own pinhole, there's probably someone out there who will do it for you. In the UK, Pinhole Solutions offer such a service. All you have to do is send them a body cap for your camera and, for a modest sum, they will drill a hole in it, fit an etched pinhole and mail it back for you ready for use. I've got one myself and it works great. In the US, Pinhole Resource sells pre-made pinhole body caps (www.pinholeresource.com).

For the best results, stick with simple, bold subjects when shooting digital pinhole images. The characteristic softness of the image means that fine detail will be lost so, if the subject matter relies on it, your images may not work so well. This stone statue of a lion was ideal and the plain background created by a nearby wall helped to ensure it stood out.
Canon EOS 1DS MKIII with home-made pinhole bodycap,
8secs, ISO100

Because exposure times are long when making pinhole images, your subject must be completely static otherwise movement will record. Pinhole images are already soft, so subject movement may take things a little too far.
Canon EOS 1DS MKIII with home-made pinhole bodycap, 30secs, ISO100

PINHOLE

look rather wishy-washy when you first open them, but you can then pull back the exposure using controls in whichever RAW converter you use—in my case, Adobe Camera Raw in Photoshop CS3.

The only downside of digital pinhole photography is that the angle of view you get is nowhere near as wide as with conventional pinhole cameras, and if your digital SLR is not full-frame then it will see even less through the pinhole. However, once you're aware of that you just choose subjects that suit it—landscapes, architecture, statues and so on. If your subject is willing and able to stay very still, you could even shoot pinhole portraits or nudes, as exposure times are briefer than using a pinhole film camera and you have the option to increase the camera's ISO to 400 or more to reduce exposure times.

Many digital SLRs have a black-and-white capture mode, but I prefer to shoot my images in full color then convert them to black and white later. There are many ways to do this but for the images shown here I used Nik Software Silver Efex Pro (see page 86), which is fantastic black-and-white conversion software that allows you to recreate the characteristics of specific black-and-white films, tone the images and so on.

Having spent hundreds, even thousands of dollars on a digital SLR, you may be thinking that the idea of taking slightly soft pinhole pictures with it is crazy—and you'd probably be right! But there's nothing wrong with going creatively crazy once in a while and, as you can see from the images here, digital pinhole can produce wonderful results if you give it half a chance.

top tips

- If you make your own pinhole, take care—the smaller the pinhole is, the sharper the image will be.

- Don't use a pinhole bodycap as your main bodycap—dust may find a way through the pinhole and on to the camera's sensor.

- Experiment! Being able to see the results seconds after taking them is a huge advantage that pinhole photographers never had before (unless they used Polaroid film, which is hard to find these days).

- If you enjoy digital pinhole photography, why not buy a proper pinhole film camera and try the real thing? Go to www.zeroimage.com to check out some fantastic pinhole cameras.

MAKE YOUR OWN PINHOLE BODY CAP

1. Cut out a 1 x 1cm piece of aluminum from a beverage can and flatten it out.

2. Take a ballpoint pen and make a small dent in the middle of the piece of aluminum.

3. With wet-and-dry sandpaper, gently rub down the protrusion on the back of the aluminum caused by the dent until there's just a very thin layer of metal left. Don't rub it all the way through.

Because the angle-of-view of a pinhole body cap is far less than a traditional pinhole camera it's ideal for subjects like still life. An added bonus is that depth of field is extensive so you can focus very close, while being able to check each image seconds after recording it means that composition can be adjusted so you get it just right.
Canon EOS 1DS MKIII with home-made pinhole bodycap, 51secs, ISO100

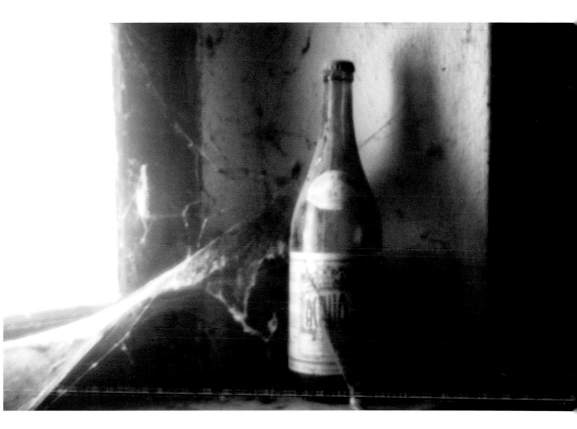

4. Place the aluminum on a flat, hard surface and carefully push the point of a needle through the thin part of the metal, making sure the point of the needle only just passes through.

5. Turn the aluminum over, place the needle point through the back of the hole and twist it gently to get rid of any imperfections in the tiny hole. The smaller the pinhole, the sharper the image, so don't be too heavy-handed.

6. Take a plastic body cap and drill a hole in the center of it measuring 5-6mm across.

7. Tape the pinhole inside the body cap using gaffer tape or insulation tape so it's light-tight. Attach the body cap to your camera body and start shooting!

POETRY IN MOTION

It's funny how some photographic techniques come about purely by accident. For example, it's said that solarization was discovered when American photographer Lee Miller (working as Man Ray's assistant at the time) turned the darkroom light on while a print was still in the developer, causing a partial reversal of the image tones and creating an effect that photographers have been exploiting ever since.

I can't claim that my latest technique will ever achieve the same level of fame or popularity, but it was discovered under similar circumstances while I was out taking pictures on the Northumberland coast.

WHAT YOU NEED

CAMERA: Ideally a digital SLR so you have full control over the exposure and you can assess each image immediately after taking it to ensure you get the effect just right.

LENSES: I tend to use either a 24–70mm or 70–200mm zoom. If the lens is too wide, distortion will be introduced when you pan the camera, causing straight lines to bow.

ACCESSORIES: If you want to produce smooth, consistent results, you need a tripod head that can be unlocked in the horizontal (pan) axis so you can quickly swing the camera from left to right or right to left, without it moving in any other plane. Traditional pan-and-tilt heads are ideal, and ball heads if there's a separate lock for horizontal adjustment of the head.

HOW IT'S DONE

At the time I was planning to shoot a sequence of images to create a stitched panorama, so I levelled the camera and scanned the scene I wanted to record. Confident that everything was ready, I tripped the shutter to expose the first frame but, without thinking, I swung the camera to the right, ready to shoot the second frame in the sequence before the exposure for the first one had ended.

Annoyed by my impatience, I waited for the image to appear on my camera's preview screen so I could erase it and start again. But when the image did appear, I did a double take. Far from being a load of old rubbish as expected, it looked fantastic—an eye-catching abstract of colored lines and streaks, more like a painting than a photograph.

Surprised by my happy accident, I decided to try and repeat the effect, only this time doing it on purpose. Second time round, because I knew what I was trying to achieve, it worked even better

and since then I've produced a whole series of these images. Not only are they easy and fun, but the results look fantastic. Here's how to achieve the effect.

First find a suitable location. I live by the sea and favor coastal views because there are defined layers of color in scenes created by the beach, then the sea, then the sky above. However, any scene containing bands of color are suitable. Fields of yellow oilseed rape against blue sky would work brilliantly. The same with lavender, sunflower, tulip or poppy fields in full bloom. Urban scenes at night are worth a try, too, as the colorful lights will record as streaks.

If you want the lines and streaks in the image to be straight—or as straight as possible—you need to make sure the camera is level and that it remains level when you pan it during the exposure. I do this first using a leveling base, which allows me to level the tripod head even if the tripod itself isn't perfectly level, then

using a bull's eye bubble on the tripod head and a hotshoe-mounted spirit level to ensure that the camera is level and square on the tripod head.

The streaking is created by moving the camera during exposure, so the shutter speed you use is important. I find anything from 1/2sec down to 2 seconds is ideal. To achieve this, I set the camera to

top tips

- It takes practise to get the effect right so keep trying!

- Experiment with different shutter speeds—the slower the speed, the more streaking you'll get.

- Shoot the same scene in different weather conditions and notice how it affects the look of the final images.

- Sunrise and sunset can produce great results as the warmth in the light looks amazing.

Aperture Priority mode and stop the lens down to f/16 or f/22. In low light, such a small aperture may not be necessary to achieve a suitable shutter speed, while in bright weather I often need a neutral density filter and a small aperture to slow the shutter speed down.

Once you're set up and ready, do a few practice runs without taking any pictures. Hold the tripod head or adjustment arm, position the camera to the left of the scene you want to shoot, then smoothly pan from left to right. When you know what you're doing, try it for real. The results may be a little jerky to begin with but you'll soon get the hang of it. As well as left-to-right pans, try right to left and also vary the speed of the pan.

Back home, download the images to your computer. I always shoot in raw so the first step is to process the raw file (I use Adobe Camera Raw in Photoshop CS3). I usually find that adjustments to Clarity and Vibrance add impact to the image, along with Tone Curve adjustments to boost contrast. Once the image is opened in Photoshop as a 16-bit TIFF file, I select the sky, make further adjustments to levels and curves, then do the same to the foreground.

The final stage, which is purely personal, is to crop the image to the square. I do this because I feel that the square format adds to the symmetry of the central horizon and makes the composition more balanced and ordered. By always keeping the horizon central, a consistent theme also runs through each image so they work well together. Why not print a set of three on canvas, mount them on stretched frames and hang them on the wall as a triptych?

This set of motion studies were all created on the same beach, just across the road from my house, and show how changes in the weather and light can transform the appearance of a scene completely. Each image works in its own right, but together they are even more effective.
Canon EOS 1DS MKIII with 24–70mm and 70–200mm zooms, tripod and remote release, 1/5–1sec at f/11–22, ISO100

POLADROIDS

Polaroid instant photos are legendary. Everyone's heard of them and if you grew up in the 1970s, as I did, you'll remember the characteristic "click-whirr" of the camera in action, then everyone crowding around the newly ejected print to watch the image magically appear before their eyes.

I still use Polaroid cameras today—vintage SX70s picked-up for pennies on eBay. They're great fun to work with and create amazing fine art images with slightly faded colors, shady corners and that wonderful cross-hatched white border.

The only problem is that genuine Polaroid film is becoming difficult to get hold of—and expensive—so it is sadly out of reach for many photographers. Fortunately, you no longer need a Polaroid camera or Polaroid film to create this look, because a free download from www.poladroid.net will re-create it for you. Here's how.

WHAT YOU NEED

SOFTWARE: The only thing you need to create fantastic Polaroid-like images is the free application available from www.poladroid.net for both Mac and PC. It's a drag-and-drop application that turns any digital image—in JPEG format—into a 400dpi print-ready file complete with unique Polaroid border and Polaroid instant image characteristics.

HOW IT'S DONE

It is possible to mimic the Polaroid look in Photoshop, but you really need to know what you're doing to produce convincing results and it takes time—I know, I've tried and failed! But when I discovered Poladroid.net I realized I no longer needed to worry and within minutes I was creating amazing instant images.

1. Download the Poladroid Polaroid Image Maker software at www.poladroid. net. There's nothing to pay, no membership or commitment required— just click the Download icon, wait a couple of minutes for the download to be complete then drag the Poladroid icon into your Applications folder.

2. Double click the Poladroid icon to launch the application. A Polaroid camera will appear on your desktop (you can move it to a convenient spot). All you need to do now is drag and drop a JPEG onto the camera and the software will go to work.

3. First you hear the "Click, whirr" of a Polaroid camera, then a small Polaroid print is ejected from it on to your computer's desktop. What's really clever is

that, in true Polaroid fashion, you have to wait as the image slowly appears before your eyes!

4. When the image is fully developed, a red crayon mark appears on the print to indicate it's ready. A JPEG icon will also appear on your computer desktop with pola.jpg at the end of its name. Double click this to see your Poladroid image.

5. You can create up to 10 Poladroid images then you have to quit the software and re-open it. This is because Polaroid film cartridges contain ten shots, so the software is mimicking how you'd use a real Polaroid camera!

top tips

- Choose images that are simple and bold and avoid those that rely on fine detail for their appeal as this won't be so obvious on the final Polaroids.

- Portraits are ideal for this treatment so why not create a set of Polaroid family photographs? They will be far more interesting than the usual digital snaps.

- To make the most of your Polaroids, print them on glossy inkje paper, block mount them on board and hang them on the wall.

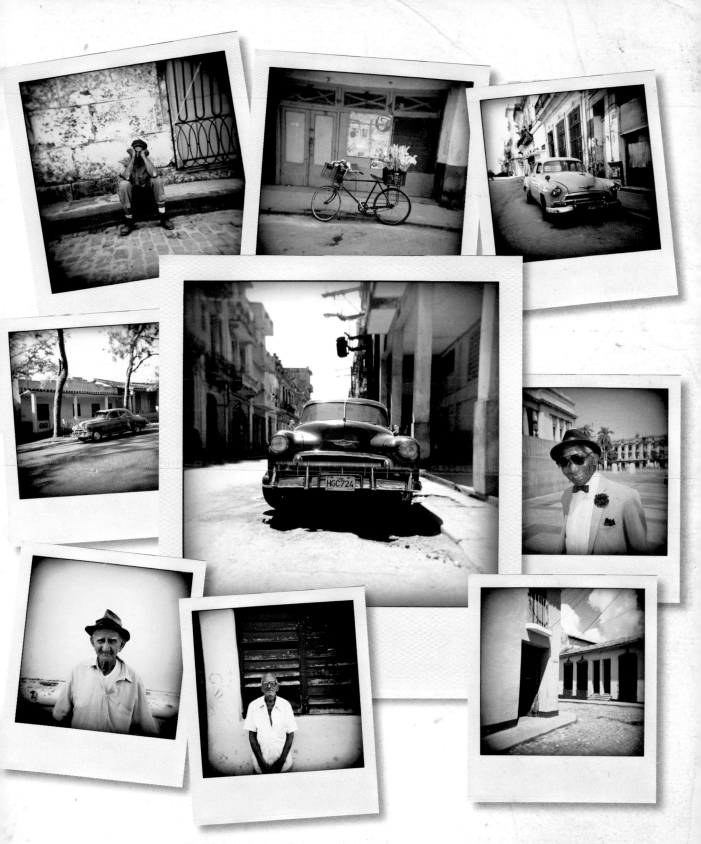

The Poladroid plug-in really does work, taking everyday images and turning them into fantastic Polaroid look-a-like images. You'll be hard-pressed to tell them from the real thing and, though re-creating the Polaroid look can never be as satisfying as going out and shooting with a Polaroid camera, it's highly likely that before long Polaroid instant film will cease to exist, so photographers will have no choice but to fall back on applications like this.

POLARIZING FILTERS

A polarizing filter is a specially made accessory that fits to the front of a lens like any other filter and helps to control the amount of polarized light being admitted. This is achieved using a "foil" sandwiched between two layers of glass or optical resin, which only allows light rays to enter that are perpendicular to it. By doing so it performs three important and useful jobs and is one of the most useful accessories in your camera bag.

■ Blue sky is made to look a much deeper color.

■ Glare on non-metallic surfaces such as foliage, plastic and paintwork is reduced so colors look much stronger and clarity is improved.

■ Reflections in water, glass and other shiny surfaces are reduced or removed altogether.

WHAT YOU NEED

CAMERA: A polarizing filter can be used with any type of camera, whether film or digital, but ideally you need one that has through-the-lens viewing (TTL)—an SLR in other words—so you can align it accurately.

LENSES: Any.

POLARIZER TYPES: There are two types of polarizing filters available—linear and circular. If you have an autofocus SLR you must use a circular polarizer, otherwise exposure error may result. A linear polarizer can be used with all other camera types.

HOW IT'S DONE

The great thing about a polarizing filter is that you can see the effect it has simply by rotating it in its mount while looking through your camera's viewfinder—when you're happy with what you see, stop rotating and fire. To get the best possible results, however, you should also bear in mind these factors:

■ Polarizers work best in bright, sunny weather when glare and reflections are more pronounced and there's more polarized light around.

■ When using a polarizer to deepen blue sky, ideally keep the sun at a right angle to the camera so you're aiming toward the area of sky where maximum polarization occurs. That way, you'll get the strongest effect.

■ Polarization is uneven across the sky, so take care when using lenses wider than 28mm, otherwise the

This pair of pictures shows the effect a polarizing filter can have on a scene. As you can see, the polarized image (bottom) exhibits richer colors, darker blue sky and less glare on the sign. All in all a huge difference.

sky in your pictures may be darker on one side than the other and the effect looks odd. This can be corrected in Photoshop, but it's tricky.

■ Glare will only be removed from non-metallic surfaces such as paintwork, foliage and plastic. To remove reflections from surfaces such as water and glass, the angle between the surface and the lens axis must be around 30°. You can find this

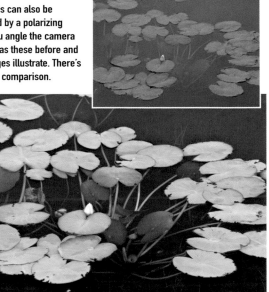

Reflections can also be eliminated by a polarizing filter if you angle the camera carefully, as these before and after images illustrate. There's simply no comparison.

by making slight adjustments to your position, then rotating the polarizer to see what happens.

■ Polarizing filters reduce the light entering your lens by 2 stops. This means if you were using an exposure of 1/125sec at f/11 without a polarizing filter in place, for example, the exposure would drop to 1/30sec at f/11 once you fitted the polarizer. If you're using an SLR with TTL metering, this light loss will be accounted for automatically to give the correct exposure. However, if you take a meter reading without the filter in place you must remember to adjust the exposure accordingly once it's fitted.

Also, watch the shutter speed when using a polarizer, as it can easily become very slow, even in bright sunlight, and increase the risk of camera shake.

■ Polarizing filters can give your pictures a slight blue color cast when used in bright, sunny weather. To remove this, either adjust your camera's white balance setting or correct the cast when you process the raw file.

Many users of digital SLRs don't bother using filters of any description as they feel the effects can be recreated later. However, you could never truly mimic what a polarizer does using Photoshop and, even if you could, it would involve yet more time sitting at a computer. Why bother, when polarizers are so quick and easy to use and do such a great job? This scene, shot in bright sunlight, is a great example of how a polarizer can transform a shot, reducing glare, enhancing the sky and increasing color saturation. I never leave home without one.
Canon EOS 1DS MKIII with 17–40mm f/4 zoom and Heliopan circular polarizer, 1/25sec at f/16, ISO100

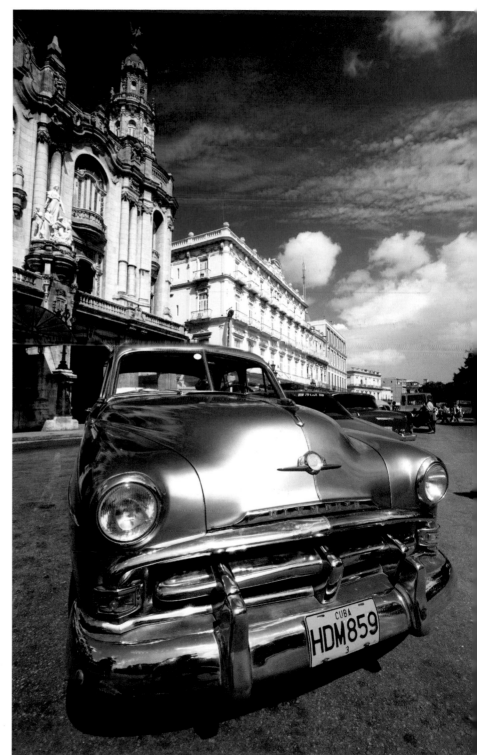

POSTER ART

Taking lots of great photographs is one thing—knowing what to do with them once they're sitting patiently on your computer's hard drive is another.

There is a danger of amassing thousands of great photographs that never see the light of day, which is a shame. I know—I've done it. But thanks to digital technology there are now more ways to show off your images than ever before, so why not make the most of them and give your work a new lease of life—as well as an appreciative audience?

One idea I've been exploring is taking sets of themed images and turning them into eye-catching posters. It's an easy technique to master, but as you can see, the end product is fantastic and would look great framed and hanging on a wall.

WHAT YOU NEED

CAMERA: Any type of digital camera—SLR, compact, even a cell phone camera. Because each image is reproduced quite small, you don't need a camera with loads of megapixels.

LENS: Again, no specific type as it depends what subject matter you choose. The images here were shot with a 24–70mm standard zoom.

HOW IT'S DONE

Obviously, you need a set of images to work with, so that's your first priority. You could choose anything really. In towns and cities that are popular with tourists you often see posters like mine on sale, based on common features such as "Doors of Dublin" or "Windows of Bath". How about taking lots of flower pictures, or details in nature? I based this poster on the color blue—why not do the same but choose a different color such as red, green or yellow? The good thing about working on a themed set of images is that it really helps you to concentrate on what you're doing and focus your eye.

1. Process the raw files, then make JPEG copies of your selected images. Using the JPEG format reduces the size of each image so that when you combine a dozen or more of them the resulting file size isn't excessive! I also reduced the image size so each image was 25cm wide at 300dpi.

2. Open the first image and increase the size of the canvas so it's big enough to add all of the other images in the set and position the first one is in the top left corner. My

montage will be three images wide by six deep so 80 x 110cm should be enough. You can always make the canvas bigger at a later stage, or crop any excess canvas.

3. Open your second image, then using the Move Tool in Photoshop, drag and drop the image on to the enlarged canvas. You can use the Move tool to position the image next to the first one and the arrow keys to then fine-tune the position of the image. I chose to leave a gap between each image.

4. Repeat step 3, dragging, dropping and positioning each image on the canvas. If you need to make changes to any of the images, open the Layers window—Windows>Layers, click on the appropriate layer and do what needs to be done. Remember to save the montage.

5. Crop any excess canvas, then go to Layer>Flatten Image to merge the layers. All you have to do now is add a border by extending the canvas again. Do this in two stages—first add an even border all around the montage, then make the bottom edge deeper so you can add text.

6. Click on the Text tool icon in Photoshop, then drag the cursor across the bottom border of the poster to create a text box. Next, add a title of your name or whatever text you like then experiment with different type sizes and typefaces until you're happy.

MOODY BLUES

Lee Frost

Here's the final result——a classy, creative poster that shows off the detail images to great effect and would look fantastic framed and hanging on a wall. The source images were all shot on a dull, gray day, so they have a common "feel," which helps to give the poster a consistent look. Now it's your turn!

REVEALING CHARACTER

Though I would never consider myself to be a portrait specialist, when I'm traveling overseas, I inevitably find myself photographing the locals as well as the buildings and scenery. The older and craggier the better in my opinion—and that's just the people! But no matter how hard I've tried over the years, whether shooting film, printing images in the darkroom or working with a digital SLR, I've never quite managed to reveal the physical character of my subjects as I saw them. The results were just too flattering!

Since switching to digital capture in the spring of 2008, however, I've been busy experimenting with new techniques, equipment and software and in doing so, may well have found a solution to my dilemma—in the form of HDR software.

HDR—High Dynamic Range—photography involves taking a series of identical shots of the same scene or subject, each at a different exposure, then merging them using special software. The final HDR image contains a much wider range of detail than a single frame, from the darkest shadows through to the brightest highlights. The results vary from slightly unreal to totally surreal, depending on how heavy-handed you want to be with the controls offered by the software, but they're always striking.

HDR is normally limited to static subjects such as architecture and landscape as you need to take a sequence of images in perfect register. People move, so it would be almost impossible to shoot a sequence of images of a person at different exposures that could be merged in perfect register. However, with a little experimentation I quickly found a way around this.

WHAT YOU NEED

CAMERA: Any type of digital camera that allow you to shoot in raw capture format.

LENS: A suitable lens for portraiture—focal lengths from 50–100mm are ideal.

ACCESSORIES: HDR software—I use Photomatix Pro 3.0 (www.hdrsoft.com).

PHOTOMATIX PRO 3.0

Although there is an HDR feature in recent versions of Photoshop (CS3, CS4), the consensus among HDR fans is that Photomatix Pro is the software to use—it's quick, easy, controllable and reasonably priced.

I purchased version 3.0 as a download direct from www.hdrsoft.com. The latest version, 3.2, is available as a stand-alone application, a plug-in for Adobe Lightroom or a plug-in for Photoshop CS2/3/4 or Apple Aperture. Prices vary accordingly.

HOW IT'S DONE

If you set your digital SLR or compact to shoot in Raw Capture mode, the amount of detail recorded in each raw file is far greater than you can ever show in a single image. Fortunately, this makes it possible to "process" a raw file more than once to create a series of images where the only difference between each one is the exposure. They can then be merged using HDR software to create a final image with much more visible detail. I tried this on some of my character portraits and it worked brilliantly, revealing every wrinkle, pimple and blemish on my subject's face. Here's how it's done.

1. Choose the raw file you want to use and open it in whichever raw file converter you use—favor Adobe Camera Raw in Photoshop CS3.

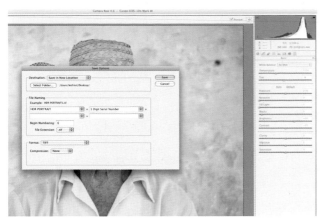

2. Make any general adjustments to the raw file you feel necessary then, with the Exposure slider set to 0.00, open the file and save your first copy of it.

3. Open the raw file again, set the Exposure slider to -2.0 (2 stops underexposed), then open the file and save it.

4. Open the raw file for a third time, set the Exposure slider to +2.0 (2 stops overexposed), then save it again.

5. Open your HDR software—I used Photomatix Pro 3.0—click on Generate HDR Image, then drag and drop your three images into the window and click OK.

6. Because you're not working from raw files, the software doesn't always recognize the exposure increments you've used so correct this and click OK.

7. Another window appears with various options for alignment of images, reducing artifacts, etc. Go with the default settings and click OK.

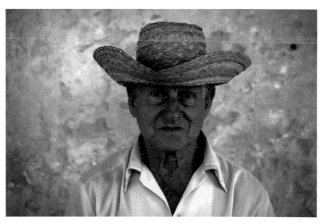

8. The software will merge the images automatically—this usually takes about 30–60 seconds—then present you with the basic HDR image.

9. The initial HDR image won't look much different than a "normal" image, but click on Tone Mapping and you can get to work on changing the look of the image.

10. First, try all the options in Smoothing and see which you prefer. Next adjust Strength, White Point, Black Point and Gamma and see what happens.

11. Once you're happy with the look of the HDR image, click on Process and the tone mapping will be applied to the image. This takes up to a minute, usually.

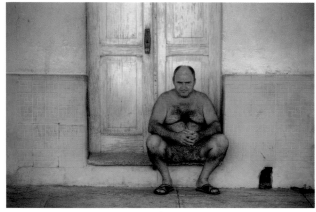

This environmental portrait (top) shows the hallmarks of HDR perfectly. Not only are the hairs on the man's body so sharp and clear you could count them—though admittedly, it would take a while—but the color, texture and detail in the wall and door has also been enhanced to give the image a slightly surreal but still believable look. The smaller image (above) is a straight interpretation of the original raw file and shows how the HDR treatment brings the portrait to life.
Canon EOS 1DS MKIII with 70–200mm f/4 L IS USM zoom, 1/320sec at f/4, ISO100

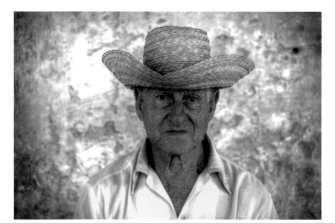

This is the end result—a colorful portrait that's full of detail and oozes character. It's far more interesting than a "straight" interpretation of the original raw file and much closer to how I remembered my Cuban subject. It also shows that HDR images don't have to be over the top and out of this world.
Canon EOS 1DS MKIII with 70–200mm f/4 L IS USM zoom, 1/250sec at f/4, ISO100

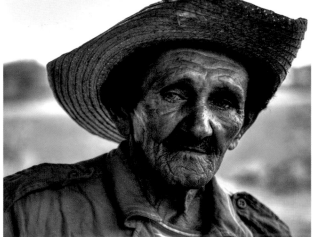

I've photographed this Cuban tobacco farmer on numerous occasions but could never bring out the amazing color and texture of his skin, or the vivid blue of his eyes. HDR software finally solved both problems and gave me the image I'd long been striving for.
Canon EOS 1DS MKIII with 24–70mm f/2.8 L zoom, 1/400sec at f/2.8, ISO100

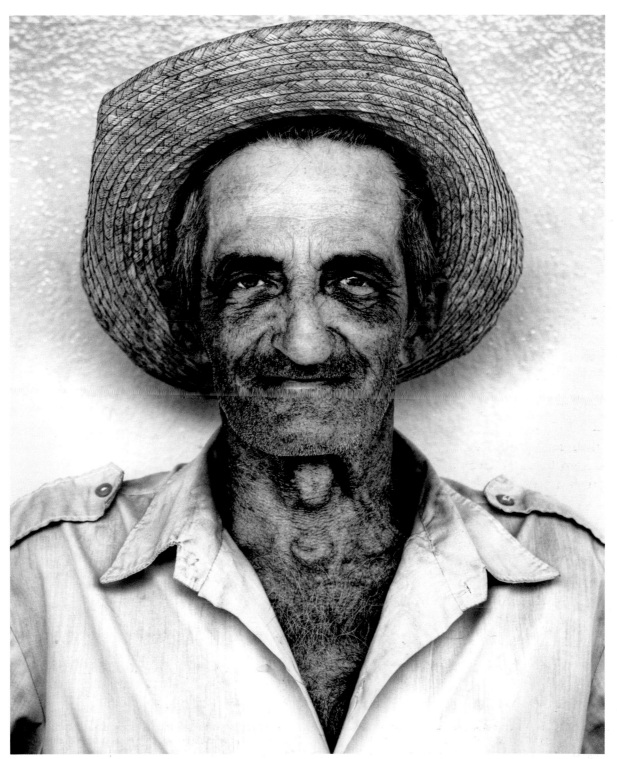

HDR Portraits also work well in black and white as the removal of color from the image simplifies it further and really focuses attention on the subject. In this case, you can see every piece of stubble on the man's chin, and the wrinkles under his eyes look so lifelike you could almost reach out and touch them. To convert the color HDR image to black and white, I used Nik Software Silver Efex Pro (see page 86 for more on this).
Canon EOS 1DS MKIII with 70–200mm f/4 L IS USM zoom, 1/125sec at f/5.6, ISO100

RULE OF THIRDS

Although photographic composition is open to endless interpretation, there are various "rules" or guides that can be adopted to help produce images that are visually balanced and pleasing to the eye. Of these, the most useful and popular is the rule of thirds. Devised by artists long before photography, the rule works on the basis that if you divide an image in a ratio of 2:1, the composition will possess order and stability.

HOW IT'S DONE

To use the rule, all you have to do is divide your camera's viewfinder into nine sections using imaginary horizontal and vertical lines. You can then use this grid to help with the positioning of important elements in a scene.

If there's an obvious focal point, such as a single tree in a field, a red flower among a group of yellow flowers, or a boat bobbing on the ocean waves, you should position it on one of the four intersection points of the grid so it's one-third in from either the top or the bottom of the frame, and one-third from one side of the frame. Any point can be used and by doing this you will automatically produce a more pleasing composition than if the focal point was positioned in any other way.

The vertical lines of the grid can also be used as a guide to dividing up the frame vertically.

If you are shooting a building through a gap between trees, for example, place the gap one-third in from the left of the picture and the building in that gap one-third from the top of the picture, so the eye travels readily through the gap to the building beyond.

Similarly, if you shoot full-length portraits, instead of placing your subjects in the middle of the picture, move them over to one side so they're one-third in from the left or right of the frame.

As another example, when the sun sets in the sky it creates a shimmering line of light on the surface of water, which

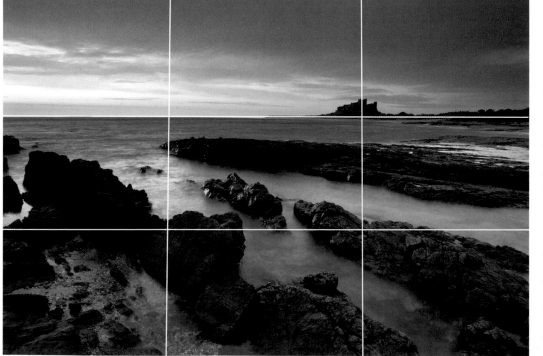

This photograph shows classic use of the rule of thirds. The horizon has been placed on the top third to give a 2:1 ratio between the foreground and sky, while the main focal point——the distant castle——has been positioned on the top right intersection of the thirds; the most effective place for it in the composition.
Canon EOS 1DS MKIII with 17–40mm zoom and 0.9ND hard grad, 4secs at f/22, ISO100

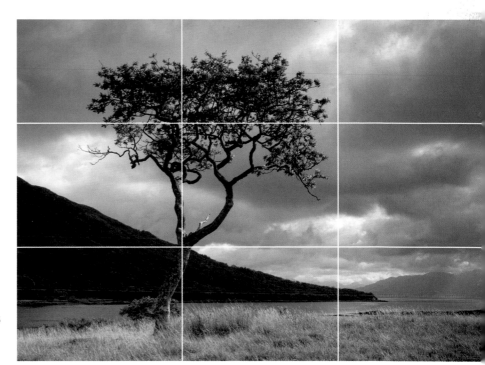

acts as a powerful frame, dividing up the scene. A natural response is to place the reflection down the middle of your camera's viewfinder, but positioning it according to the rule of thirds will be more effective.

Finally, when shooting landscapes many photographers have a habit of placing the horizon across the center of the frame. While this works well on scenes that are obviously symmetrical—when capturing the mirror image of a scene in

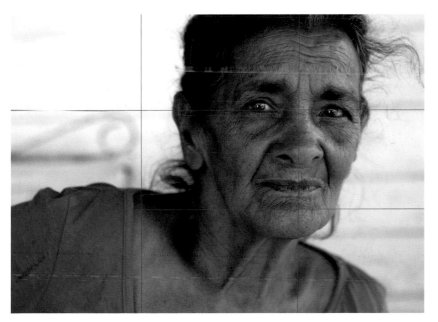

top tips

- Photographers mainly use the rule of thirds for landscape and scenic pictures, but it's just as useful for still life, portraiture, architectural photography, close-ups and literally any subject where there's a main point of interest or natural divisions in the scene.

- Although the rule of thirds is a useful aid in composition, never force a picture to comply with it—or any other "rule" for that matter. Doing so will make your work predictable and, more importantly, boring.

the surface of a calm lake, for example—it should normally be avoided, as a central horizon divides a picture into two equal halves and usually results in a rather static, unimaginative composition.

A more successful approach is to use the horizontal lines in your imaginary grid as a guide to where the horizon should be. Placing the horizon along the top line

of the grid will give a landscape-to-sky ratio of 2:1 and emphasize the foreground of a scene, while placing it on the bottom line of the grid will give a landscape-to-sky ratio of 1:2 and emphasize the sky.

You don't need to follow this slavishly, but generally, the further away from the center of the viewfinder you keep the horizon the better.

SILHOUETTES

A silhouette is basically the outline of a solid figure as cast by its shadow. This phenomenon was first documented by the 18th-century French politician Etienne de Silhouette, but popularized by the Victorians who used silhouettes as a form of portraiture—the outline of a person's profile was cut from black paper and mounted on a bright background.

Photographically, silhouettes are very simple to produce. All you have to do is position a solid object between the camera and a bright light source or background, then expose for the brighter background. Doing so means the solid object—which is in shadow on the camera side—is grossly underexposed and rendered a silhouette because it's much darker than the brighter parts of the scene.

WHAT YOU NEED

CAMERA: Any type of SLR or compact camera is capable of recording silhouettes—on film or a digital sensor.

LENSES: Any lens can be used, but tele-zooms are particularly useful for isolating distant subjects.

ACCESSORIES: When light levels are lower, after sunset, for example, a tripod will be necessary to keep your camera steady.

HOW IT'S DONE

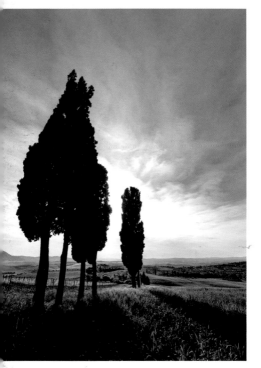

When the sun is higher in the sky you can still create silhouettes by shooting from a low viewpoint and hiding the sun behind your subject so it doesn't cause flare. I used that technique when shooting these cypress trees and had to sit on the ground to get the angle I needed.
Canon EOS 1DS MKIII with 17–40mm zoom, 1/125sec at f/11.3

All types of subject can be turned into striking silhouettes—people, boats, trees, buildings, statues, electrical towers, bridges, windmills, to name but a few.

The most important criteria is that whatever you choose as your subject it should form an easily recognizable shape when reduced to a silhouette, otherwise the appeal of the image will be lost. You should also keep the composition of your picture nice and simple, with perhaps just one or two bold objects against the background so you don't end up with a confusing muddle of overlapping forms.

The best time to shoot silhouettes outdoors is around sunrise and sunset, when the sun is very low and the sky is full of beautiful colors, which will make a perfect backdrop. All you have to do then is place a solid object between yourself and the sky, such as a building or tree, and fire away. If the sun is very bright, hide it behind your subject so the risk of flare is reduced.

Sunlight shimmering on water during the morning and evening also makes an ideal background for silhouettes of boats, piers, bridges, surfers or people standing on the shoreline. The approach is just the same—find a position where your subject is against the bright background so they're rendered a silhouette.

When it comes to getting the exposure right, most photographers find that their camera's integral metering system produces perfect results without any help. This is because the meter sets an exposure that's correct for the bright background, which is exactly what you want to create a silhouette.

The only exception to this is if the background, or part of it, is very bright. At sunset, for example, the sun is often much brighter than the surrounding sky. In situations like this there is a high risk of underexposure because the intensity of the sun can fool your camera's meter. To avoid exposure error, dial in +2/3 or +1 stop of exposure compensation.

You should also take care if the

silhouette occupies a large part of the picture area, as its dark, solid mass can again fool your camera's meter—only this time into causing overexposure. The easiest way around the problem is to take a shot, check the image on your camera's preview screen and adjust the exposure as required.

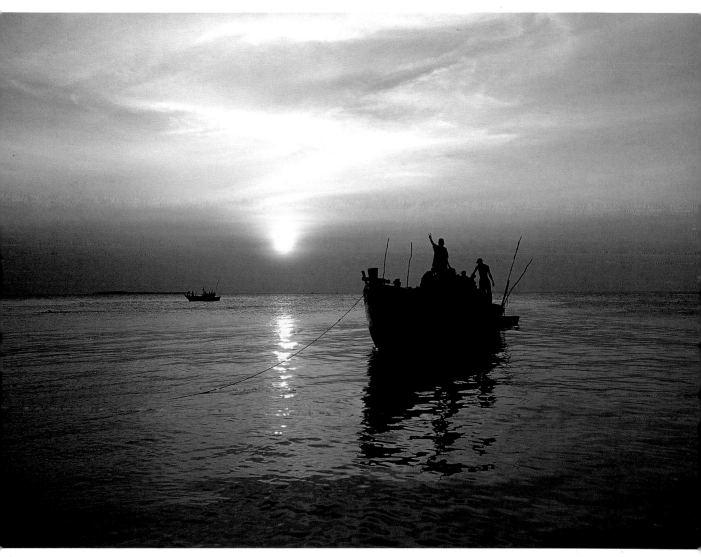

This is a classic silhouette scenario——boats drifting by against the setting sun. In a situation like this, any solid objects will record as silhouettes simply because contrast is so high. All you have to do is set your camera to aperture priority mode, compose, focus and fire away. Perfect results should be achieved every time.
Nikon F5 with 80–200mm zoom, 1/250sec at f/4, ISO100 film

SOFT FOCUS

On the face of it, adding soft focus to an image seems like a rather bad idea. After all, what's the point in spending a fortune on the sharpest lenses if you then proceed to reduce their definition with a piece of misty plastic? However, when you see the results possible it all begins to make sense.

Soft focus filters add mood, and mood is one of the most powerful tools at your disposal when it comes to encouraging a response from the viewer. A plain portrait can be miraculously transformed with the addition of a little diffusion. Hard edges disappear, the light takes on a dreamy, romantic quality and the overall effect is incredibly evocative. Soft focus is also ideal for hiding spots and blemishes and making even the roughest skin look silky smooth—a fact most people will be thankful for!

You don't have to limit your activities to people, though. Soft focus works equally well on landscapes, still-life shots, street scenes, close-ups—pretty much any subject, really.

HOW IT'S DONE

Traditionally, soft focus was added to images by shooting through a filter and you can still do this as all filter manufacturers still produce them.

The effect obtained varies enormously from brand to brand. Some are very strong, others weak, and you may find it necessary to purchase a variety so you can produce different effects.

Alternatively, you can make your own using simple materials. If you smear a tiny amount of petroleum jelly (Vaseline) on to a piece of clear plastic or an old skylight filter, for example, you can create all kinds of unusual soft focus effects—just smear different patterns into the jelly with your finger or a cotton ball to transform the effect. You need to use the jelly sparingly, however, as even a small amount can distort the image beyond recognition—which itself can produce appealing results if you're aiming for a more abstract approach.

Basically, any clear or slightly frosted material can be used as a soft focus filter, so experiment. For an even, gentle diffusion, spray a little hair spray on to an old skylight filter, or stretch a piece of black stocking material over your lens. Breathing on your lens just before you take the shot is another option worth trying—though the effect is more like mist than soft focus.

ADD IT LATER

The alternative, thanks to digital technology, is that you add the soft focus during post-production. This is far more versatile than shooting through a filter because you can:

■ Add the effect to images already taken.
■ Experiment with many different types of diffusion.

■ Control the level of diffusion
■ Change your mind if you don't like the effect.
■ Make sure there's always a copy of the original image.

There are various ways to create soft focus using Photoshop, all of them quick, uncomplicated and effective. Here's a rundown of the ones I prefer.

■ Adding soft focus during raw processing

I discovered this method almost accident while playing around with some of the controls in Adobe Camera Raw (ACR), the raw file processor in Photoshop.

When a raw file is opened in ACR, you're presented with the Basic menu of tools and controls to adjust color temperature, exposure, saturation and so on.

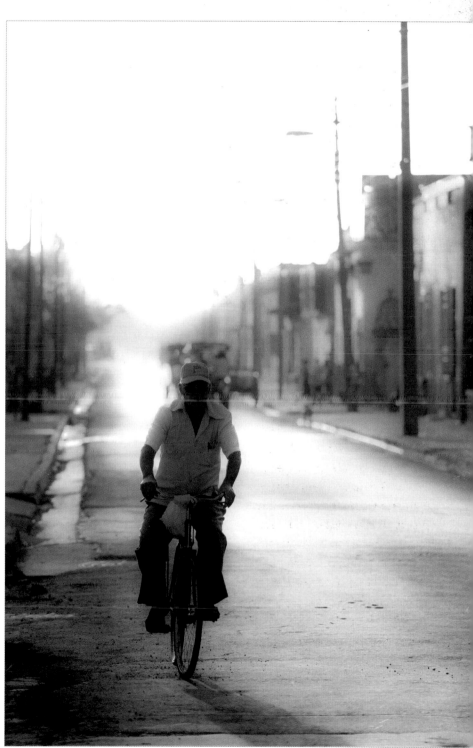

Toward the bottom of the menu window is the Clarity slider. Normally, this slider is moved to the right to sharpen the image. However, if you move it to the left instead, the image is softened. It's an unusual kind of softness, but on backlit subjects like the street scene shown, it creates a very attractive effect. Obviously, because you're adding the effect to a raw file, it's applied to the main image rather than a layer. This means the effect is fixed once the image is opened and saved as a TIFF file. All is not lost, however, because you still have the original raw file, so you can open and re-process it as many times as you like. You can also create a more

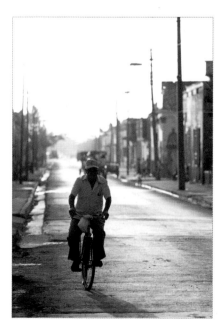

This is the kind of result you get by reducing Clarity during raw processing. It works best on backlit subjects, burning out the brighter tones to give a dreamy, high-key effect that adds atmosphere to the original image (left).
Canon EOS 1DS MKIII with 70–200mm zoom, 1/500sec at f/4.5

SOFT FOCUS

controllable image by processing the same raw file once with no adjustment to Clarity, again with it reduced to –100% to add the soft focus effect, save both as TIFF files then combine them. All you do is open both images, drag and drop one over the other using the Move tool in Photoshop, and they will be combined as layers. You can then adjust layer opacity to get just the level of diffusion you want. I find that Normal blending mode gives the best results, but feel free to experiment with others.

▪ Using Gaussian Blur

The most common way to add soft focus digitally is by using the Gaussian Blur filter under the Photoshop Filters menu: Filter>Blur>Gaussian Blur. Instead of adding the effect directly to the main image though, as with all special effects, create a duplicate layer first—Layer>Duplicate Layer—and add the soft focus to that so you can experiment with different opacities and blending modes.

There's only one control in the Gaussian Blur dialogue box: Radius. The farther you drag it to the right, the more blur you get. It's easy to go too far, but that's not a problem because you can pull it back by adjusting the opacity of the layer, so don't worry too much about that.

This "before" and "after" comparison shows the type of effect you can create using Gaussian Blur on a duplicate layer and Blending mode set to Luminosity. It reminds me of the diffusion I used to get from purpose-made soft focus filters and is ideal for portraits as it softens skin tones and hides spots and wrinkles——not that my young subject here had either!
Canon EOS 1DS MKIII with 24–70mm zoom, 1/350sec at f/3.2, ISO100

Normal blending mode gives perfectly fine results, while Darken blending mode adds a delicate black-and-white mask. My personal favorite is the Luminosity blending mode as I feel the effect it creates is the closest to that of a soft focus lens filter.

▪ Using Diffuse Glow

I mainly use this technique on my digital infrared images, to recreate the dreamy highlights I used to achieve when printing infrared negatives in my darkroom. However, it works on conventional images, too, and is well worth experimenting with.

Diffuse Glow is found under the Distort filters in Photoshop: Filter>Distort>Diffuse Glow. It only works on 8-bit files though, so if you normally save everything in 16-bit you'll need to change the mode of the file before applying the filter: Image>Mode>8 Bits/Channel.

There are three variables in the Diffuse Glow dialogue box: Graininess, Glow Amount and Clear. Play around with them and see how they affect the image. There are no rules here, as always, so adjust to taste—and remember that if you apply the glow to a duplicate layer, you can reduce opacity if the effect is too strong. It's better to overdo it then pull back opacity than not add enough glow initially.

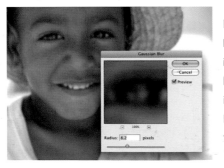

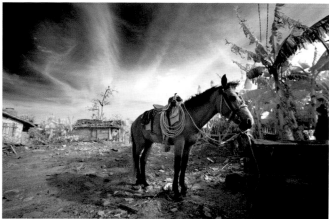

Diffuse Glow can make a huge difference to the feel of an image, adding a dreamy glow to the highlights so the darker tones stand out. The effect is very noticeable here. Even on the "straight" shot (above), the sky behind is bright, but adding Diffuse Glow has created an explosion of light behind the horse that adds plenty of atmosphere (below).
Infrared-modified Canon EOS 20D with 10–20mm zoom, 1/40sec at f/8, ISO100

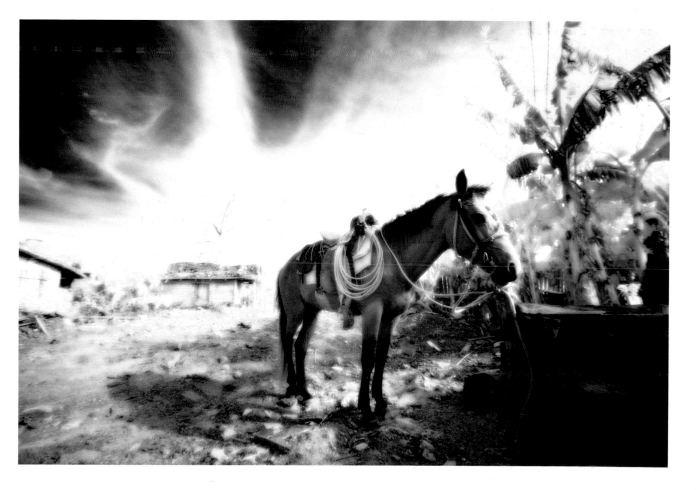

TEN MINUTE CHALLENGE

How many times have you planned a day of photography and spent all week looking forward to it, only to find yourself faced by horrible weather, a creative brick wall or, worse still, a combination of the two? It happens to us all, and our usual reaction is to pack our cameras away, head for the nearest café and sulk.

But I hate returning home empty-handed, so over the years I've gathered together a range of techniques and ideas that make it possible to produce successful photographs no matter what the weather throws at me.

Some of them are covered in this book—capturing waterfalls (page 144), converting images to black and white (page 86), shooting details (page 12) and merging exposures (page 80). Another good one is to set yourself a time limit to take as many interesting photographs as you can. Ten minutes is a good time frame, so let's call it the Ten Minute Challenge.

WHAT YOU NEED

CAMERA: Any type of camera can be used. The images here were shot with a digital SLR, but a compact camera will be fine, or even the camera in your cell phone. The technique is also suited to film as well as digital.

LENSES: It depends on the type of subjects you decide to photograph. I favor my 24–70mm standard zoom when shooting details.

ACCESSORIES: A tripod would be useful, but I prefer to shoot handheld when working on a project like this, so I can move around freely and take lots of photographs without wasting time setting up a tripod. Ten minutes doesn't last long!

HOW IT'S DONE

There are no hard and fast rule—just use your imagination. The photographs shown here were all taken in relatively close proximity on the island of Lindisfarne (Holy Island), close to my home. The day was gray and wet so I decided to look for interesting details around the island's old harbor—peeling paintwork, lobster pots, rusting chains, old ropes and rotting timbers.

As it was raining steadily at the time, I decided not to bother with a tripod and instead increased the ISO on my digital camera from the usual 100 to 400 so that I could set shutter speeds fast enough to avoid camera shake. When handholding a standard zoom lens, 1/125–1/250sec is sufficient for this.

Initially I looked around me and saw little of interest, but once I started taking a closer look, interesting subjects started to emerge and once I had a few pleasing shots "in the bag," it became much easier to find others.

I intentionally decided to concentrate on details as the sky was gray and washed out so there was no point trying to include it. Also, wider views wouldn't have worked so well as a set of selective compositions and by closing in on smaller subjects, I was able to build a collection of cameos that successfully revealed the wonderful old character of the location.

On a more practical note, in the rain it's also easier to shoot close-ups because you can keep the camera angled down to prevent raindrops landing on the lens and causing flare.

So, the next time you find yourself in a similar situation, don't let rain end your day—pull your hood up and set yourself a ten minute challenge. If you can come up with good shots in bad weather, imagine how great your pictures will be when the sun shines!

And surely a wet day of photography has to be better than a dry day shopping?

top tips

- Once you've returned home with your images, why not turn them into an eye-catching poster (see page 118).

- You don't have to travel far to tackle a challenge like this—how about spending ten minutes shooting details on the street where you live?

- Need more focus? Then why not concentrate on a single color or shape or number? You could even shoot all the letters in the alphabet.

Here's a selection of the pictures I took during one of my own ten minute challenges. The day was flat, gray and very wet, but many of the subjects I discovered benefited from the soft light such weather conditions create and wouldn't have looked nearly as interesting if the sun had been shining. Sometimes, a rainy day can be a bonus. Honest!

Canon EOS 1DS MKIII with 24–70mm f/2.8 zoom, various at ISO400

TEN STOPS TO PERFECTION

The only downside to being a landscape photographer in the UK is the unreliable weather. So, what often happens is this: you get your gear all packed and ready the night before, put your boots by the front door, set your alarm clock nice and early and creep out to shoot the sunrise. Trouble is, more often than not the sunrise fails to materialize and you head back home with an empty memory card, wishing you'd stayed in bed.

Don't you just hate it when that happens? I know I do. I'm impatient. I like the odds of success, not failure, to be stacked in my favor—especially when sleep has to be sacrificed. And so, over the years, I've made it my mission in life to find ideas and techniques that I can use to make successful shots possible no matter where I am or what the weather's doing.

The most recent addition to my creative arsenal is a strong neutral density filter that allows me to use long exposures. We're not talking the usual 0.6 or 0.9ND that increases the exposure by 2 or 3 stops, though. No, my ND filter is so dark you can't see through it, so dense that metering systems struggle to take exposure readings. It has a filter factor of 1000x and increases exposures by 10 stops, which in plain talk means an unfiltered exposure of 1 second becomes 1000 seconds—almost 17 minutes!

WHAT YOU NEED

CAMERA: A digital SLR with a bulb (B) setting and, ideally, Live View so you can see through the filter when it's attached to your lens.

LENSES: This really depends on your subject—I use 17–40mm, 24–70mm and 70–200mm zooms.

FILTERS: There are numerous strong ND filters available (see panel on page 136) but I use a B+W ND-110 (3.0) SH filter. This is available from all good camera stores, though often only on special order, and is a screw-in filter. Buy one to fit the biggest filter thread you have—77mm, say—then use step-up adapter rings to adapt it to fit lenses with smaller filter threads. In addition to this ND filter, 0.6 and 0.9ND graduated filters are also invaluable.

ACCESSORIES: Tripod and remote release, clock or stopwatch (if you camera doesn't have a timer).

HOW IT'S DONE

Using a super-strong ND filter is straightforward enough, but you do have to take a few things into account.

First and foremost, because you can't really see through the ND filter—maybe just in bright sunlight—you need to compose the shot before screwing it on to your lens, and accept that once the filter is in place the viewfinder will be plunged into darkness—unless your camera has Live View. It goes without saying that you'll need a tripod, so don't even think about leaving home without one.

The density of the filter also creates problems with focus and metering. It's highly unlikely that your camera's AF system will work with the ND in place, so

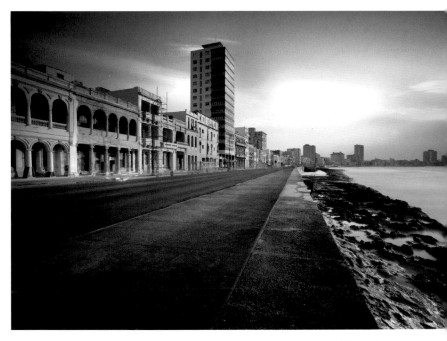

A strong ND filter allows you to capture scenes as they've never been seen before. This road was busy with traffic and people when I photographed it, but because the shutter was open for several minutes, anything moving simply didn't record and the road appears completely deserted!
Canon EOS 1DS MKIII with 17–40mm zoom, 3.0ND filter and 0.6ND hard grad, 180sec at f/16, ISO100

switch to manual focus and focus the lens before fitting the filter.

As for metering, when I first bought a 10-stop ND I did try metering through it with the camera set to Aperture Priority, but the exposures were all over the place and the images were always under-exposed. Also, the longest metered exposure you can usually achieve with an SLR is 30 seconds, and if you try to keep exposures within that range you're defeating the object of using a super-strong ND. So switch to manual exposure mode and scroll through the shutter speeds until you get to bulb (B), which allows you to open the shutter for as long as you like.

Oh, and attach a remote release so you can hold the shutter open without having to keep the shutter button pressed down with your finger—which would almost certainly lead to camera shake.

EXPOSURE POSER

How do you calculate correct exposure? One option is to take a meter reading before you fit the filter then work back from there. For example, if the meter says 1/30sec unfiltered, with a 10-stop ND on the lens it will be 32 seconds (one-stop = 1/15sec, two stops = 1/8sec, three stops = 1/4sec, four stops = 1/2sec, five stops = 1sec, six stops = 2secs, seven stops = 4secs, eight stops = 8 secs, nine stops = 16secs, ten stops = 32secs).

To save you the hassle of working this out, take a photo of the chart on the right then print it off and keep it in your camera bag. Alternatively, use a calculator to work it out: 1/30 x 1000 = 33.3333. If you happen to own an iPhone, as I do, there's even an App available called

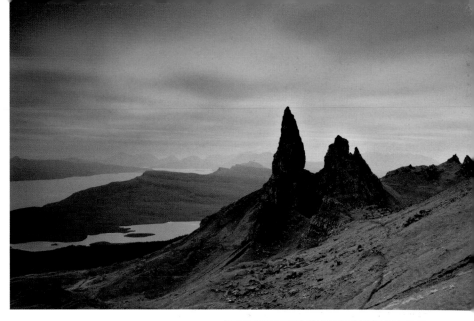

Here's a before and after comparison showing the difference a 10–stop ND filter makes to a photograph. The unfiltered "before" shot (right) is cool and subdued, whereas the "after" is not only much warmer but the long exposure has recorded motion in the sky and added lots of atmosphere. Canon EOS 1DS MKIII with 24–70mm zoom, 0.6ND hard grad (before) 3.0ND filter and 0.6ND hard grad (after), 0.6sec at f/11, ISO100 (before), 90secs at f/8 and ISO200 (after)

NDCalc, which works out the exposure for any ND filter from a 0.3 (2x) to a 6.0 (1,000,000x) then counts down the time for you and sounds an alarm so you know when to close the shutter.

I tend to do a "guesstimated" test shot based on experience. So, with the camera on a tripod, the scene composed, the lens focused, the ND filter on place and the shutter set to bulb, I'll make, say, a 2-minute exposure at f/8 and ISO100, check the image and the histogram and increase or reduce the exposure accordingly.

I generally shoot at ISO100 and stick to f/8 or f/11 for optimum image quality, using the exposure duration as my main variable. However, when ambient light levels are quite low, such as at dawn and dusk, I may increase the ISO to 200, or even 400 occasionally, so the exposure with the ND filter in place isn't too

EXPOSURE CHART

To save you the hassle of working out correct exposure when using a 10-stop ND filter, take a meter reading without the ND filter in place, locate it on the chart below then read across to find the exposure you need to use once the 10-stop ND is in place.

Unfiltered exposure	Exposure with 10-stop ND
1/500sec	2secs
1/250sec	4secs
1/125sec	8secs
1/60sec	16secs
1/30sec	32secs
1/15sec	1min
1/8sec	2mins
1/4sec	4mins
1/2sec	8mins
1sec	16mins
2secs	32mins
3secs	48mins
4secs	1hour

LEFT: **An ND filter is ideal for coastal views as the long exposure records motion in the sea and sky. This shot was taken on a flat, overcast day so the sea and sky have been transformed into textureless gray tones. There is no other way to achieve this effect other than by using a long exposure.** Canon EOS 1DS MKIII with 24–70mm zoom, 3.0ND filter and 0.6ND hard grad, 110sec at f/11, ISO100.

OPPOSITE: **The B+W 3.0ND filter I use adds a warm cast to photographs taken in all but the dullest weather. This makes it a perfect choice if the light is subdued at dawn and dusk as it add a rich glow to the scene that looks completely natural and really brings the landscape to life.** Canon EOS 1DS MKIII with 17–40mm zoom, 3.0ND filter and 0.6ND hard grad, 180sec at f/16, ISO200

excessive. If I don't need lots of depth of field—when shooting from a high viewpoint, say—I may open up the lens to f/5.6 or f/4 instead.

Noise is more of an issue when using long exposures—especially hot pixels, which glow like pin-pricks of light. Modern digital cameras have long exposure noise reduction (NR) to combat this, but it works by making a second exposure the same duration as the first with the shutter closed, so if you make a 5-minute exposure you'll have to wait another 5 minutes before the image appears on the preview screen. I'm far too impatient for that, so I make sure my camera's NR is turned off and I clone out any hot pixels in Photoshop—which takes about a minute.

Finally, remember to use an ND grad filter to prevent the sky from overexposing, just as you would when shooting without an ND filter. I screw my B+W ND on to the lens then attach a 77mm wide-angle adaptor ring from my Lee Filters kit. A filter holder is then clipped into the adaptor ring as normal so I can slot ND grads into it.

The main difference, of course, is that you can't see through the lens with the ND filter in place, so you can't align ND grads by sight.

To get around this, attach the filter holder to the lens before fitting the ND filter, slot in the grad, align it, remove the holder (with the grad still in place), fit the ND filter on the lens, pop the filter holder over the ND (with the grad still correctly aligned) and fire away.

One of the great things about this technique is that the raw files rarely need much post-production work to get to the final, finished image because you're doing the bulk of the work in-camera. Okay, you may need to zap a few hot pixels and if the light was really flat, contrast may need a boost. But that's about it, and within minutes your printer will be purring away as it makes yet another masterpiece ready for the wall!

EXTREME ND FILTERS

The 10-stop ND filter I used for all the shots here is made by German manufacturer B+W and is called an ND-110 (3.0) SH filter.

B+W also makes an ND1.8, which gives a 6-stop exposure increase while Heliopan makes a 3.0 (10-stop) ND like B+W plus a 4.0 (13-stop) ND and Hoya an ND400 (9-stop). There's also a Singh Ray Vari-ND filter, which offers variable neutral density from 2–8 stops—all you do is twist the front section like you do with a polarizer to achieve different densities.

As I haven't used any of these filters, other than the B+W 3.0, I can't vouch for their color balance. Neutral density filters get their name because they're supposed to be neutral—they block light without changing colors. However, the super-strong ND filters are designed more for industrial and scientific use where neutrality is less important, so they aren't always perfectly neutral.

My B+W 10-stop ND is far from neutral, which is why it creates the wonderful warmth, and why I enjoy using it. Other brands and densities of strong ND may not give the same color shift.

TONING

When I wrote the first *A–Z of Creative Photography*, digital technology had yet to make an appearance, so traditional techniques and practices were very much at the forefront. This was particularly so in the world of black-and-white photography, where practitioners developed their own film and printed from their own negatives. If you wanted to tone a print, to add warmth, cool it down or merely make it archivally stable, you did so using chemicals—a time-consuming and costly process.

No one saw it that way, of course, because there was no alternative, no shortcut. But once Adobe Photoshop entered our lives, everything changed.

For the better? I think so. Digital technology has undoubtedly raised the standard of photography and opened creative doors that would otherwise have been closed to many. Black-and-white photography is far more accessible now that a darkroom is no longer required, and creating successful images is easier than ever before. To show you just how easy, here's a guide to toning your own black-and-white images.

HOW IT'S DONE

The benefit of digital toning over chemical toning is that it's quicker, easier, reversible and infinitely repeatable. You can take the same digital file and tone it with any number of colors, and if you make a mistake, you just start over again. The degree of control you have over the tone is also much greater when working digitally—if you apply the toning to a duplicate layer of the main image, for example, you can adjust the opacity (visibility) of that layer to make the tone more or less obvious. If you don't like the effect you can delete the layer completely or make it invisible so you revert to the original image.

TONING USING HUE/SATURATION

The quickest and easiest toning technique involves the Hue/Saturation tools in Photoshop.

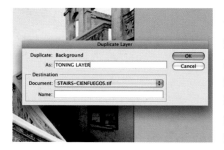

1. Open your image and make a duplicate layer by going to Layer>Duplicate Layer. Here I named it "Toning Layer".

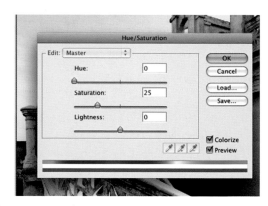

2. Go to Image>Adjustments>Hue/Saturation. In the dialogue box that appears, click on the Colorize window in the bottom right-hand corner. All you do then is adjust the Hue and Saturation sliders until you're happy with the effect. A wide range of colors can be achieved by adjusting the Hue slider while the strength of that color is controlled using the Saturation slider—though you can also do that by adjusting the opacity of the duplicate layer.

Here are some examples of the effects you can achieve. In each case the opacity of the duplicate layer remained at 100%. Reducing it would weaken the tone color.

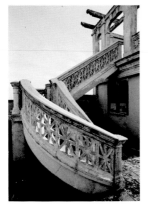
Original black and white image

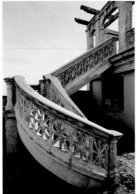
Hue 0/Saturation 30

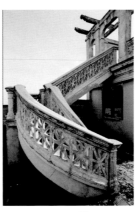
Hue 20/Saturation 20

Hue 40/Saturation 50

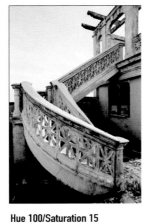
Hue 100/Saturation 15

Hue 200/Saturation 25

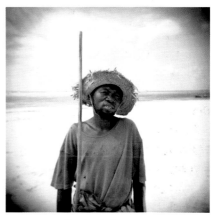

ABOVE AND BELOW: **Here's a before and**
after comparison showing the original untoned
black-and-white image and the toned version of
it created using Channel Mixer. You can vary the
color considerably by adjusting the three color
channel sliders.
Holga 120GN with fixed 60mm lens and Ilford XP2
Super ISO400 film, 1/100sec at f/11

TONING USING CHANNEL MIXER

Another quick fix is to use Channel Mixer in Photoshop.
As before, open your image, make a duplicate layer then
go to Image>Adjustments>Channel Mixer. When the
dialogue box opens, adjust the sliders for the Red, Green
and Blue channels as required to achieve the effect you
want. The key here is not to overdo it as you will also
change the contrast of the image.

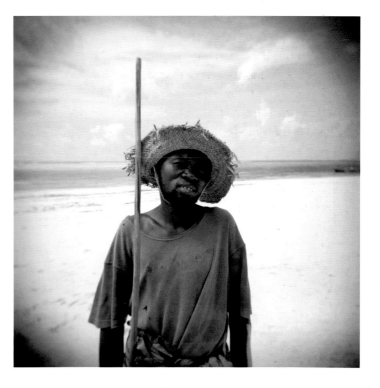

TONING

TONING USING CURVES

This is a favored toning method among photographers and the one I initially used when I became involved in digital imaging. Having tried the others, however, I wouldn't say it's any better—though it does make split toning possible, which we'll look at later.

Having opened your image and made a duplicate or adjustment layer, go to Image>Adjustments>Curves. In the Channel window near the top of the Curves dialogue box you'll see RGB. Click on the blue tab and a drop down menu appears

with the options of Red, Green and Blue—the individual color channels that make up the whole image.

To create toned effects, all you do is adjust these curves, as follows.

■ Sepia toning

To add the traditional sepia tone to an image, select the Blue channel, click on the curve and drag it down to the right so the image goes green. Next, select the Green channel and drag it down to the right so the image goes brown. Finally, select the Red channel and drag the curve down a little to

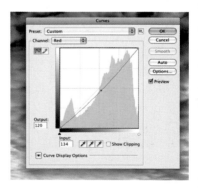

the right to produce a more attractive sepia tone. If the tone color is too strong, adjust the opacity of the layer, or go to Image>Adjustments>Hue/Saturation and reduce the saturation to your taste.

■ Copper toning

Follow the steps for sepia toning but drag the curve for the Red channel farther down to the right to give a redder effect.

■ Blue toning

Open your untoned image, go to Image>Adjustments>Curves, click on Blue in the Channel window then drag the curve to the left. The farther left you drag it, the bluer the image will become. Blue toning with chemical toner tends to produce quite subtle results, so be careful that you don't go over the top. If you do, reduce the opacity of the layer or reduce saturation in Hue/Saturation.

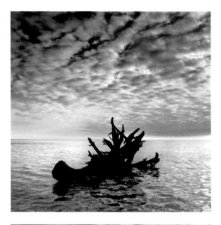

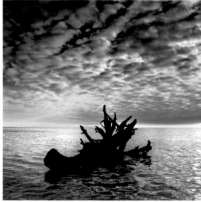

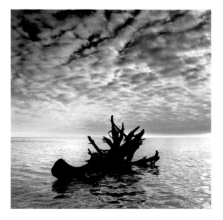

These images show the kind of effects you can achieve by toning using the Curves method. The original, untoned image (top) works well in its own right, but the addition of a sepia tone (middle) gives it a warm, atmospheric feel while blue toning (bottom) creates a colder look that's equally effective on the image.
Canon EOS 1DS MKIII with 24–70mm zoom, 1/80sec at f/6.3, ISO50

SPLIT OR MULTIPLE TONING

Single toning is child's play, as you can see. However, you can create more subtle and attractive effects by split or multiple toning. This involves adding one color to the highlights and another to the shadows.

In the traditional darkroom this was a time-consuming job because you had to make sure the print was thoroughly washed to remove all traces of fixer, partially tone it with the first toner, wash it again, then partially tone it with the second color before a final wash and dry.

The most common form of split toning involved first a partial and weak sepia tone to add warmth to the highlights, followed by a partial blue tone to add a cool color to the shadows. Sepia and gold were also popular, and sepia and selenium.

The same effect can be added to digital images using the Curves method outlined above, but instead of adjusting the position of the whole curve so the color is added to the whole image, you can "peg" the curve for each color channel so only certain parts of the image are affected.

To add sepia and blue tones to a photograph, first open the image, create a duplicate layer, then go to Image> Adjustments>Curves.

Select the Blue Channel then click on the curve line from just above the central point, all the way to the bottom left.

Each time you click on the curve you'll create an anchor point to stop it moving. Next, drag the top section of the curve down to the right. Repeat this for the Green and Red Channels, "pegging" the curve each time, so you add sepia tone to the highlights and lighter midtones.

Now go to Image>Adjustments>Curves, select the Blue channel and peg the curve from top right to just below the

central point, as shown, and drag the rest of the curve up to the left to add a blue tone to the shadows and darker midtones. Save the changes you've made and that's it—job done!

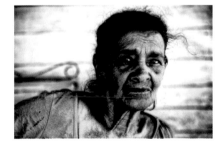

I've exaggerated the effect here, so you can see what has happened to the image—sepia has added a pleasant warmth to much of it, while a deep blue is noticeable in the darker areas. This is a very effective color combination and suits all manner of subjects, so why not give it a try? And when you've done that, you can advance to tritone and quadtone effects!
Canon EOS 1DS MKIII with 24–70mm zoom, 1/250sec at f/3.5, ISO100

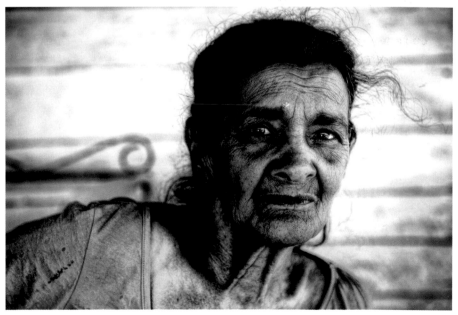

URBAN DETAIL

Shopping, it has to be said, isn't my favorite pastime. Not only does it cost money, but I can't think of anything less interesting than wandering around busy stores for hours on end, looking at things I don't really need. There are so many other more satisfying ways to spend my time. Like being eaten alive by killer ants.

In order to alleviate the boredom of these regular retail trips, I've taken to carrying a digital compact with me. That way, instead of following my dearly beloved around like an obedient puppy dog, I can go wander and look for interesting things to photograph while she checks out the housewares.

WHAT YOU NEED

CAMERA: A small compact camera is ideal because you can slip it into your pocket and carry it everywhere. The cameras in cell phones are also capable of great results these days, so you don't even need to carry a separate camera!

LENSES: The integral zooms in modern compacts give you plenty of optical options, though a fixed lens is also suitable—it just makes you work that little bit harder.

HOW IT'S DONE

The great thing about shopping malls and retails parks is that they're all full of stores that want to grab your attention and tempt you inside, and the usual way for them to do this is by using big, colorful signs. Modern architecture employs strong shapes, bold lines, and striking patterns—the perfect ingredients for interesting images.

I've always had a penchant for simple abstracts—anything bold and colorful basically—so I'm never short of things to shoot when there are signs in sight. I find it difficult to walk down my own street without stopping to take a few photographs, which means it takes me ages to get anywhere and I drive my family mad!

The key to this style of photography is to forget what you're shooting and instead see it purely as the raw material for your art and regard your camera as a visual notebook with which you can record whatever grabs your attention. I'm mainly a landscape photographer, so I'm

used to locking my camera to a tripod and spending a long time on each image, perfecting the composition and waiting for the light to be just right. But put a compact in my hand and my approach changes completely.

Holding a camera out at arm's length and using the LCD on the back as a viewfinder is an alien way of working for SLRs users like myself. However, for abstract photography it's perfect because it allows you to ignore the actual subject and concentrate only on what you can see on the screen; it detaches you from reality so you forget what it is you're actually looking at and become totally immersed in the process of creating images.

Working in this way, I walk around my subjects, constantly changing my camera angle to see what effect it has on the composition and racking the zoom back and forth to get more or less in frame. With each movement or adjustment, another great image appears on the

screen—bold colors, strong lines and angles, simple shapes. The possibilities are endless and it's not uncommon for me to shoot 100 or more images in the space of an hour.

The best part of all, though, is that it keeps me out of the stores. My wife has a great time, I have a great time. Everyone's happy. Now that's what I call a result!

top tips

■ Abstract images like this make great canvas prints to hang on the wall. How about printing a series and displaying them together? Beats portraits of the dog!

■ Alternatively, have a set of images turned into small printed cards then use them to create a colorful montage (see www.lulu.com).

■ Don't be afraid to boost color saturation in Photoshop to make the images more eye-catching.

Here are some of the striking abstract images I've created while wandering around retail parks. As well as store signs, take a look at street furniture, street signs and road markings. Sunny weather provides the best conditions to shoot images like this as the light is strong, shadows can add extra interest and blue sky provides an effective backdrop if you're looking up.

Sony Cybershot 6mp digital compact with 6.3–18.9mm integral zoom, various at ISO80

WATERFALLS

Moving water, be it in a raging waterfall or a tumbling mountain stream, provides an irresistible subject for photographers. You may not have access to Niagara Falls or similar wonders of the world, but that doesn't matter because even the smallest trickle of water can, with care, be the source of pleasing images.

WHAT YOU NEED

CAMERA: Any, providing you can set slow shutter speeds of at least 1/2 second, preferably longer, or which has a bulb (B) setting.

LENSES: Focal length will be governed by the location and size of the waterfall, but anything from a wide-angle to a moderate telephoto or telezoom will be suitable.

ACCESSORIES: A sturdy tripod to keep your camera steady, plus a remote release to trip the camera's shutter. It's also a good idea to carry a neutral density (ND) filter of 0.6 or 0.9 density, though a polarizer will have the same effect as a 0.6ND.

HOW IT'S DONE

The most common method of photographing moving water is to use a slow shutter speed, so it records as a graceful, milky blur—the slower the shutter speed is, the smoother the effect becomes. As a starting point, set your camera to 1/2sec or so, but don't be afraid to use much longer exposure times of several seconds.

The slowest shutter speed you can set will depend on light levels at your chosen location. If you're in a shady, wooded area you may find that with your lens set to its smallest aperture—usually f/16 or f/22—an exposure of many seconds is required. However, out in the open in sunny weather the slowest speed you can use at the minimum lens aperture could be as fast as 1/15sec, which is too fast to create sufficient blur in the water.

To overcome this, use a neutral density (ND) filter on your lens to reduce the amount of light entering and force an exposure increase. A 0.6 ND requires a 2-stop increase, so instead of using 1/15sec you could set 1/4, while a 0.9 ND requires a 3-stop exposure increase and in this example would allow you to use a shutter speed of 1/2sec instead of 1/15.

If you don't have a neutral density filter, a polarizer can be used instead as it reduces the light entering your lens by 2 stops and has the same effect as a 0.6ND filter.

When taking an exposure reading of the scene you're about to photograph, remember that water is highly reflective and can fool your camera's metering system by bouncing a lot of light around—especially if the waterfall or river fills a large part of the viewfinder.

To avoid exposure error, move the camera to one side and take a meter reading from an area that doesn't contain water but that's in the same light. A grassy bank or green trees would be ideal. When you've done that, set the exposure on your camera, re-compose and take the picture, remembering to use a remote release so you don't have to press the camera's shutter button with your finger and risk causing vibrations.

If you're using a digital camera, don't worry about taking a "substitute" exposure reading—just use the first shot as an exposure test and increase or reduce the exposure as required—though modern metering is so good that the majority of cameras will get the exposure correct.

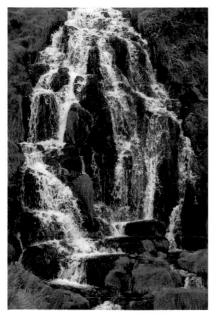

1/160sec

Slightly overcast weather provides ideal conditions for waterfall photography as light levels are much lower than in bright sunshine, making it much easier to use long exposures to blur the water. Contrast is also low so there are no bright highlights on the water to contend with. There was just enough water flowing in this waterfall to give an attractive effect without areas of the water overexposing. The smaller inset shows how the same waterfall looked when photographed with a faster shutter speed.
Canon EOS 1DS MKIII with 70–200mm f/4 zoom and polarizing filter, 6 seconds at f/32, ISO50

6 seconds

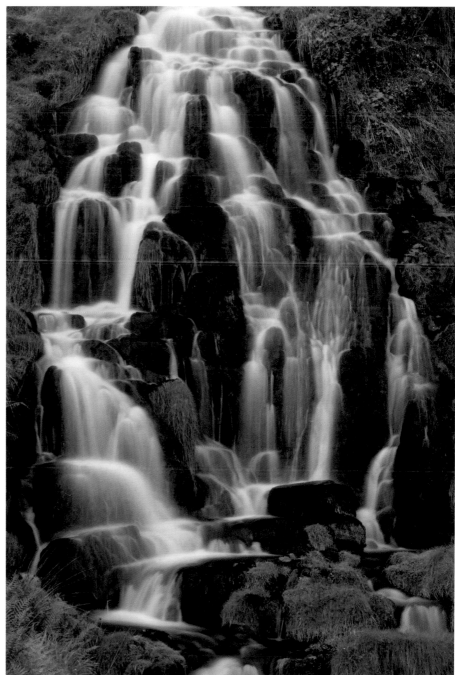

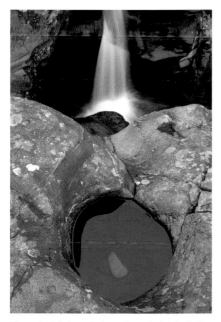

The waterfall doesn't always have to dominate the composition. In this case, I decided to relegate the waterfall to the background and make a feature of the water-filled hollow in the foreground. The solidity of the rock contrasts well with the blur of the falling water behind it.
Canon EOS 1DS MKIII with 17–40mm f/4 zoom and polarizing filter, 6sec at f/16, ISO50

WIDE VIEWS

When it comes to the subject of lens choice, photographers can be divided into two distinct groups.

On one side of the fence you have the telephotoids, those crazy guys who walk around with a telephoto lens stuck to their face and live by the maxim, "less is more." On the other you have the wacky wide-anglians; photographers who aren't satisfied with the limited view of the human eye and love to lose themselves in the gaping void of the wide-angle lens.

Ever since I was bitten by the photography bug almost 30 years ago, I've been a fully paid-up wide-anglian—and proud of it. Within days of becoming the owner of my first SLR, I was off to my nearest camera shop, checking out the wide-angle lenses. First a 28mm was added to my collection, followed by a 21mm and finally a 17mm. Today, my preference is still the same, and a 17–40mm zoom spends more time on my camera than any other lens. Here's why….

WHAT YOU NEED

CAMERA: To make the most of wide-angle lenses you need an SLR. Compact cameras only go as wide as 24mm whereas interchangeable SLR lenses go as wide as 8mm circular fisheye lens!

LENSES: You decide. I find that the wide end of a 17–40mm zoom on my full-frame digital SLR is ideal. On SLRs with smaller sensors, a 12–24mm or 10–20mm zoom would be the equivalent.

HOW IT'S DONE

If you're into shooting subjects that require wide-angle lenses, such as landscapes, architecture and general travel, the ultra-wide zoom is the most versatile lens you're likely to own.

Ironically, it's the last one you're likely to invest in—first choice usually being a 24–70mm standard zoom followed by a 70–200mm telezoom, or equivalent in both cases. However, if you're already the proud owner of those two and are wondering if you could really use a lens that provides focal lengths wider than 28mm or 24mm, don't hesitate for a minute—I've yet to meet a photographer who owns an ultra-wide zoom and regrets the day he bought it. Usually the response is "I can't believe I didn't buy one sooner".

The great benefit of an ultra-wide zoom is that it allows you to take things to an extreme. You still have those moderate wide-angle focal lengths such as 35mm, 28mm and 24mm, which are ideal for general scenic and architectural photography, as well as environmental portraiture and nature work, but you also have the option of zooming out to 20mm or wider, and that's when things get really interesting.

Take the angle of view. At 17mm you're recording at least four times more than a 50mm standard from the same position, so you can take in vast areas that are impossible to appreciate with the human eye in one fell swoop, or cram large subjects into the viewfinder from close range such as the interior of a cathedral, or a high-rise building.

The extensive depth of field you get at ultra wide focal lengths is also very handy. Zoom back to 17mm, stop the aperture right down to f/22 and you can achieve front-to-back sharpness from less than 30cm to infinity (depending on the minimum focusing distance of the lens).

The creative possibilities this presents are endless, not only for landscape and architectural photography but nature, travel and documentary—pretty much any subject. If you flick through the pages of National Geographic you'll see many images that were shot with ultra-wide lenses. This approach is favored because it allows the photographer to get right into the heart of the action and make the viewer feel like they were there too.

The main thing you need to be aware of once you start zooming wider than 24mm is that it's very easy to end up with pictures that look like they were taken in the middle of the Gobi Desert. Empty, in other words.

Elements in a scene that would make great foreground interest if you were shooting at 28mm seem tiny and insignificant at 20mm or 17mm. This is not only because you're getting

more in the picture, but also because the wider the focal length is, the more it seems to stretch perspective so that everything appears farther away than it really is, and the distances between the various elements in a scene are grossly exaggerated. When used creatively this is one of the things that makes ultra-wide lenses so exciting to use, but at the same time can be their downfall.

To get an idea of the effect, try standing in the middle of a long, straight road (when no traffic is coming, naturally), peer through your camera's viewfinder with an ultra-wide zoom fitted, then zoom back from 35mm to 20mm or wider. The effect is amazing, with the parallel sides—the leading edges—of the road converging dramatically into the distance until they seem to meet at an imaginary place on the horizon known as the *vanishing point*.

Now kneel down (you need a quiet road for this!) and look through the viewfinder. You can get so close to the road surface that you'll clearly see the texture of the tarmac, yet the farthest point in the picture, and the sky, will still appear to be in sharp focus.

That's the key with ultra-wide lenses. You need to get in close. No matter how close you are to key elements in the foreground of a composition, you can always get closer—there's enough depth of field to keep everything sharp, as we've already discussed, so you have no excuse not to, and no choice if you want the image to be a success.

Portraits are usually taken using a short telephoto lens, but you can produce some fantastic results by bucking tradition and using a wide-angle lens instead. You'll need to shoot from close range to fill the frame, which means that your subject's face will be distorted into a comical caricature of themselves, but that's all part of the fun. This shot of my son was also given the HDR treatment (see page 120) to make it even more off-the-wall.
Canon EOS 1DS MKIII with 17–40mm zoom at 17mm, 1/125sec at f/7.1, ISO100

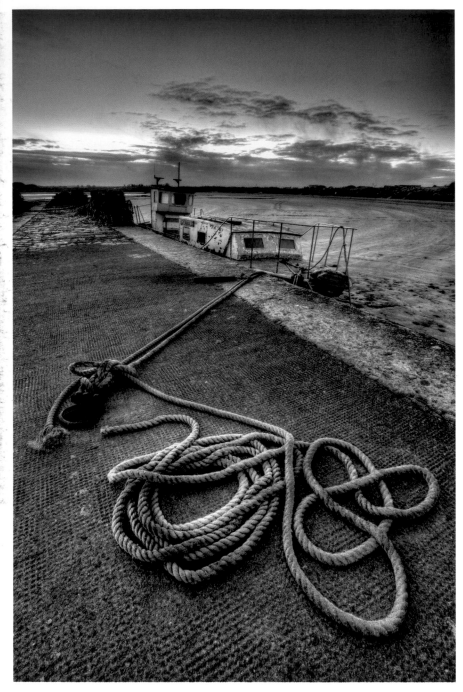

This image exhibits classic ultra-wide characteristics—the way perspective has been stretched so that the boat appears smaller than the rope, the coil of rope dramatically filling the foreground and, of course, the expansive depth of field, which enabled me to record everything in sharp focus from front to back.
Canon EOS 1DS MKIII with 17–40mm zoom at 17mm and 0.9ND hard grad, 1/2sec at f/16, ISO100

DISTORTED VIEWS

Something else you'll notice when you do this is that distortion can be pretty extreme. Modern ultra-wide zoom lenses are fairly well corrected for distortion, so you tend not to get straight lines looking like bananas anymore unless you buy a fisheye lens or an uncorrected ultra-wide. However, because perspective is exaggerated so much, things close to the camera, especially at the frame edges, lean dramatically in the same way that parallel lines converge.

To see this for yourself, walk up to a building, point the camera straight at it and zoom back to 20mm or wider. If you keep the camera square so the film plane is parallel to the front of the building, any vertical lines you can see will appear vertical. Now tilt the camera

AVOIDING FLARE

The wider a lens is, the greater the risk of flare simply because it takes so much in and the bulbous front element tends to pick up stray light more readily. Even if the sun is well out of shot, it can still cause flare when you're shooting at 20mm or wider.

Most—if not all—wide zooms come with a clip-on or screw-on lens hood to help you avoid flare. Unfortunately, they're usually ineffective and can't be used with slot-in filter systems. A better way of keeping flare at bay is by using a remote lens shade. An 8 x 11" piece of cardstock held in position can work wonders, or even your hand—if you're shooting with an SLR you'll be able to see if it strays into the field of view of the lens.

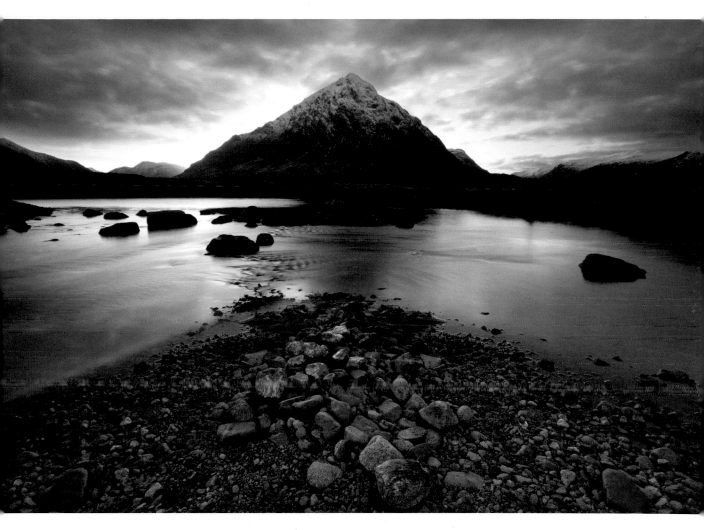

back a little, and notice how those vertical lines converge dramatically.

This effect, known as *converging verticals* funnily enough, is common when shooting buildings with any wide-angle lens, but it's compounded as you go wider because the larger angle of view of an ultra-wide lens encourages you to get closer to the building in the first place, then you end up having to tilt the camera back even farther to get the top of the building in the picture.

One option is to back off a little, keep the camera square so you don't have a problem with converging verticals and

I find that my 17–40mm zoom is the one I reach for most often when shooting landscapes as it allows me to make a big feature of foreground interest and in doing so adds a strong sense of depth and scale to my compositions. In this wild winter view, the rocky riverbank provides a perfect entry into the scene by forming an inverted 'V' that not only leads the eye into the scene but also echoes the shape of the towering mountain in the distance.
Canon EOS 1DS MKIII with 17–40mm zoom at 17mm and 0.9ND hard grad, 6secs at f/18, ISO100

find something that you can include in the foreground so you don't end up with an empty composition. It could be anything—a statue or monument, a staircase, an archway—anything that puts some depth and scale into the picture. The other option is to exploit this convergence for creative effect—move even closer to the building and look

up toward the sky. The effect can be staggering, especially on skyscrapers in big cities. For the best results, position yourself between tall buildings then look up so they appear to lean toward each other.

Converging verticals isn't limited to just architectural photography either. If you photograph a person by kneeling

Ultra-wide lenses and zooms are invaluable for interior shots as they allow you to produce successful shots in confined spaces—though you have to accept some degree of distortion as par for the course, and also take care to avoid converging verticals.
Canon EOS 1DS MKIII with 15mm fisheye lens, 2secs at f/9, ISO200

down in front of them and looking up with your zoom at 20mm or wider you're going to get a pretty bizarre effect, with your subject's legs looking much longer than their body and their feet looking much bigger than their head. Not exactly flattering—but in the right situation it can look great.

It's these three properties—the stretching of perspective combined with a huge angle of view and endless depth of field—that makes the wider focal lengths on an ultra-wide zoom so effective. Even a slight change of position in any direction will dramatically alter the whole balance of a composition and the way different elements in a scene relate to each other.

With an ultra-wide zoom you can produce stunning pictures of everyday subjects and scenes just because of the way they exaggerate the truth and allow you to capture a view of the world that can never be witnessed with the naked eye. At the same time, if you don't treat them with respect and think about what you're doing they can be a disaster waiting to happen, so just remember: be brave, be bold, but above all, get in close.

Don't say I didn't warn you!

top tips

■ It's easy to end up with windy compositions when using ultra-wide lenses because even things that are close to the camera seem small and far away. Avoid this by exploiting near foreground interest and get as close to it as you need to.

■ Polarization is uneven across the sky.

Wide zooms tend to show this because they capture such broad areas of sky so you may find sometimes that one side of the sky is darker than the other when using a polarizing filter.

■ Take care when shooting with the sun to your back—it's easy to get your own shadow in the picture.

"Close and low" is the key to success when using ultra–wide lenses. Get up close and personal with a feature in the foreground and you'll really see the benefits that the lens has to offer. You'll also end up with a composition full of impact, like this Cuban street scene.
Canon EOS 1DS MKIII with 17–40mm zoom, 1/60sec at f/8, ISO100

WINDOW-LIT PORTRAITS

Enthusiastic photographers have a tendency to overestimate the amount of equipment required to produce successful pictures, and the complexity of the techniques involved.

Nowhere is this more evident than with portraiture. It is taken for granted that banks of expensive studio lights are required, along with special backgrounds and fancy attachments to modify the light.

While many photographers do go to these lengths, most would confess that it isn't essential, and that a single window can be just as effective in providing flattering illumination for portraiture. In fact, professional photographers often use studio equipment to re-create the beautiful light a window can provide, and some of the most memorable portraits have been shot using natural daylight flooding in through a window.

WHAT YOU NEED

CAMERA: Any type of camera, film or digital, can be used for window-lit portraits.

LENSES: A focal length from 85–105mm is considered the best choice for head-and-shoulder portraits, as the slight compression of perspective is flattering to facial features. For half

or full-length portraits, a 50mm standard lens is ideal.

ACCESSORIES: A white reflector will be handy for bouncing light into the shadows to give more evenly lit results. This doesn't have to be any more complicated than a sheet of white cardstock.

HOW IT'S DONE

The type of illumination present will depend mainly on three factors: the size of the window, the direction in which it faces, and the weather conditions.

Generally, the larger the window is in relation to your subject, the softer and more even the illumination. Small windows such as skylights and portholes produce a small pool of light that can be used to create bold, spot-lit effects, whereas large windows and patio doors tend to flood your subject with light so contrast is lower and shadows less harsh.

If you're working with a large window, you can control the quality of light using cardstock to mask off areas, though little can be done with small windows. In most cases, an average-sized room window will be sufficient for head and shoulders portraits.

You can control the amount of light coming through a window simply by pulling the curtains closer together.

Where direction is concerned,

windows facing south receive direct sunlight through much of the day, so the light tends to be harsh and contrasty, especially in bright, sunny weather. To soften the light coming through a window, fix a sheet of white cotton muslin or tracing paper over it. North-facing windows, on the other hand, only admit reflected light from the sky and surrounding buildings, so it tends to give much softer and more flattering illumination.

Direct light flooding in through a window offers more options, as its color and intensity will vary depending on the time of day. During late afternoon, for instance, the light is much warmer and softer than it is at midday, and you can make good use of the golden glow and raking shadows created by the low sun. Try hanging net curtains over the window to create dappled shadow patterns across your subject's face.

Finally, weather conditions. The effects

of changes in the weather are seen more in south-facing windows, which receive direct sunlight—the brighter and sunnier the weather, the harsher and more intense the light. North-facing windows are less affected, though in bright weather light levels will obviously be much higher than during dull, rainy days, simply because there is much more light being admitted.

As a general rule, most photographers prefer a north-facing window and shoot in bright but slightly overcast weather conditions when the light is diffuse and flattering. That said, it's well worth experimenting with other options as all can produce successful images.

Another factor that will affect the overall mood of your portraits is where you position your subject in relation to the window. If your subject is side-on to it, one half of their face will be lit and the other half in shadow. This is the most popular approach, especially with men and older people, as the bold side-lighting reveals

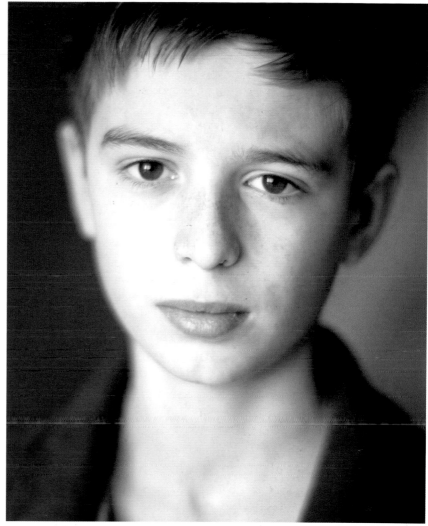

the texture of the skin, while the gradual fall-off in light produces moody results.

If you don't want dense shadows, position a large white reflector opposite the window so it bounces light back toward the shadow side of your subject. Alternatively, ask your subject to face the window a little more so the light floods over their face. This can produce beautiful results in overcast weather, when the light is naturally soft and shadows weak.

Alternatively, you could position your subject so the window is behind them. This obviously means their face will be in shadow, but if you expose carefully for the shadows the background (the window) will overexpose and burn-out to create a moody, high-key effect.

Finally, keep the background plain and simple so it doesn't compete for attention with your subject. If the existing background in the room is unsuitable, hang a sheet of cotton or canvas from the wall. Often you will find that light levels behind your subject are much lower than next to the window, so the background will come out very dark anyway. However, it's wise to take precautions.

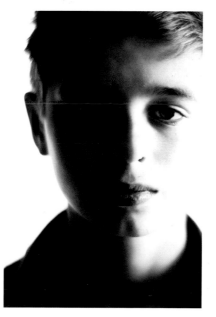

These three portraits of my son, Noah, were all taken within a few minutes of each other using the same window to provide illumination. They're a clear illustration of how completely different effects can be achieved by varying the position of the subject in relation to the window itself. For the first portrait, Noah stood a few feet away from the window so sunlight shining through it cast shadows across his face to create a contrasty effect. Next, I moved him farther away from the window so he was lit only by reflected light off nearby walls—you can see how the light is much softer and more flattering. Finally, I posed Noah in the bay window itself so part of it acted as a background, which overexposed and turned white, and part of it lit one side of his face to give a simple but bold effect.
Canon EOS 1DS MKIII with Zeiss 85mm f/1.4 lens, 1/800sec, 1/2000sec and 1/320sec respectively, all at f/1.4, ISO400

WINTER WONDERLAND

Winter. The season of short days and long, long nights. Of frost and snow, stormy skies, driving rain and spine-tingling cold. Most of us wish winter was over before it has even begun. But photographically, it's the season of goodwill, and all the things that drive mere mortals mad are the stuff of amazing images. Which is why, as the mercury starts to plummet, photographers everywhere start digging out their thermals, stocking up on batteries and preparing for a few months of fun. So bring on the cold—we're ready for it. Let the wild winds blow—we love a good storm. As for snow—the more the better.

WHAT YOU NEED

CAMERA: A digital SLR or compact will be ideal for capturing winter.

LENSES: Focal lengths from 24–200mm should cover most eventualities.

FILTERS: A polarizer will be invaluable on sunny days, plus ND grads to stop the sky from overexposing (see page 92).

ACCESSORIES: Tripod and cable release, spare, fully charged batteries, waterproof cover to protect your camera if the snow starts to fall.

HOW IT'S DONE

Taking great pictures in winter is actually no harder than in any other season, it's just that you're working on a slightly different canvas. Instead of the lush greens of summer and golden hues of autumn, the landscape is stripped to its bare bones. And OK, the weather may be less predictable, but who's complaining if you wake up to an unexpected hoar frost that coats everything in a million sparkling ice crystals, the magnificent sight of the sun's golden orb slowly rising over a frozen landscape or freshly fallen snow that transforms everything into a winter wonderland?

As for the short days, remember quality is better than quantity. Throughout winter the sun never climbs more than about 30° above the horizon so the quality of light is great from sunrise to sunrise and you can end up with more effective shooting hours than in mid-summer, when the light between 10 am and 4 pm is pretty useless.

Planning is the key to success in winter. Because the weather's unpredictable you need to be prepared for whatever the elements throw at you. So make a list. Note great locations for sunrise or sunsets. Do some scouting locally and establish places where you can get shots after snowfall, if it's a crisp, frosty morning, or when a heavy fog comes down. By compiling this winter wish list you'll know exactly where to go to make the most of whatever weather conditions happen to befall you on a day-to-day basis.

FRESHLY FALLEN

To capture snow at its best you need to be on location as soon as possible after the fall ceases, so it's in pristine condition and devoid of footprints or slushy gray patches. Ideally, the weather should be clear and the sun shining. Crisp snow against a deep blue sky looks wonderful, but snow against a dull, gray sky looks far less inspiring—unless you decide to convert the images to black and white.

Early morning and mid-afternoon are generally the best times to shoot. This is because the sun is low in the sky so it casts long, cool shadows, which add interest to your pictures. The warmth in the light also keeps the snow looking pure and white. Around midday or in dull weather there's a tendency for snow to record with a slight blue cast because the light's cooler.

Small details can make interesting pictures after a fall of snow. Look out for milk bottles half-buried on a snow-covered doorstep, or snowy trees against the blue sky. Kids building a snowman, having a snowball fight or sledging down a hill make good subjects too.

In the countryside, ice often appears as beautiful natural sculptures: leaves trapped in a frozen puddle, twigs enclosed in a glassy coat, elaborate icicles created by the constant dripping of water, or waterfalls

OPPOSITE: **You don't get better winter weather than this—freshly fallen snow, ice patterns on a frozen mountain stream, perfectly clear blue sky and crisp sunlight. Faced with such a perfect combination of elements, it's difficult not to take great landscapes. The hardest part is deciding where to point your camera first—and not tramping through what you later decide was the best foreground!**
Canon EOS 1DS MKIII with 16–35mm zoom and polarizing filter, 0.3sec at f/16, ISO100

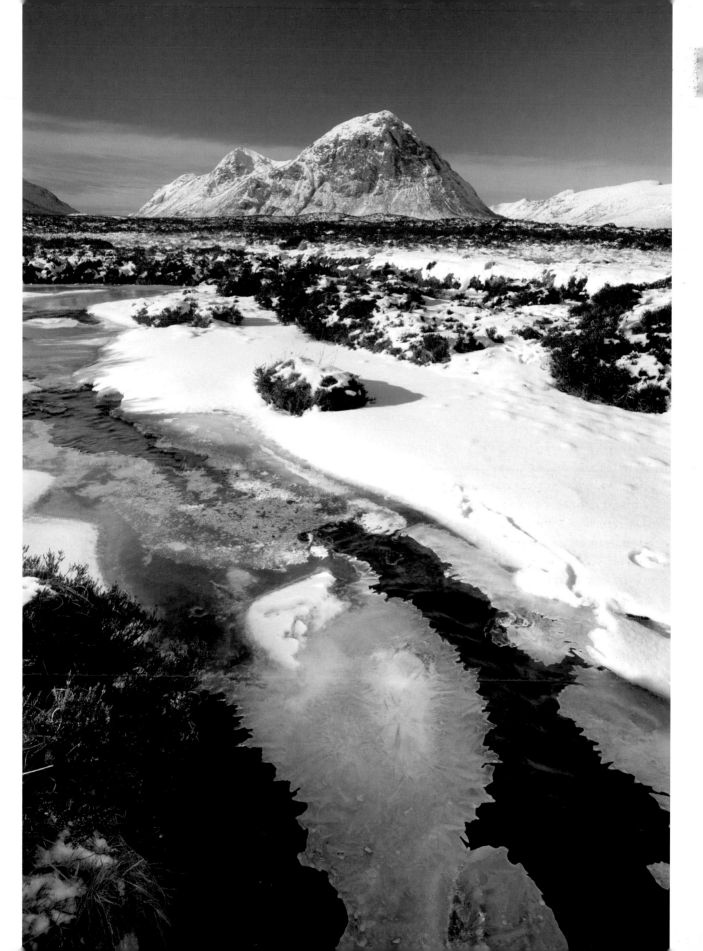

EXPOSE YOURSELF

The trickiest aspect of winter photography always used to be getting the exposure right. Snow, ice and frost are all highly reflective and had a habit of fooling camera meters into underexposing—often by as much as 2 stops.

This still happens today—even the best metering systems struggle when faced with a sea of pure white. Fortunately, as the vast majority of them are inside digital cameras, you at least have the benefit of knowing exposure error has occurred when you check images on the preview screen, and you can then set about correcting it so you don't mess up a great shot. If you shoot in raw format, there's also a reasonable amount of latitude to correct exposure error, though you still need to take care.

The golden rule with digital capture is "Never Blow The Highlights", because if you do it means no detail has recorded in those areas, so there's nothing to rescue other than pure white. Heeding this rule is even more important when shooting winter scenes because you have much greater areas of "highlight" to deal with—especially in snow scenes.

What I do is mount my camera on a tripod, compose the scene then attach and align any filters I intend to use. Next, with the exposure mode dial set to Aperture Priority and the lens stopped down to the desired aperture, I take a shot with no exposure adjustment applied. This is my exposure test shot—a digital

Polaroid if you like—to see how the camera's coping.

I always expect a degree of underexposure and I'm rarely disappointed, so after looking at the preview image and its histogram, I dial in extra exposure using the camera's exposure compensation feature. I may start with as little as +1/3 stop or as much as +1 stop and I may end up going to +2 or even +3 stops to get the effect I want—it all depends on the scene and how far out the first exposure was.

The key is to pay attention to the histogram because as you increase the exposure, the tones in the histogram shift gradually to the right. What you don't want to do is move it so far to the right that the highlights start to blow, because with a winter scene, where the histogram tends to be fairly condensed, this can be catastrophic. "Clip" the highlights in a normal scene and you may get a few tiny areas where no detail records. Clip them in a snow scene and half the image ends up pure white. You don't want that, because while snow is white, it's not pure white and it does have texture, which you need to retain.

So, I increase the exposure as far as I can before the highlights touch the right side of the histogram, and that gives me a raw file where texture and details is recorded in the lighter/higher tones—the snow, ice and frost—but plenty of shadow detail has also been recorded.

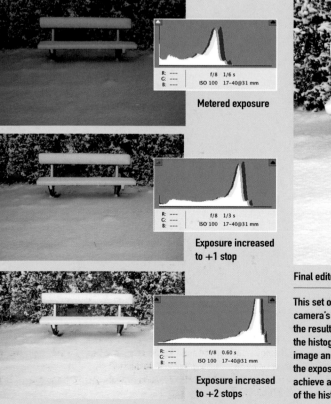

Metered exposure

f/8 1/6 s
ISO 100 17-40@31 mm

Exposure increased to +1 stop

f/8 1/3 s
ISO 100 17-40@31 mm

Exposure increased to +2 stops

f/8 0.60 s
ISO 100 17-40@31 mm

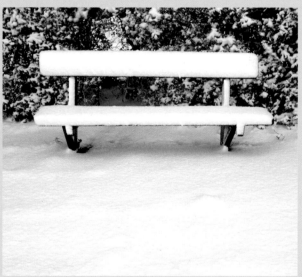

Final edited image

This set of images shows how to expose for winter scenes using your camera's integral metering system. The initial exposure was way out and the resulting image is underexposed. Note the position of the tones on the histogram. Increasing the exposure to +1 stop has brightened the image and shifted the histogram more to the right. In the end, however, the exposure had to be increased to +2 stops over the metered reading to achieve a satisfactory result with the tones shifted much farther to the right of the histogram without being "clipped."

that have been completely frozen by the cold temperatures.

Shots can also be set up. Leave some autumn leaves or fresh flowers outdoors in a tray of water so they freeze overnight and you've got the makings of a great winter still life. Hang some colorful clothes out on the line when sub-zero temperatures are forecast then photograph them frozen solid the next morning. Being one step ahead of the game; that's the key to successful winter photography.

If you rise early on a cold winter's morning you'll often find mist swirling around trees, hanging over rivers and streams like a mysterious shroud and reducing the world to pastel colors and simple, two-dimensional shapes. Mist also tends to settle in valleys, and when viewed from a high position can look incredibly evocative, with treetops and church spires just visible, or plumes of smoke from fires drifting into the frozen

air. Scenes like this tend to look their best after a very cold night, when the mist has frozen and stays put for much longer. If you descend into the mist you will also find trees covered in a thick coat of frost due to the moisture in the air settling on them before freezing.

Take care when composing winter landscapes. If you're using a wide-angle lens, look for features that can be used as foreground interest, to add a sense of depth and scale and lead the eye into the scene. Rocks and boulders work well as do paths and tracks, or the patterns in ice at the edge of as frozen lake. With telephoto shots, look for natural patterns in the landscape and try to fill the frame for maximum impact. Wasted space leads to windy, boring compositions. Place the horizon a third from the top of the frame for a balanced composition, and use the rule of thirds to help you position the focal point in a scene.

top tips

- Cold weather can cause the batteries in your camera to drain, so keep a spare set in your pocket where they will stay warm, and swap the batteries if necessary.

- After taking pictures outdoors for a while, you may find that your camera and lenses develop a coat of condensation after coming back inside where the temperature is much higher. To prevent this, place your equipment inside a large plastic bag with a few sachets of silica gel before going indoors, so any condensation will form on the bag and be absorbed by the silica gel. When all traces of condensation have gone, you can take your equipment out of the plastic bag.

- Remember to keep yourself warm when venturing outdoors in cold weather. Wear lots of thin layers of clothing rather than two or three thick layers. A hat is also essential as 40 per cent of our body's heat is lost through the head.

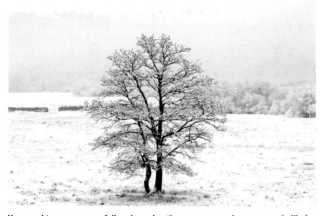

You need to expose carefully when shooting snow—underexposure is likely. but if you over-compensate you'll end up with a little more "white" than you were expecting. Watch the histogram and avoid clipping the highlights.
Canon EOS 1DS MKIII with 70–200mm zoom, 1.3sec at f/11, ISO100

Dawn is a magical time to be out in the winter landscape—it's quiet, cold, wonderfully atmospheric and chances are you'll have the place to yourself. Better still, the sun rises at a respectable hour so you don't need to head out in the middle of the night to catch the dawn light! It was –8°C when this scene was captured and I hid the rising sun behind a tree to prevent it from creating an unwanted "hotspot" in the sky.
Canon EOS 1DS MKIII with 70–200mm zoom and 0.6ND hard grad, 1/2sec at f/11.3, ISO100

WORKING A SCENE

One of the trickiest aspects of landscape photography is continually turning up at new locations—or stumbling upon them by chance—and coming away with pictures that really capture the spirit of the scene. It's so easy to rush around, taking a handful of obvious shots before heading on to the next place. But if you adopt this kind of whistle-stop approach you'll end up with lots of good pictures but few great ones, so think quality instead of quantity and give yourself the time to explore each location and get a feel for what it's all about.

WHAT YOU NEED

CAMERA: A digital SLR or compact.

LENSES: I used a single wide-angle zoom here, but a range of focal lengths from wide to telephoto will be useful.

ACCESSORIES: Polarizing and ND grad filters, tripod and cable release.

HOW IT'S DONE

There's no secret formula here—it's simply about using your eyes and your feet. Usually, there will be an obvious feature that draws you to a location in the first place, but that feature will only be one aspect of the composition, so be prepared to spend time wandering around and looking at it from different viewpoints, or even changing tack

USING A TRIPOD

Although it's quick and convenient to move around a location if you're shooting handheld, mounting your camera on a tripod is advised as it will slow you down and make you think more about each shot you take— instead of just snapping away. It's also much easier to fine-tune a composition with your camera on a tripod, make sure that it's level and accurately align neutral density grad filters. Plus, you don't have to worry about slow shutter speeds causing camera shake so you can stop the lens down to a small aperture to maximize depth of field.

completely if you see something better.

Take note of different foreground options: if the light works better from different angles, how the sky looks as you change position. Will a really low viewpoint work better than shooting from eye-level? Should you turn the camera on its side instead of shooting in landscape format? Are there lines in the scene that you can use to make the composition more interesting? Should you get closer, or back off? Is the focal point better placed centrally or off to one side? Will switching lenses give you a better view?

Other factors will also dictate where you shoot from. For example, a polarizing filter works best on the sky when the sun is roughly at a right-angle to the lens axis, but shows little change if you shoot with the sun to your back.

Think of all these questions and considerations like a checklist for successful composition and mentally tick them off as you go. If this is an area where you tend to struggle, it's also a good idea to take pictures as you move around, so

that once home you can look at them in order and see how the composition evolves. Similarly, when you've taken a shot, take a close look at it on your camera's preview screen and think about how it can be improved—maybe a slight tweak here and there is all it needs.

To demonstrate this, here is a series of shots of a Tuscan scene, showing how slight variations can make a big difference, and spending time working a scene will lead to better images.

1. I spotted these two cypress trees on the top of a hill and instinctively knew they would make a great subject. The only downside was that they were quite a way in the distance and I had no

idea what else was on the hill. The only solution was to hike up there and find out. On arrival, after catching my breath, I took this head-on shot. It's an obvious interpretation really, and I reckoned I could do better.

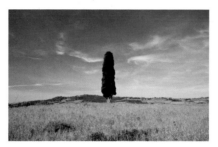

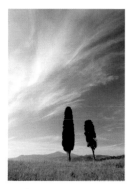

2. There were some interesting wispy clouds in the sky so I attached a polarizer to my 17–40mm zoom and rotated it to see what effect it had on the sky. I also decided to try an upright shot and moved the trees over to the right of the composition. There was a smattering of poppies in the field, but sadly nothing to get excited about—a blanket of red filling the foreground would have been amazing.

4. As I moved around the location, checking out the view from different angles, I realized that it was possible to line up the two trees so the smaller one was hidden behind the taller one, giving the impression there was only one. Compositionally, it's simpler than the other shots, but I actually think that in this case, two trees are better than one because they make the composition more active.

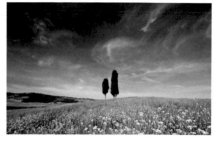

5. The position I took the shot in step three from gave me a better view of my immediate surroundings, and I could see that no more than 15 meters away there were some patches of oilseed rape complete with vibrant yellow flowers. As yellow and blue make a striking color contrast, I decided to investigate. From this angle the sky was also much more interesting and the polarizer more effective.

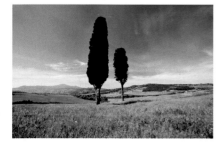

3. My next idea was to move closer to the trees so I could get a clearer view of the stunning Tuscan landscape rolling away into the distance. The composition still isn't particularly exciting, but it does capture the character of the scene and holds the attention of the viewer for longer as there's a lot to take in— farmhouses, barns, rolling fields and hill villages.

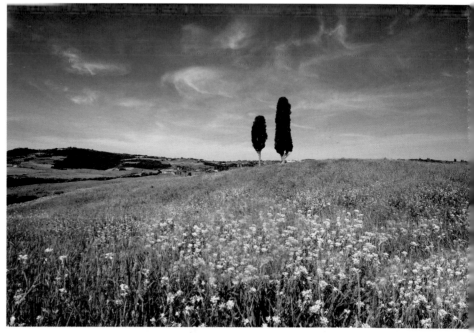

FINAL IMAGE
I was almost there with step five, but decided that the composition would be stronger if I included more foreground and also pushed the two trees over to the right a little. I don't know if you've noticed, but the smaller tree also looks neater than in previous shots. I didn't like the fact that one half of it was looking rather shabby, so I put Photoshop's Clone Stamp tool to work and tidied up the left side of it. Oh, the wonders of digital technology!
Canon EOS 1DS MKIII with 17–40mm zoom and polarizing filter, 1/8sec at f/22, ISO100

INDEX